Muses

Translated from the French by David Radzinowicz
Design: Delphine Delastre
Copyediting: Lindsay Porter
Typesetting: Anne Lou Bissières
Proofreading: Chrisoula Petridis
Color Separation: IGS-CP, Paris
Printed in China by Toppan Leefung

Originally published in French as *Muses: Elles ont conquis les cœurs*
© Flammarion, S.A., Paris, 2011

English-language edition
© Flammarion, S.A., Paris, 2012

87, quai Panhard et Levassor
75647 Paris Cedex 13

editions.flammarion.com

12 13 14 3 2 1

ISBN: 978-2-08-020102-7

Dépôt légal: 09/2012

Muses

Women Who Inspire

Farid Abdelouahab

Flammarion

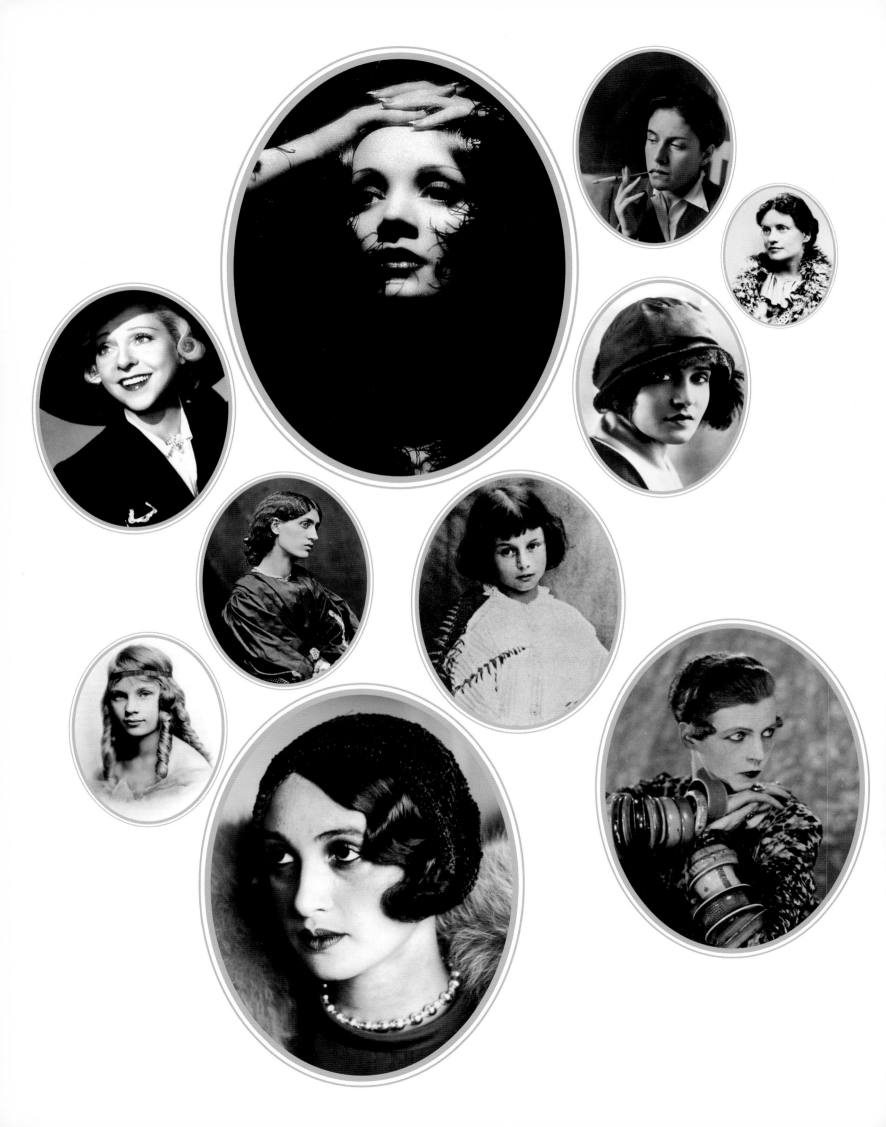

Contents

I call my wife: Gala, Galuchka, Gradiva
(because she has been my Gradiva) Olive (because of the
oval of her face and the color of her skin) Olivette,
the Cataloniar diminutive of olive; and its delirious derivatives
Olihuette, Orihuette, Buribette, Burbuteta,
Sulihueta, Solibubulete, Oliburibuleta, Lihuetta. i also
call her Lionete (little Lion) Because she roars like the
Metro-Goldoyn-Mayer lion when she angry;
squirrel, Tapir, Little Negus (because she
resembles a lively little Forest animal
Bel (beucausse She Discouvers
and brings me all the
become convertet into the honey of my trought in the busy hive of essences tha
mi brain)
"Regard perceur de murailles"
Paul Eluard

Je brought me the rare book on magic that was in the Process
of elaboration the paranoiac immage tha my subconscius wished for, the
photograph of an unknown Painting destined to reveal
a new esthetic enigma, the advice tha would save one of my too
subjective images from romanticicism. i also call Gala Noisette
Poilu-Hairy Hazelnut (beucause of the very fine
down tha covers the "hazelnut" of her cheeks); and also
"Four Bell" (because she reads to me aloud during
mi long sessions of painting, making a murmur
ad of a fur bell be nstutte of which i learnt all
the things tha but for her i should
never know) Dalí

W

*The Eternal Feminine
Draws us upward.*
Goethe, *Faust II*

hy does man elevate woman into a symbol? Where does this male obsession, this fascination—a combination of desire and admiration—come from? When did it begin?

It is not impossible to imagine that marble sculptors in Ancient Greece—despite the sacred and cultic purpose of their works—took inspiration from local girls when carving their Aphrodites. Although those ancient times were ruled by athletic gods, at this time the Muses, the nine female companions of Apollo (or ten if one includes Sappho of Lesbos, as Plato does) were already hard at work. Descending from Mount Helicon wielding trumpets and drums, they acted as intermediaries between the gods and humans, and whispered in the ears of poets and musicians, actors. The influence of these daughters of Mnemosyne—goddess of Memory—born, according to myth, following nine unforgettable nights with Zeus, has endured to the present age. For centuries the foremost poets of French literature, no less in awe of the classical model than poets of other countries, placed their work under their auspices. Joachim du Bellay, Voltaire, Alphonse de Lamartine, Victor Hugo, and Paul Claudel, to name but a few, have all paid due homage, while even the rebellious sixteen-year-old Arthur Rimbaud wrote in *Ma Bohême*: "I walked beneath her sky, o Muse! And I was your vassal!" Likewise, no major movement in the history of painting could afford to miss out on the subject.

And yet, like so many other divinities, the Muses eventually tumbled from their heavenly peak. The avant-garde, reacting against academic art, and preferring to dip their brushes in the colors of everyday life and the modern world, were fired by a quest for authentic realism or inner truth, or else by the fantastic landscape of the dreams and the unconscious. They gave up singing paeans and odes to the Muses, and the Muses in turn fell silent. These artists found their models and muses in their partners: Manet with Victorine Louise Meurent and the actress Ellen Andrée; Degas and Bonnard with their respective spouses; Picasso with his various wives and companions, Dalí with Gala, and Man Ray with Lee Miller. Hence, women who shared the life of an artist—even if just for a short time—found themselves placed on a pedestal. Centuries earlier, painters' wives also played a preeminent role as models: Rembrandt's first wife, Saskia van Uylenburgh, as well as his second, Hendrickje Stoffels, served the painter on several occasions. The same can be said of Rubens's wife, Helena

Portrait of Gala entitled *The Names of My Wife*. Salvador Dalí wrote over this Man Ray photograph of 1927 in pen and India ink some five years after it was taken. The center of this paean to womanhood features a quotation from Gala's first great love, the poet Paul Éluard.

Fourment. For the more fickle painter, the present incumbent could be ousted by a new muse; for the more faithful, a single woman became etched into the marble of their existence.

The increasing focus on a single individual, this shift from mythological and imaginary figures to a real woman, had long been underway among poets and writers before the tendency become more common among the avant-garde. Historic muses of flesh and blood had risen to prominence with the appearance of courtly love in the Middle Ages. Then troubadours would venerate the lady in verse, singing on behalf of an increasingly refined chivalric class that saw a paragon of femininity as promoting grandeur of soul and nobility of spirit, as a spur to epic feats, romantic dreams, and the search for an absolute. In such cases, however, her inspiration was more a means—a tool or instrument employed for spiritual advancement or mystic asceticism—than the creative power behind an artwork dedicated to beauty. If today's historians no longer consider Eleanor of Aquitaine the symbol of courtly love she was once believed to be, the twelfth-century queen of France and England did nonetheless contribute greatly to its development, protecting at her court some of the greatest bards of the time, who paid her due homage. The same tradition motivated Dante when he lauded his Beatrice.

> *The stories of these women are often checkered and tragic,*
> *occasionally happy and harmonious,*
> *but each is unique and never less than affecting.*

Over the course of the centuries the women who have fascinated and inspired philosophers, authors, and musicians are as many and various as the artists themselves, and obviously we cannot refer to all of them here. In the Renaissance, Michel de Montaigne felt his heart leap in the presence of the young Marie de Gournay, an enlightened woman of letters whose mind and beauty impressed him so much that he dubbed her his "adopted daughter" in his *Essays*. His actual wife took no umbrage at this and even entrusted Marie with the first posthumous publication of Montaigne's masterwork, to which she provided a foreword. Some of these Muses, on the other hand, perhaps through possessiveness or a misplaced sense of duty, thought of themselves as heirs to a body of work that seemed to concern them more than anyone else. During the Enlightenment, a besotted Voltaire lavished praise on the bluestocking

Dalí with his arm round Gala in a set designed to celebrate the couple's love in 1939. Begun some nine years earlier, the construction of their house in Port Lligat near Cadaqués in Catalonia was a joint effort. At the end of a road leading down to the creek, Gala—the "divine protein" of the whole architectural enterprise—left the imprint of her hand and her foot in the wet cement.

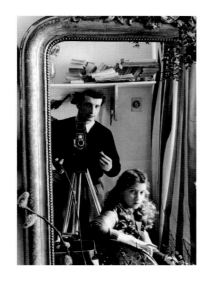

Vision and mirror effects often play an important role in relations between creative artists and the women who inspire them. Here, a self-portrait by the photographer Édouard Boubat with Lella (1952), whom he met in 1946 and who became his first wife. It was to portraits of her that he owed his initial success.

mathematician Émilie de Châtelet, seeing her as the ideal of the "*femme savant.*" Many French society ladies, aristocrats, and demimondaines alike, who held literary or political salons during the nineteenth century were adulated by the male intellectual elite. Valentine de Laborde, mistress and inspiration of Prosper Mérimée, was extolled by him as a "pearl of women." Later, the Countess of Loynes, was venerated by a bedazzled Gustave Flaubert, who fell for her hook, line, and sinker—just as he had with the legendary Louise Colet.

The muses in the present volume, however, though all very different, nevertheless represent a form of modernity. Though the selection is subjective, they were all chosen for their acute intelligence, indomitable will, extreme elegance, singular independence, or unbounded devotion. Some oscillate between the traditional figure of the protective mother (a few were incapable of fulfilling that role biologically) and emancipation from male domination. For some, the passion for independence—sometimes through their own creativity—would be undone by the trap of celebrity and money (Gala Dalí, for instance) or else overweening narcissism (as with Countess Virginia de Castiglione). Another pitfall lay in wait for a good number of them: the artistic life by proxy, as exemplified by Alma Mahler, obliged to give up writing music at the insistence of her composer husband.

This book ends with the immediate aftermath of World War II. Thus, it does not address the celebrities of the "society of spectacle"—with ephemeral stars or living logos for a label or fad. Edie Sedgwick, Andy Warhol's muse, essentially represents a drugs and clubbing lifestyle; Grace Jones evokes a decade more than a body of work; while supermodels such as Kate Moss symbolize a battery of cosmetic and luxury brands. This is not to denigrate them, but this book focuses on a more romantic age.

As readers will discover in the following pages, these women set sail on the stormy waters of creative art, with authors or painters—some possessive and obsessive, others worshipful, perhaps, but thoughtless, self-centered. Their stories are often checkered and tragic, occasionally happy and harmonious, but each is unique and never less than affecting. There is a contingent of flappers with bobbed hair who made their bid for freedom—like Kiki de Montparnasse or Nancy Cunard, Aragon's muse in the Roaring Twenties. While some of these women have since become legends, muses have always, since time immemorial, been part of the act of creation. Indeed, it is a strange union that requires the consenting female to become—for better or for worse—the future of the artwork.

Lizzie and Jane

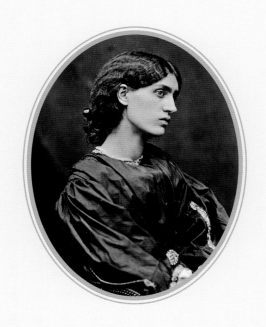

Rossetti's Beatrices

Facing page and page 16:
Portrait of Jane Morris taken
on July 7, 1865, by John R. Parsons
at the request and under the guidance
of Dante Gabriel Rossetti in his garden
in Chelsea, London. Like the portrait
on page 16, this picture of a woman who
was at once mistress and model was
intended for a private photo album.
Although Jane posed for Rossetti many
times, some of these photographs were
probably later used as the basis for
paintings that portray her as a figure
from mythology.

The incredible tale of the relationship between Dante Gabriel Rossetti, the Pre-Raphaelite painter and poet of Italian extraction, and his various muses—fiancées, wives, and mistresses—is fantastic enough to rival the most lurid melodrama. Edgar Allan Poe might have drawn inspiration from some of the episodes in the artist's tireless, reckless quest for the beautiful and the inexpressible, undertaken as the figurehead—against his better judgment—of the Pre-Raphaelite movement. It is remarkable just how destructive an egocentric, single-minded, yet sincere search for harmony and the eternal feminine can be in the terrestrial realm. Did Rossetti come to grief precisely because he strove, not to look into the eyes of his muses, but to produce an idealized image of them? His life ended in loneliness and madness, obsessed with the pictures of the women who had once inspired him; if he exalted their mystical sensuality and angelic grace in both verse and painting, he also pushed them to despair and even death.

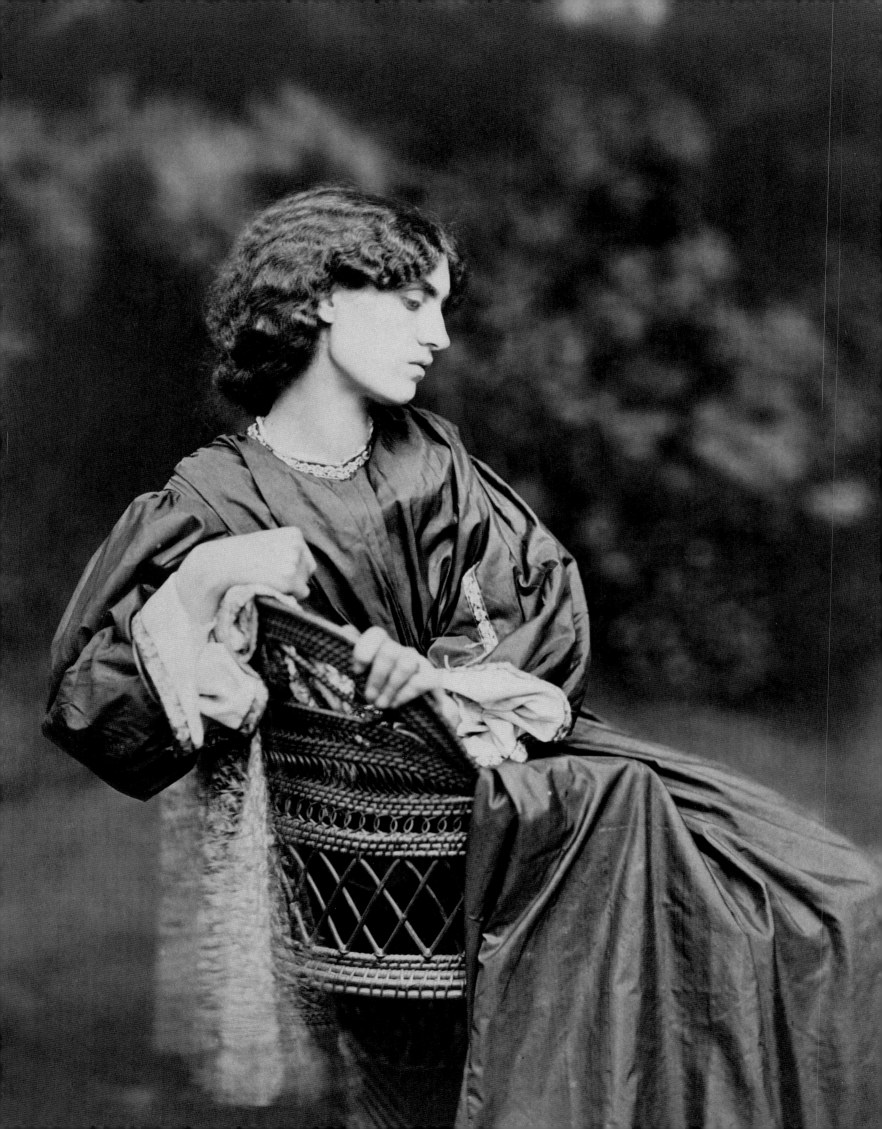

Rossetti's first model had been his sister Christina: she takes the role of the Mother of Christ in this picture entitled *The Girlhood of Mary Virgin*, while their mother provides the features of St. Anne.

Reincarnation of the muse

Born in London in 1828, Rossetti had barely emerged from childhood than he was affirming his talent as a writer and draftsman with a marked taste for the mysterious and medieval.

His muses were legion. If the opulent Fanny Cornforth long shared his life, the majority of his muses proved fleeting, with the artist truly extolling only those whose personality and charisma were a match for his philosophical and spiritual aspirations. His first model, his sister Christina, already personified a nostalgic yearning for an unattainable love.

It was she whose features appear in *The Girlhood of Mary Virgin* with Christina as the title figure and his mother as St. Anne. The Virgin was to become a privileged figure among the Pre-Raphaelites, an image of the Incarnation and the Ideal; as Rossetti was to write in later years, his picture was "a symbol of female excellence. The Virgin being taken as its highest type."

A short story written later by Rossetti, "St. Agnes of Intercession," reveals much about his approach to the notion of the idyllic muse, as well as the mysterious bonds that Rossetti believed linked him to the masters of the past, and to Dante in particular. In the story a Rossetti-like artist meets a beautiful young woman, Mary Arden, through his sister, and was immediately captivated by the majesty of her features, painting her in a portrait that he hopes will make his fortune.

When the picture was first shown, however, the young artist learned that the central figure bore an uncanny resemblance to a representation of St. Agnes in Bologna by the Florentine Renaissance painter Angiolieri. Intrigued by this alleged likeness, the artist set out for the land of his ancestors to verify for himself an incredible pictorial coincidence that defied both time and space. But there was no St. Agnes in the capital of Emilia Romagna. After a fruitless search in various centers of Italian art, Rossetti at last came across the object of his search in the academy at Perugia. He was struck dumb: the resemblance was so striking that it seemed as though his beloved were standing before him after five months apart. Perhaps Angiolieri, in portraying his saint, had been inspired by a muse and lover of his own. Rossetti's metaphysical speculations reached their peak when he described a scene in which the young artist-Rossetti figure discovers the portrait of her creator in the same city: it was his double. The Quattrocento painter could be his twin. Thus in his fiction, Rossetti played out his own preoccupations with art, love, and the early Renaissance.

Rossetti, Dante's spiritual son

From the pictorial as well as literary point of view, the tutelary figure of Dante Alighieri hovers over Rossetti's oeuvre. At twenty-one, he swapped around his Christian names of Charles Dante Gabriel to place Dante first (and, coincidently, to revert to the name of his father). Thus, following in the footsteps of the master of the *Commedia*, Rossetti set out to perpetuate in his own, less systematic, manner a cult of the Lady. Rooted in the feudal tradition of courtly love as celebrated by the troubadours, the beloved, the damsel, becomes at once object of worship, muse, and inspiration. For the Fedeli d'Amore, the name of a secret society to which Dante belonged and whose principles Rossetti and some of his fellow artists appear to have copied, the practice of poetry is based on the expression of love elevated to the point of sanctification. Thus adored, the woman serves simultaneously as a source of inspiration and a mirror reflecting a more exalted love, as Rossetti writes in the sonnet "Her Love" in his collection *True Woman*:

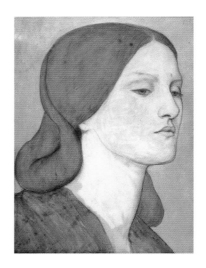

Elizabeth Siddal, known as Lizzie, lent her features to this watercolor drawing entitled *Head of a Woman Wearing Green*, from the 1860s. An art lover herself, Siddal posed for many English Pre-Raphaelite painters (such as Deverell, Hunt, and Millais), who saw her as their absolute ideal.

> She loves him; for her infinite soul is Love,
> And he her lodestar. Passion in her is
> A glass facing his fire, where the bright bliss
> Is mirrored, and the heat returned.

In this context, the figure of the Virgin, a symbol of female excellence, also served as a paragon of love and wisdom. Like Dante, Rossetti aspired to the inexpressible, striving to attain the ineffable and the eternal feminine by way of muses that were taken to represent the divine incarnation of love. Works by the Florentine poet inspired studies, drawings, and pictures by the hundreds, and, at the height of Victorian society's fashion for spiritualism, Rossetti even went so far as to try to summon Dante's spirit at séances. But, before plunging headlong into disaster with his new muse, the unfortunate Elizabeth Siddal, known as Lizzie, Rossetti went through a period in which drama and creativity worked side by side. As Timothy Hilton has pointed out in his book *The Pre-Raphaelites*, it was the dual influence of Dante and Lizzie that allowed Rossetti to explore in his art a new and entirely personal universe.

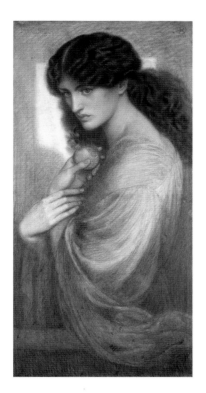

Jane Morris as *Proserpine* drawn
in colored chalk on paper by Rossetti
in 1871. Swinburne, a writer and decadent
poet very close to the Pre-Raphaelites,
observed, "Could a man dream of anything
finer than to kiss her foot?"

The ghost of Lizzie

At the end of 1850, Walter Deverell, painter and friend of Rossetti, had been bowled over by an elegant young milliner. Copper-haired and slim-waisted, Elizabeth Siddal, who lived in London and who had been born in 1834 to a modest family originally from Sheffield, was fond of painting and poetry. With the agreement of her mother (who nonetheless forbade nudity) Lizzie was soon to pose for Deverell, and then for Holman Hunt and John Everett Millais (hours at a stretch in a bathtub for the latter's celebrated *Ophelia*), before finding herself in the studio of Rossetti, who was soon similarly enthralled by the beauty with the crystal-clear complexion. The woman, who, as Rossetti was to confess later, sealed his destiny, started out by playing the role of Beatrice when Dante first saw her. Rapidly becoming an ideal of beauty for the Pre-Raphaelites, Lizzie joined Rossetti when he left the family home in an affirmation of his late emancipation from his mother and sisters Christina and Mary. Lizzie's health was fragile; she suffered from consumption and, like Rossetti, she was affected by nervous disorders. Together they formed an unstable, tormented couple, forever on the brink of ending their relationship. Although resigned to the worst, Lizzie was surely devastated by Rossetti's infidelities. Sometimes these would take place under the same roof, as with Fanny Cornforth, or else out and about at night, with the prostitutes he frequented. Rossetti repeatedly shrank from putting their relationship on an official footing. Remaining his uncontested muse, as the innumerable works (poetry, drawings, paintings) that were created over the following years testify, Lizzie developed a disturbing dependence on the opium-based concoction laudanum. In 1856, at her lowest ebb, Rossetti promised to marry her; the following year, however, he met Jane Burden and Lizzie found herself temporarily usurped. Within a year, however, in 1858, she was posing for one of her lover's most famous canvases, which was finished after her death: *Beata Beatrix*. For Evelyn Waugh the painting is "perhaps, the most purely spiritual and devotional work of European art since the fall of the Byzantine Empire." Lizzie and Dante were eventually married on May 23, 1860, leaving soon after on their honeymoon. At the time Rossetti shared his wife's insatiable appetite for opiates and alcohol, which seemed to aid the unequal struggle against panic attacks and insomnia. Their return from their gloomy sojourn boded ill. The painter was mired in endless financial difficulties, while Lizzie lost their first child, a tragedy that further undermined her health. She decided she would no longer sit for her now famous husband. After she become pregnant once again, the couple's existence descended into a prolonged series of arguments

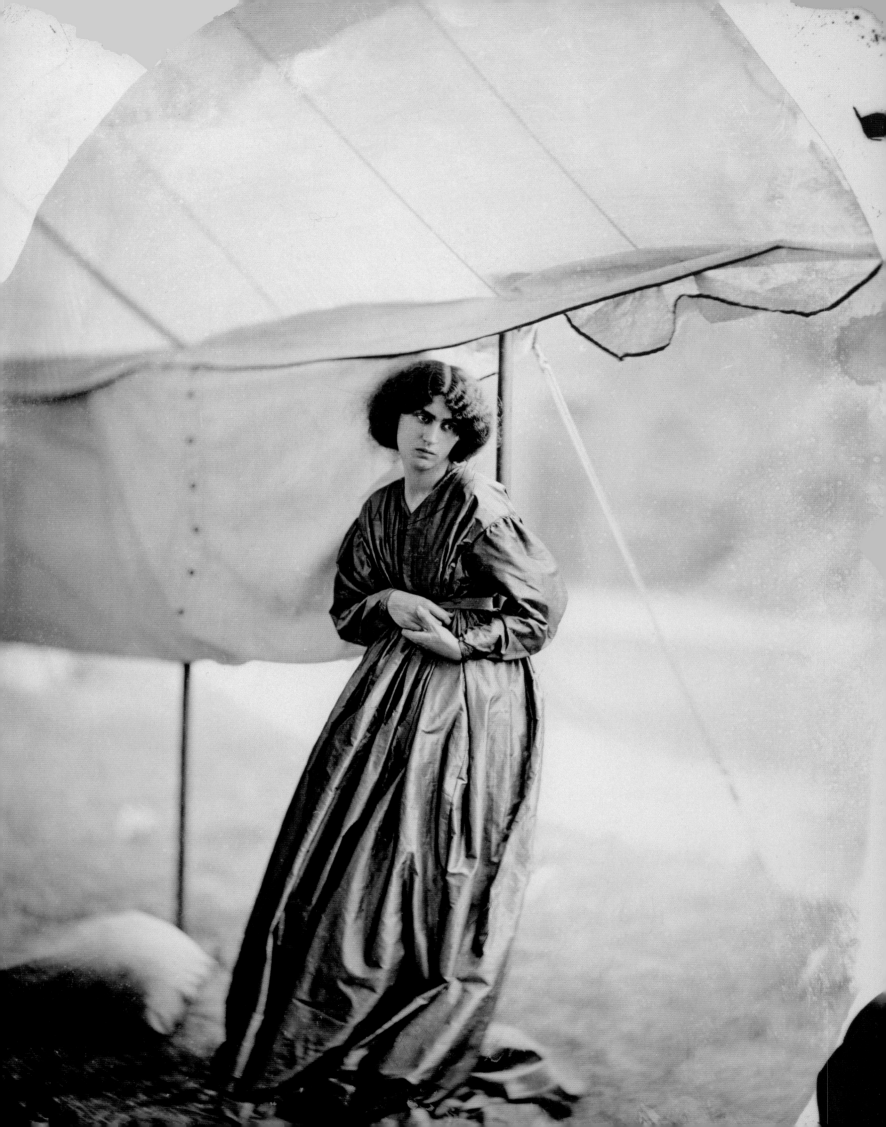

and crises, while Lizzie drifted off further into her artificial paradise. On the morning of February 11, 1862, she was found dead, having taken an overdose of laudanum. Stuck on her bodice were the words "My life is so miserable I wish for no more of it." Deranged with grief, Rossetti paid her one final tribute, placing in her coffin the manuscript of a collection of poems started years earlier, many of which were dedicated to her.

Over time, the enigmatic Jane Burden became a new wellspring of inspiration for his work and Rossetti became determined to consolidate his talent as a poet. After much thought, in the summer of 1869 he decided to exhume Lizzie's body in Highgate Cemetery to retrieve the poems. In October, the grave was dug up in his absence. Though dead some seven years, Lizzie's body was, it was related, in an amazing state of conservation: the glorious auburn hair was intact—and the manuscript, too, which was published in his 1870 collection *Poems*. Only later was he struck by the sacrilege he had committed in the name of literary ambition. Following an attack of paranoia and hallucinations, and convinced that Lizzie's spirit was coming back to demand retribution, he took a dose of laudanum so excessive that it put him into a coma. The year 1872 was one of violent crises and ravings. Pursued by the memory of Lizzie, he wrote the following verses in 1881, a few months before his death: "Ah! dear one, you've been dead so long?—How long until we meet again?"

Mysterious and imperious: Jane Morris

Rossetti became acquainted with Jane, a beautiful young woman from an unpretentious Oxford family, at a performance at the Oxford playhouse in the summer of 1857. Bewitched by her refined features and oriental allure, that very evening he asked whether she would agree to pose for him. Not long afterwards, however, Jane married William Morris, a friend of Rossetti's and fellow painter in the Pre-Raphaelite group. Nonetheless, over the next few years, she became Rossetti's favorite muse, before their relationship took a less platonic turn toward the end of 1860. First sitting for him as Queen Guinevere, Jane seemed to steer Rossetti in a new pictorial and technical direction, in which medieval mysticism would play an ever more dominant role. Henry James described her in the following words: "she is a wonder. Imagine a tall lean woman in a long dress ... with a mass of crisp black hair heaped into great wavy projections on each of her temples, [and] a thin, pale face, a pair of strange, sad, dark, Swinburnian eyes, with great thick black oblique brows joined in the middle, and tucking themselves somewhere under her hair."

Portrait of Jane Morris taken in July 1865. For the sitting, Rossetti had a kind of large tent erected in his London garden, complete with chairs and a sofa. As other commentators have remarked, some of Jane's poses recall a celebrated series of publicity pictures of Sarah Bernhardt taken by Félix Nadar some years previously. The photographic emulsion has become degraded over time, leaving a vapor effect on the edges nearest the frame and making it seem as though the muse is floating in the center of a cloud.

By the end of the 1860s, drugs and alcohol had frayed Rossetti's nerves and further amplified his melancholia; his mental state was hardly improved by his straightened circumstances. It was, however, during this turbulent period that Jane became a close friend, the fulcrum of his artistic and literary oeuvre. Mysterious and superb, she appears in dozens of compositions—as Proserpine and Mariana, as well as in several versions of Pandora—while the celebrated *Pia de' Tolomei* that monopolized Rossetti for some ten years took its cue from the fifth canto of Dante's *Purgatory*. The legend tells how a jealous husband locked Pia up in a stone tower surrounded by marshland in Maremma. It is not hard to see links with Jane's biography. Testimonies from the time record various public demonstrations of an idealization that suited Rossetti's narcissism. He would ogle his lady at London soirées, while Jane, entering into the spirit of her role, sat enthroned on a pedestal, while the artist sat "beside Mrs. Morris, who looked as if she had stepped out of any one of his pictures, both wrapped in a motionless silence as of a world where souls have no need of words," as R. E. Francillon recounts in his book *Mid-Victorian Memories*.

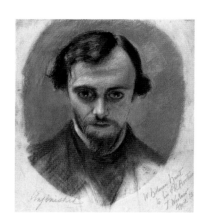

In both his art and literature, Dante Gabriel Rossetti's work is occupied by the female ideal. A portrait in pastel and ink on paper by his Pre-Raphaelite friend William Holman Hunt, dated 1853.

"She's a wonder. Imagine a tall lean woman in a long dress ... with a mass of crisp black hair heaped into great wavy projections on each of her temples, [and] a thin, pale face, a pair of strange, sad, dark, Swinburnian eyes."
Henry James

This quest for transcendence through the figure of the muse spawned a perfect, imaginary world that was fated to merge with reality. As Rossetti suffered another breakdown in 1872, the couple began living under the same roof. William Morris soon put an end to the arrangement, however, and Jane readily distanced herself from Rossetti, alarmed by his mood swings. She was not to break off all contact, however, and would still visit occasionally, even still posing for him, as for the studies and finished work, *Astarte Syriaca*, in 1875. Three years later, she returned from a journey to Italy in bad health, studiously avoiding the company of her longtime admirer. The final versions of *La Donna della Finestra* and *The Day Dream* proved to be the last of the love songs celebrating Jane's unearthly beauty, which Rossetti admired to the end of his days, as bewitched as he had been that very first day in Oxford.

Facing page:
A charcoal drawing on paper of 1868 by Rossetti, entitled *The Day Dream* once again portrays Jane Morris. As so often, emphasis is placed on the perfection of her features.

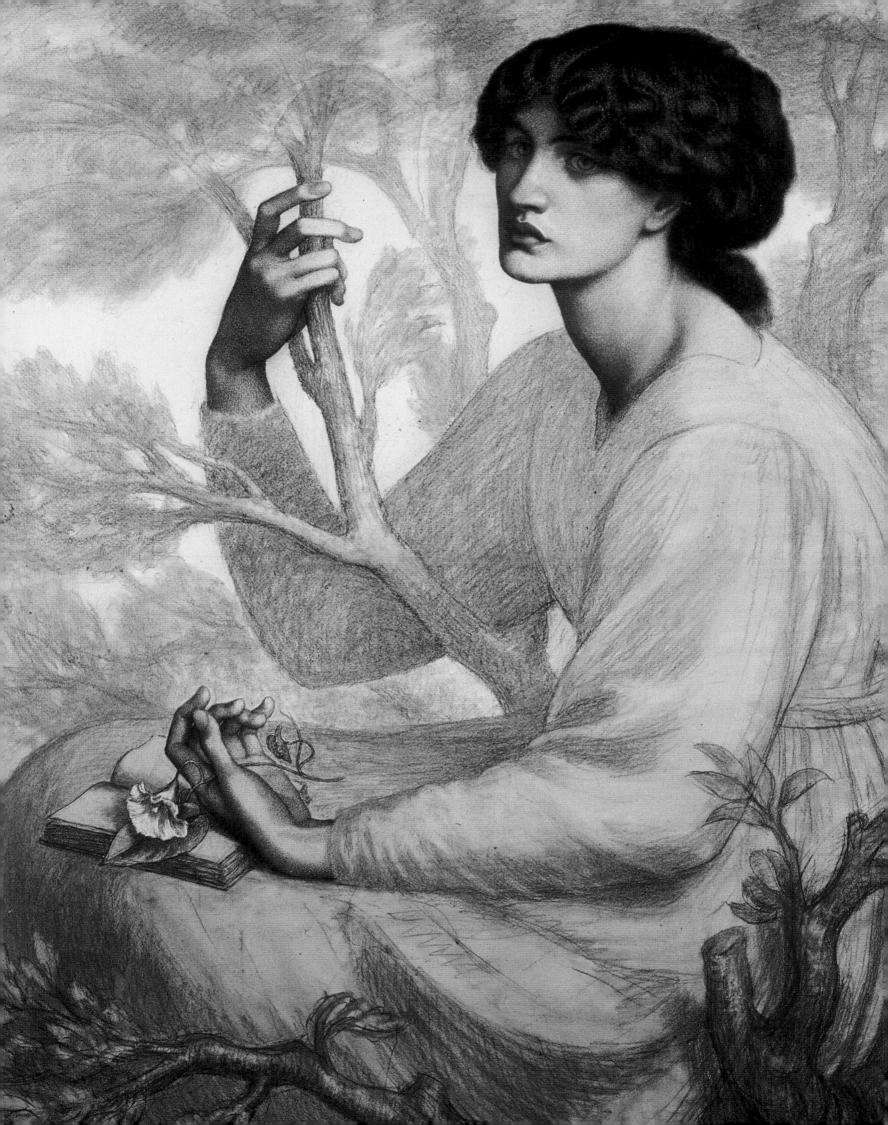

George Sand
Balzac's inspiration

In 1831, after a loveless marriage with Casimir Dudevant and a gloomy existence with their two children in Nohant, in the Berry region of central France, Aurore Dudevant (born Amantine Aurore Lucile Dupin in 1804) decided to settle in Paris with her lover, Jules Sandeau. With little money saved, she soon had to work. After a first, unsuccessful attempt at drawing, she had better luck with writing.

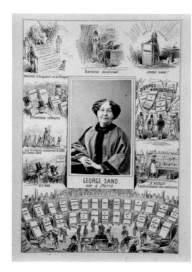

The life story of George Sand in pictures, dated 1864. In the middle, a portrait by Félix Nadar; the caricatures are by Carlo Gripp. Liberated and eccentric, the woman author was often the butt of her contemporaries' scorn.

Facing page:
Portrait of George Sand dressed in man's attire, drawing, c. 1830.
Concerning the young woman's influence, Honoré de Balzac wrote in *La Muse du département* (1843), "When, after the revolution of 1830, the glory of George Sand shone over the Berry, many cities envied La Châtre the privilege of having witnessed the birth of a rival to Madame de Staël, to Camille Maupin, and became rather keen on lavishing honor on the least female talent. Thus there arose in France many Tenth Muses, girls or young women diverted from their peaceful lives by the blandishments of glory!"

After a first venture, *Le Commissionnaire,* written together with her lover under the name Alphonse Signol, the novel *Rose et Blanche* (again co-written with her lover, now under the joint pseudonym J. Sand) was well received. Now signing herself George Sand, Aurore branched out on her own the following year, publishing a substantial novel, *Indiana.* Like so many others, a critic on the illustrated satirical weekly magazine *La Caricature*, a certain Honoré de Balzac, could hardly contain his enthusiasm: "This book marks the reaction of truth against the fantastic, of the present age against the Middle Ages, of private dramas against the tyranny of the historical genre. . . . I have never read anything more artlessly written, nor more delectably conceived."

Balzac soon formed a friendship with the couple, feeling genuine admiration for George Sand, even though they had little in common. After an inspiring visit with Sand in 1838, at the property in Nohant she had recovered in her divorce settlement, Flaubert returned with the idea for *Béatrix*, based on the story of Madame d'Agoult and Franz Liszt, who had both formed part of her entourage. The book came out late the following year and features two female protagonists: the first is the blonde Marquise de Rochefide (it is her first name that gives the novel its title), while George Sand was the inspiration for the second, the emancipated Félicité des Touches. In 1837, Balzac had entertained an idea for a story about Parisians going to the provinces and a woman from the country going up to the capital, which, by 1843, had become *The Muse of the Department*. It was George Sand who supplied the shortcomings of Countess Dinah de La Baudraye, a lover of literature and author of poetry during her leisure hours. At the beginning of his book, Balzac pays her the following dubious homage: "One might say that George Sand has created 'Sandism', since it is true that, morally speaking, good is almost invariably accompanied by a measure of evil. This sentimental leprosy has ruined many a woman who, without such claims to genius, would have been charming. Sandism, however, does possess the advantage that, since the woman prey to it tends to turn her self-proclaimed superiority towards feelings she scarcely knows, she becomes a sort of bluestocking of the heart: it is a less annoying outcome, since love tends to neutralize all that literature. Nonetheless, the principal effect of George Sand's fame has been to make clear the fact that France boasts an unconscionable number of 'superior' females." In 1842, Balzac nevertheless dedicated his *Letters of Two Brides* to Sand, while after his death she penned a foreword to his vast *Human Comedy.*

Jeanne Duval

Baudelaire's nonchalant muse

Portrait of Jeanne Duval (detail), drawn in India ink in 1865 by Charles Baudelaire. Below the image runs a handwritten inscription: *"quaerens quem devoret"*, literally, "seeking somebody to devour," an expression taken from the First Epistle of St. Peter: "Be sober, be vigilant; because your adversary the devil, as a roaring lion, walketh about, seeking whom he may devour." The quotation speaks volumes about their tumultuous relationship.

Jeanne Duval is one of the great unknowns in the annals of literature. Yet the importance of her influence on Baudelaire's work merits her position as a great muse. Very little is known about her: even her name is uncertain, although her first name seems reliable enough. In his correspondence Baudelaire refers to her by other family names, including Lemer (or Lemaire) and Prosper. Perhaps this can be explained by the fact that civil records for descendants of slaves or non-Europeans were extremely haphazard at the time: Jeanne was indeed a "woman of color," of mixed race, "with a café au lait complexion."

But where and when was she born? Assumptions about her origins are as varied as they are unfounded: theories range from Nantes, India, Madagascar, the Dominican Republic, the Mascarene Islands, Mauritius, Réunion, Rodrigues Island. According to Théophile Gautier and Maxime Du Camp, both friends of Baudelaire's, Jeanne had met the poet at the Cape of Good Hope. Du Camp wrote, "He is meant to have brought back from the Cape a Negro woman (or *quadroon*) who gravitated around him for many years." The mystery surrounding her origins and where and when Baudelaire met the woman who remained his muse for nearly twenty years is yet to be solved.

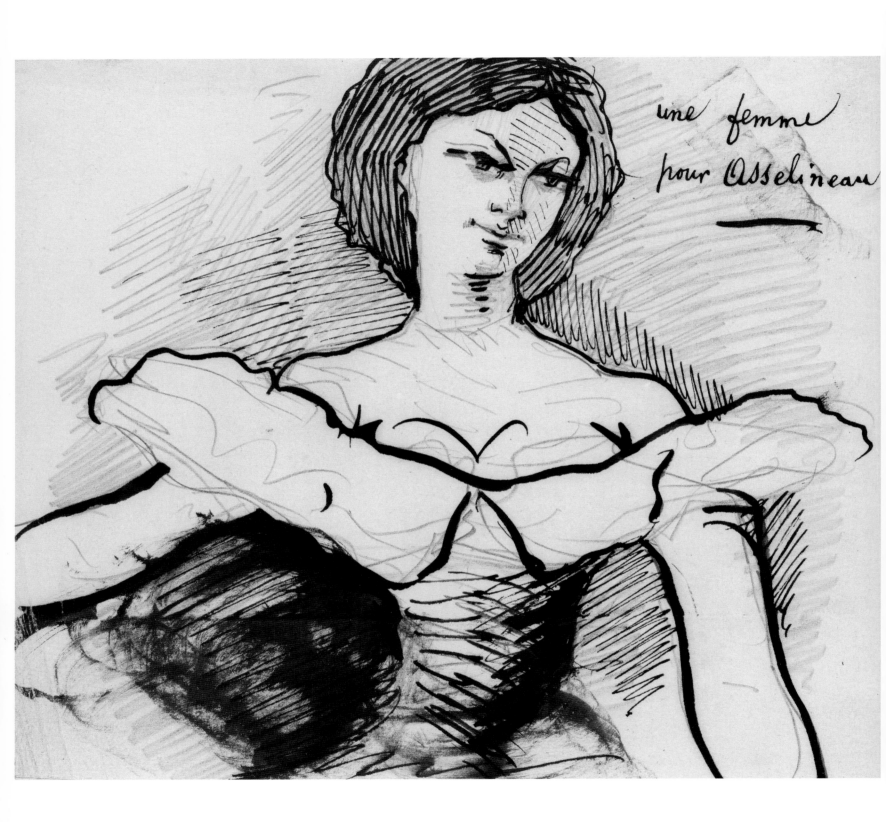

une femme
pour Asselineau

Self-portrait by the photographer Félix Nadar. A lover of Jeanne Duval's in her youth, the great photographer writes, *"Cherchez la femme!* they say. The saying is inescapable in this case. Here then first of all is the woman who occupied such a place in the poet's life, the one that his work embraced over so many pages, especially in anger and imprecation."

Facing page:
A sketch by Baudelaire representing his muse in the 1860s.

Portrait of an unknown celebrity

Even if his memoirs read fancifully in places, photographer Félix Nadar's description of Jeanne is likely to be accurate, since prior to becoming Baudelaire's mistress she had been his lover. At that time, in about 1838–39, she acted under the stage name Mademoiselle Berthe, playing minor roles in light comedies and plays at the theater at the Porte-Saint-Antoine. Initially, some of the audience reacted negatively to her skin color. As for Baudelaire, he wrote, "I recognized my beautiful visitor / It is She! Black, and yet luminous." A little later Jeanne reappeared at the Théâtre de Belleville, but her far from fabulous career was soon cut short. According to Nadar, "When [she] mounted the stage, she simply melted into the scenery, making no attempt to improve on what was at best a partial success." In all likelihood, she ceased working as an actress when she began her relationship with Baudelaire, with whom she was often to go to the theater playhouse as a spectator.

It is known that she lived at number 6 rue de la Femme-Sans-Tête, on the Île Saint-Louis, not far from the Hôtel Pimodan which hosted the Club des Hachishins, devoted to drug experimentation and to which Baudelaire belonged, along with other poets. At this time, the distinction between actress and courtesan was not clear, but, as Nadar insists, "She gave, but she did not receive. Even at a restaurant, whenever we went to one, we'd go Dutch." Jeanne was a statuesque woman, exceeding "ordinary proportions by a good head," as Ménard, a friend of Baudelaire's put it, referring to her as a "tall, nonchalant, mulatto woman."

This idea of a languid sensuality recurs in lines from the poem "Le serpent qui danse," in *Les Fleurs du mal*: "To see you ambling by, / Beautiful in your abandon, / You look like a snake dancing / On the end of a stick." According again to Nadar, her opulent torso was "particularly remarkable in the exuberant, incredible development of her pectorals"—meaning she had generous breasts. Jeanne possessed a fine voice, rather low in tone. Contemporaries were also struck by her eyes; in his colorful language, Nadar describes them as "large as soup tureens," while Baudelaire writes in *Les Yeux de Berthe* (a poem that alludes to her former stage name), "My child has eyes, dark, deep, and vast, / Like you, Night immense, luminous eyes like yours! / Their fires are the ponderings of Love, admixed with Faith, / which, voluptuous or chaste, sparkle deep down."

In addition to the Parisian photographer, Jeanne rubbed shoulders with many writers: she knew Alexandre Privat d'Anglemont, also a journalist, as well as the poet and playwright Théodore de Banville, who sketched the following portrait in his *Souvenirs*: "She was a woman of

color, extremely tall, who carried her brown head, artless and superb, wonderfully, crowned as it was by tightly frizzled hair, and whose queenly gait, full of wild grace, evinced something at once divine and bestial. Capped, as I can still see her, in a little velvet bonnet that suited her to a 'T' and wearing a dark blue dress of thick wool trimmed with gold braid, she spoke to us at length about 'M. Baudelaire', about his fine furniture, his collections, his 'eccentricities'; and to tell the truth, this man, possessed by an absolute love of perfection, who lavished equal care on all things, must have seemed like a madman to this untutored woman!" The woman reclining in Manet's oil entitled *Baudelaire's Mistress*—dated 1862 and discovered in the painter's studio after his death—does indeed exhibit a degree of lassitude. Still, doubts remain about the precise identity of the model, and the only sketches known for certain to provide an accurate likeness of Jeanne are Baudelaire's. Her good looks might have been captured for posterity in Gustave Courbet's *The Artist's Studio* (1854–55), had Baudelaire—determined as ever to keep his private life out of the way of prying eyes—not persuaded the painter to expunge her from the canvas. All the same, an ethereal trace lingers in the picture, in keeping with the ghostly biography of the poet's muse: the outline of a woman with head bent standing behind Baudelaire, who is reading a large book seated at a table. The painter wrote that he had started by portraying Jeanne gazing at her image in a looking-glass "with great coquetry."

A lively debate has arisen around this portrait by Édouard Manet of 1862 (here, a detail): certain art historians, relying on an inscription by the painter on the back, believe it is Jeanne Duval, whereas others base their arguments on chronological factors and reject her as the likely subject.

A tempestuous liaison

Relations between Jeanne and Baudelaire could scarcely be described as untroubled. No doubt their financial problems (she seems to have had no income at all) contributed to their fraught situation. They met during or just after the journey the poet made aboard the *Paquebot-des-Mers-du-Sud*, a steamer that had initially set sail from France for Calcutta in 1841. The writer Ernest Prarond, Baudelaire's contemporary, confirmed this: "Jeanne was the woman he loved, or preferred, after India. Before India, there was the Jewish one. I can't recall her name (Sara, I think)." The Indian Ocean cruise in fact put in at Mauritius and at the island of Réunion. Baudelaire returned to France in February 1842, deeply impressed by the exotic locations he had visited. It is difficult to paint an accurate picture of their liaison, since studies—all too often tainted by racism—by both professional Baudelaire exegetes and critics, as well as letters from the poet's mother, who never accepted his companion, are all unforgiving of Jeanne. Her illiteracy, too, was much mocked. In a 1926 essay "La Folie de Ch. Baudelaire" (The Madness of Charles Baudelaire), Maurice Barrès

The autographed manuscript of Charles Baudelaire's autobiographical *My Heart Laid Bare*, published posthumously in 1887.

takes "his liaison with Jeanne Duval" as proof that the poet must have been afflicted by some deep-seated neurosis. In most of these studies, the young woman is seen as a parasite, reduced to nothing but a racist stereotype as a "lazy mulatto"; she is described as an obscene, perverse, uncultured creature; the incarnation of lust (the polar opposite of the poet's more ethereal Muses), or a kind of goddess of evil (*le mal*), who sabotaged the artist's talent. For Alphonse Séché and Jules Bertaut, writing in 1910, she represented the fatal muse: "Often we wondered what influence this terrible woman exerted over her lover! For many Baudelairians, this black Venus was harmful. What might he not have done without her! It is Jeanne who exhausted him and made it impossible for him to work. She betrayed him, pestered him with demands for money. . . . Not for a moment did he have the peace of mind essential to an artist." Although their affair was undeniably tempestuous, characterized by arguments and slammed doors, it is certain that Jeanne was not one to bleed Baudelaire dry. On the contrary: she provided him with accommodation on several occasions (in 1846, 1852, and 1858), and even lent him money. At the time of an unsuccessful suicide attempt in 1845 (which left him with little more than a scratch), Baudelaire expressed deep attachment to her, bequeathing everything he owned, including his portrait, "because she is the only being with whom I have found any rest." In 1852, however, against a backdrop of growing violence, they separated, as the poet's correspondence reveals: "And in truth I was delighted there was no weapon at the house. I think of all the times when it is impossible for me to see reason and of that terrible night when I gave her a gaping head wound with a side table." Their rupture was not absolute, however; they continued to meet and the poet is believed to have helped provide Jeanne's mother with a decent burial. In 1855, they reconciled once again, living together in the area around the boulevard du Temple in Paris. Some witnesses claim that Jeanne betrayed him—flagrantly, according to the painter Eugène Delacroix— and perhaps she did borrow money from him. But, as their contemporary Charles Asselineau remarked, she remained one of the closest friends of a poet who was not terribly easy to live with: tyrannical and inconstant, he lived a hand-to-mouth existence. In 1856, due to his intractable nature, as Baudelaire himself acknowledged, they split up again. The poet suffered greatly from the separation, constantly thinking about the woman who "was my only distraction, my sole pleasure, my only comrade, and, despite all the inner conflicts of a tempestuous relationship, never did the idea of irrevocable separation ever enter my mind." He also confessed that he left her with a number of debts. They were reconciled yet again, at the

beginning of 1859, shortly before Jeanne suffered a stroke. Baudelaire covered her medical expenses at the private Faubourg-Saint-Denis hospital and rented an apartment in Neuilly for them. From this time on, Baudelaire felt overcome by a responsibility to protect Jeanne, becoming, in his words, a kind of "guardian" for "an enfeebled mind." Despite this change in their relationship, in 1861, the arrival of one of Jeanne's brothers prompted yet another estrangement and Baudelaire withdrew all financial support. While Jeanne was in a convalescent home, her brother sold all the furniture. This was the last straw, and a relationship that had continued on and off for almost twenty years collapsed irredeemably. Théodore de Banville recalled of Baudelaire, "We know that his entire life, like his work, was filled but by one love, and that, from the first day to the last, he loved only one woman, that Jeanne, admirably beautiful, graceful, and witty, about whom he never ceased singing." Banville also remarked that the poet who had loved her when he was twenty never ceased to do so and, indeed, in a letter from Belgium in 1864 Baudelaire wrote how frightened he was that Jeanne might be going blind. After Baudelaire's death in 1867, she slipped into obscurity, and lived out her final years modestly, suffering from ill health. According to the opera singer Emma Calvé, who visited Jeanne some years later, "Under the name Jeanne Prosper, she lived in a modest abode, somewhere in Batignolles. She entered on a pair of crutches, wearing a multicolored madras headdress from which escaped straggly locks of gray, frizzy hair, and with gold rings in her ears." Baudelaire's muse died alone.

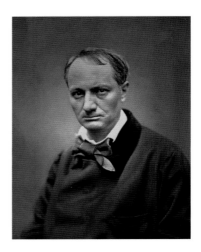

Charles Baudelaire a few years before his death, by Étienne Carjat.
Their lack of money and their rejection by a large part of bourgeois society could not have improved relations between the poet and his mistress.

A subtle air, a dangerous perfume
Swims around her brown body.
Baudelaire, "The Cat"

Facing page:
The fascination for his muse is palpable in both this pen and ink drawing by Baudelaire and the commentary he added for a painter friend ("Heaven-sent vision for the use of Paul Chenavard").

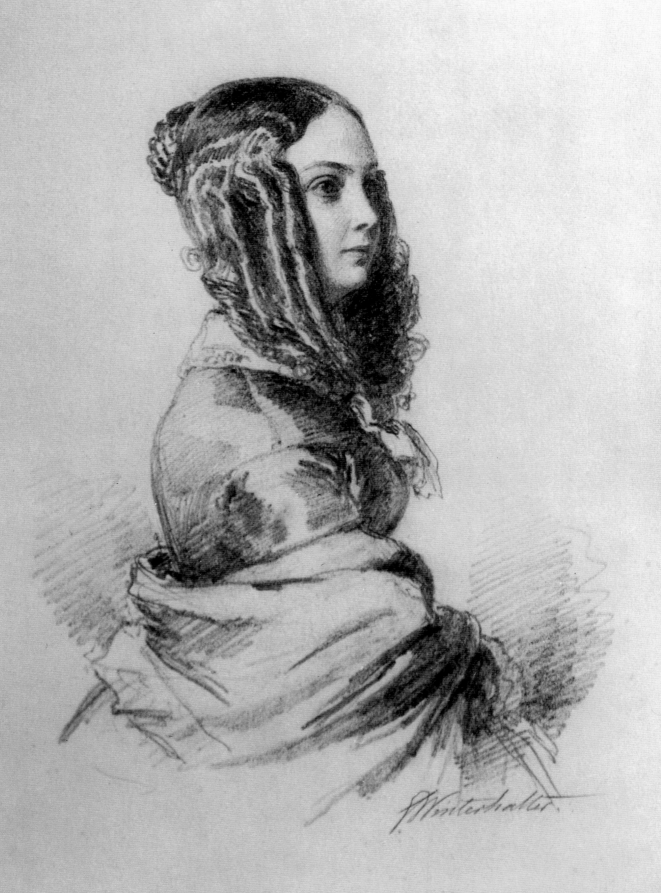

Louise Colet
Flaubert's fetish muse

Louise Colet first met Gustave Flaubert in the workshop of sculptor James Pradier, in Paris, at the end of July 1846, when she was sitting for a bust. A quintessentially neoclassical artist, Pradier had already portrayed Colet reclining thoughtfully in 1837.

Gustave Flaubert quickly forgot his fleeting muse, who had nonetheless, as he wrote, opened "a broad breach" in his existence. Louise Colet in a photograph by Grillet, c. 1860.

Born in 1810, she was eleven years older than Flaubert, who at that time had not published anything, while her writing was relatively well known. She was married, though her husband had fled the marital home, and a string of lovers kept her busy. Flaubert, at the time, had been living quietly, recuperating from a nervous breakdown. After their first encounter, however, they began meeting regularly, and soon became lovers.

After their first night together, Flaubert purloined a pair of slippers, a handkerchief stained with blood, a lock of hair, and a few of Louise's books. Two days later, he returned home to Rouen, carrying his booty. He was frequently to refer to these trophies (to the slippers especially) in the almost daily correspondence that began the same day and which was to continue for many years. In the letters, Louise is very often referred to as "my Muse." Though the auspices had been good, from this day on, to the incomprehension of his mistress and counter to his ardent declarations, Flaubert lived their relationship as a kind of permanent separation. In her novel, *Lui: A View of Him*, published serially in 1859, and in which another of her conquests, the poet Alfred de Musset, also appeared, Louise provided a portrait of her onetime lover in the shape of the character Léonce, who lived far away "in onerous pride and in eternal self-analysis." On learning of Louise's death in March 1876, Flaubert wrote: "You have sensed the effect the death of my poor Muse has had on me. Thus revived, my memories of her make me retrace the course of my life."

Facing page:
Drawing by Franz Xaver Winterhalter, c. 1825. Less than a month after first meeting on August 14, 1846, Flaubert wrote to his lover in the middle of the night, "He brought me your portrait. The frame is finely carved in dark wood and sets off the engraving nicely. It's here, your fine portrait, opposite me, leaning gently against a cushion on my Persian sofa in a corner between two windows, in the place where you would sit were you to come here."

Virginia de Castiglione

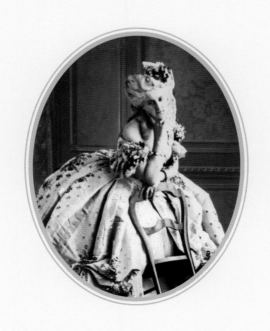

Her own muse

When having her portrait taken by the photographer Pierre-Louis Pierson, the Countess de Castiglione would choose both pose and backdrop herself. Photograph early 1860s.
A contemporary observer, Pierre-Antoine Berryer, was unreserved in his praise: "Not the splendid bearing of the Countess of Castiglione, nor her strange perfect beauty, nor her blooming youth, nor her exceptional situation in the world, nor her superb lips, nor her eyes, ablaze or sad can hope to afford a complete idea of her spirit, her intelligence, her kindness, generosity, and rare penetration."

One day in July 1856, Countess de Castiglione, not yet twenty, paid a visit to the well-appointed studios of Mayer and Pierson, located at 5 boulevard des Capucines in Paris, to have her portrait taken. In this she was simply following in the wake of many eminent members of society, by frequenting a studio whose reputation was at its zenith—especially since Napoleon III and Empress Eugenie had made an appearance in 1853. The photographic partnership also specialized in retouching prints using watercolor, gouache, or oil. The event marked the beginning of the countess's enduring preoccupation with her own image, an image she was to bequeath to posterity. Dressed in elaborate outfits and arranging the backdrops herself, she had her photograph taken regularly by Pierre-Louis Pierson over the next forty years, ceasing only in 1895, four years before her death, when she had become little more than a shadow of her former self, missing her teeth and hair. Her descent from youthful glamour to physical and mental decrepitude is thus captured in hundreds of pictures.

When her estate was disposed of in 1901, an admirer, the poet Robert de Montesquiou, acquired 434 photographs at the auction. Perhaps many more existed, since after her death a witness who dealt with the affairs of "the century's most beautiful woman" stated that a box filled with various prints was destroyed: contemporaries clearly thought they possessed "no monetary value."

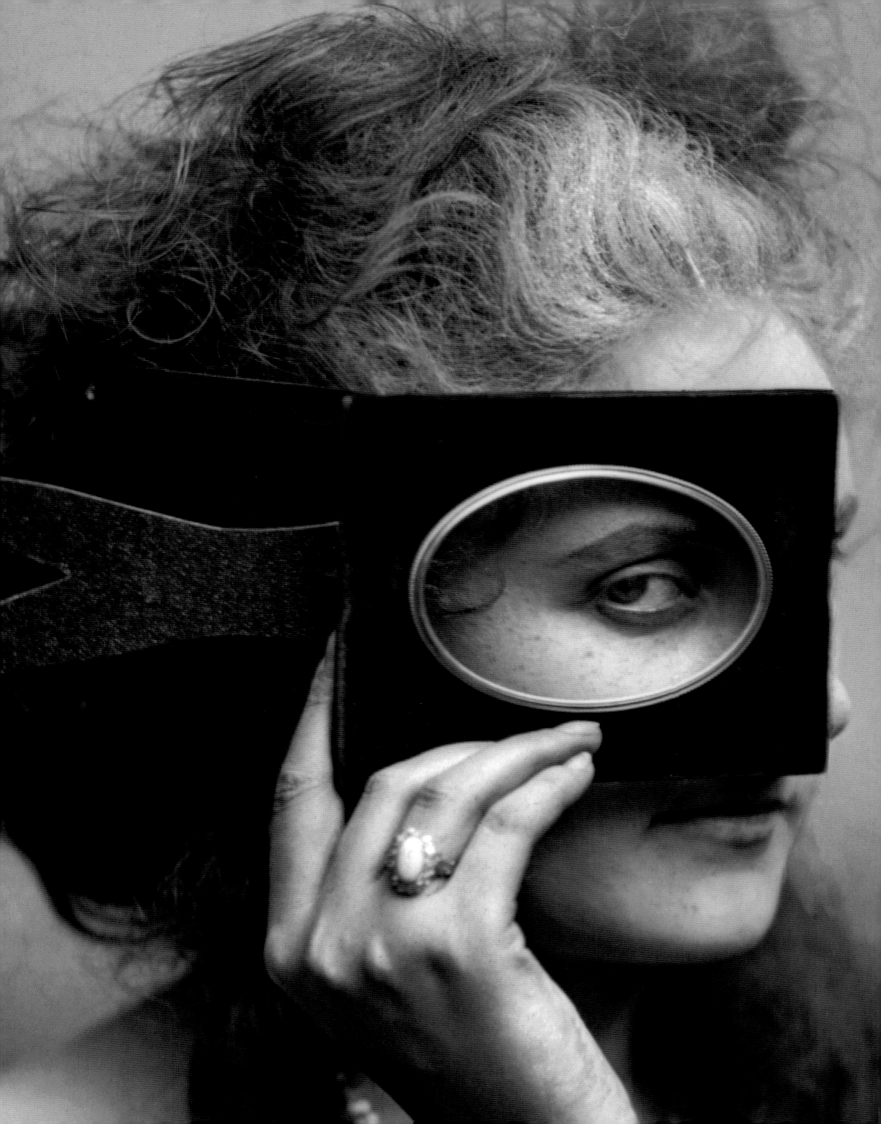

The prettiest woman in Europe

Virginia Oldoini was born in Florence in 1837 (a year she would later attempt to alter). The daughter of a marquis and diplomat, after an unhappy childhood and while still very young she married Count François Verasis de Castiglione in 1854, after Count Walewski, natural son of Napoleon I, had described her to him as the "prettiest woman in Europe." The couple settled in Turin, where the young woman made a huge impression in society. The Marquess d'Azeglio noted, "The countess's beginnings in Turin were dazzling. People would run up to catch a glimpse of her; whole crowds would gather beneath her box, people swooned, well, it was quite an event." To crown her success, in January 1855 she was presented to Victor Emmanuel II, king of Sardinia-Piedmont, with whom she became close. As her marriage began to flounder and the fortune of her extremely wealthy husband began to dwindle due to her extravagant spending sprees, the countess embarked on a life of unbridled adultery. One of Virginia's cousins was Count Camillo di Cavour, who for a few years occupied the post of president of the council (prime minister, effectively) of Sardinia-Piedmont. As his cabinet strove to lay the foundations of Italian unity and elevate the country to the rank of an authentic European power, support from Napoleon III became essential. Early in 1856, Cavour and the king decided to dispatch Virginia to Paris; the foremost beauty in all Piedmont, she was required to promote their cause, in the minister's words, "by every means necessary." Essentially, the countess's diplomatic mission masked a form of state-sponsored prostitution. Arriving in Paris with her husband (and lodging not far from the Tuileries, in a street that already bore their name), the countess's reputation had preceded her. A high-society diva, she was considered a star of court life—a quality that could scarcely be a hindrance when it came to worming one's way into the presence of the emperor of France. Still, Napoleon III only made his approach after a few weeks, during a ball thrown for six thousand guests. "The emperor came to speak to me, then everyone looked and they came to see me. I laughed," she wrote in halting French in her diary. Captivated by her splendid attributes, the imperial fish took the beauty's bait of his own volition. Consequently, their relationship was consolidated at balls and receptions at which Virginia appeared in new outfits she designed herself, each more original than the last, to the singular consternation of her rivals. One witness wrote how her bosom "threw down a challenge to all womanhood." She certainly exerted a magnetic attraction on men, the vast majority of whom fell under the spell, some to the point of idolization. One chronicler of the time proclaimed, "This young countess is undoubtedly

Photograph by Pierre-Louis Pierson, c. 1865. The passions that led to the fall of the countess were essentially self-centeredness, egocentrism, and narcissism.

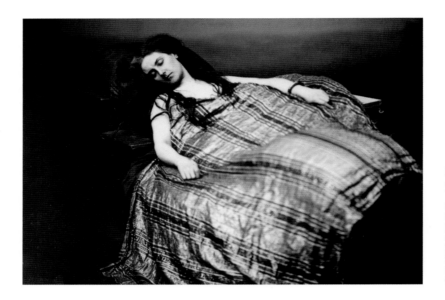

Photograph by Pierre-Louis Pierson,
c. 1861–67.
The Countess of Castiglione's end was
a pathetic one. Having lost her mind
and been rejected by a son who died
prematurely, she spent her final years
alone, in a voluntary isolation alleviated
by an occasional nocturnal escapade.
She was loathed by her peers, and far
from wealthy, having mismanaged a vast
fortune.

charming; she possesses marvelous brown hair, superb eyes with a wild and singular expression, a pretty waist, all together original and attractive, to which [is] added her admittedly bizarre hairstyles, outfits of her own devising, and that je ne sais quoi that astonishes and forces one to just stand there, gaping, almost in defiance of propriety."

At the end of June 1856, a pastoral soirée was organized at the imperial residence at Villeneuve-l'Étang, during which the countess disappeared for some time with the emperor on an island in one of the lakes on the estate. The incident did not escape the notice of the empress nor the courtiers and rumors spread like wild fire, threatening a scandal. In autumn, the countess was invited to spend a week in the imperial residence at Compiègne, where her illicit affair with the sovereign continued. If her grace and unusual attire sometimes earned plaudits (Frau Metternich spoke of her as "Venus descended from Olympus"), her pretentiousness provoked criticism among the imperial entourage—most notably from the ladies, some of whom openly snubbed her. When one day she fell awkwardly and broke her wrist, nobody came to her aid. The countess remained blissfully unaware that to be truly accepted at court required the unwavering support of a clan, but nonetheless in March 1857 the emperor presented his mistress with an extremely valuable emerald. Meanwhile, back home, her forsaken husband was struggling with the debts occasioned by her extravagant ways. The following month was marked by an event that called time on the countess's formidable ascension: one night, while leaving the countess's

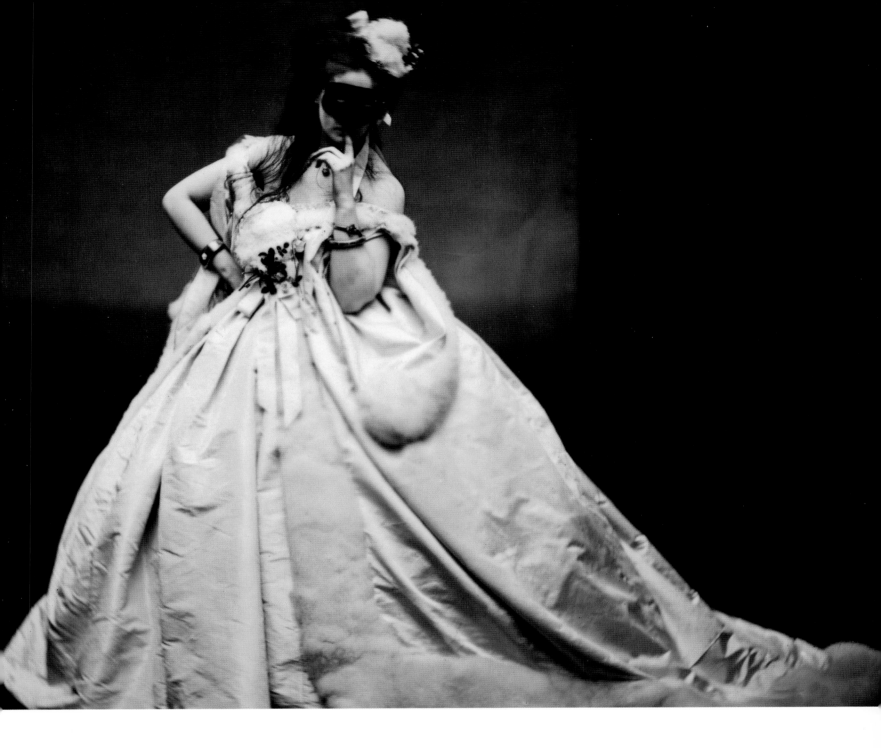

new residence incognito, Napoleon was the victim of an attempted assassination by three Carbonari.

Virginia fled Paris in disgrace. Shuttling between France and Italy, she nevertheless continued her life of lovers and high-society amusements. Her imperial mission may have been terminated, but her delusions of grandeur had won her enduring fame, and Virginia was still little more than twenty. As she later wrote, "Hardly had I entered life and my role in it already ended."

"Happenings" and self-representation

Scarcely had she made her debut in Paris than the countess was making a show of her uncontrollable pride and absurd self-regard. Over subsequent years, these tendencies continued to make themselves felt,

The countess oversaw every last detail of her photographic sittings: viewpoint, costume, attitude, composition type, final format, even the title, and was sometimes inspired by the opera or theater. Pierre-Louis Pierson executed these directives to the letter, as in this scene of c. 1865 that recalls the countless parties at which she had been the star attraction during her heyday.

even away from society's eyes. Alone, in the privacy of her own home, she embarked on an egocentric artistic monologue, becoming her own muse, fascinated by her photographic image—painting apparently being unable to do justice to her perfections. In 1857, the English society artist George Frederic Watts was to have painted her, but, probably reacting to the dissatisfaction of his subject, the project was abandoned. General Fleury, the emperor's aide-de-camp, referred to the elaborately contrived settings in which the countess would make public appearances by the end of the 1850s. Prey to a process of self-deification, she seemed "infatuated with herself, always draped in the classical manner, with hair magnificent in every style, bizarre in her person and manners, she appeared at receptions like a goddess descending from her cloud. She would have herself conducted by her husband to some distant corner of the drawing room where she would be admired like a relic in a shrine, indifferent to the crowd, parading herself before all eyes, without the unabashed admiration she aroused altering her chilly attitude one jot." Yet men queued up to feed her arrogance and self-importance: one of her many lovers, Ignace Bauer, a banker and diplomat, sent her an astonishing one thousand six hundred pages of passionate letters, while it was said that one night with her had cost Lord Hertford the eye-watering sum of a million francs. In 1863, she was photographed wearing a dress she had worn six years earlier for a costume ball at the Ministry of Foreign Affairs. This "Queen of Hearts" gown became a legend in her lifetime. At the soirée, the empress, seeing one heart was placed beneath her stomach, quipped: "The heart is rather low!"

> *"The Countess of Castiglione drew her magic power from her looking glass. As soon as what she saw there appeared no longer perfect in her eyes, she lost faith in herself."*
> *André Maurois*

A number of plates, autobiographical rather than in costume, were taken under her instructions by Pierson, with the assistance of his young son, Georges, to whom Virginia allotted the role of page; suitably accoutered, he would hold part of her gown or gaze up admiringly at her finery. For a time she had him play the same role in the real world. When he was no more than ten, the countess had him decked out as a servant to receive her guests in her antechamber. The characters she did deign to dress up as—such as Virginia in Bernardin de Saint-Pierre's novel of the same name or Dante's Beatrice—were always inaccessible women, with whom

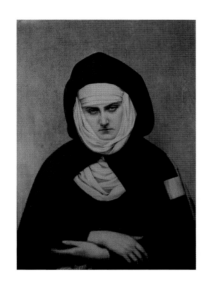

The countess disguised as "the Hermit," as she appeared for her "show" at the Countess Tascher de La Pagerie's salon in the Passy district of Paris. Her haughty expression remains undaunted. The figure later described as "the madwoman on place Vendôme" left this world in 1899, surrounded by memories from another era and with cloths over every pier glass and mirror.
Photograph by Pierre-Louis Pierson, 1863.

she identified deeply. In 1863, shortly after a ball, she had a photographic portrait taken wearing the same "Queen of Etruria" outfit in which she had made her entrance. Emmanuel Hermange, in his 1999 book on the countess, writes that "photography, which begun by reflecting back the image of a renowned, adulated beauty, apparently later became in her eyes the most effective means of feeding a narcissism for which there can never be enough mirrors. The restricted space and theatricality of the studio, where the camera acts as a self-reflecting device often further intensified with arrangements of mirrors and frames, and finally the rich variety of pose and setting permitted by her relationship of trust with Pierson, are all cogs in the very modern process of self-invention she put into action." Such acts of self-creation have resonances with today's contemporary artists and are now compared to the work of Claude Cahun or Cindy Sherman, whereas the use of series with variations recalls Andy Warhol. Her fondness for mise-en-scène may have made the countess an unconscious precursor of the 1960s art happening, but the self-fetishism that led her to take photographs of parts of her body (shoulders, legs, feet) is all her own.

Later in her life, suffering from chronic depression and afflicted with a persecution complex, the countess began to hide away in her residence in the fashionable Passy district of Paris. Calling herself "the Hermit," it was in this guise that she one day made an appearance at the mansion of Countess Tascher de La Pagerie, a cousin of Napoleon III's, who had a weakness for eccentric behavior. In a cardboard set representing a cave entitled the "Hermitage of Passy," a gloomy-looking Virginia stood wearing a hair shirt, her head draped with a cowl. Expecting to see her in one of her proverbial gossamer gowns, the audience, who had spent a fortune in entrance fees, was livid and booed her roundly. She responded to this mockery with the single word, "Vile!" and cut short her performance. By the end of her life, the hundreds of photographs the countess had taken with Pierson were meant to form part of a far larger project that would have consecrated its unique subject: herself. This plan, which she was unable to realize, would have resulted in an exhibition she wanted to entitle "The Most Beautiful Woman of the Century."

Alice Liddell

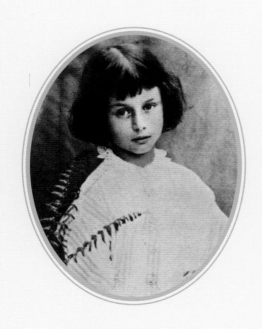

Lewis Carroll's child friend

In the afternoon of July 4, 1862, near the city of Oxford, two men and three young girls went boating on the River Isis. Charles Lutwidge Dodgson, professor of mathematics—writing for the past six years under the pseudonym Lewis Carroll—was at the prow of the skiff; Mr. Duckworth, one of his friends, handled the oars at the stern, while two of the three Liddell sisters sat amidships. The eldest, Lorina Charlotte, thirteen years old, was placed next to Edith, aged eight. Alice Pleasance, aged ten, directed the excursion. The waters were calm, the day bright, and a heat haze quivered above the meadow. As Carroll was later to recall, it was "on this occasion I told them the fairytale of Alice's Adventures Underground," the original title of the famous tale. Alice found the story even better than usual, to the point that on their return she began to "'pester' him to write it down." This he did, though not without a struggle. Anxious to satisfy the exacting demands of his young patron, he continued the story, filling out adventures of the heroine who had fallen down a rabbit hole, and that night did not sleep a wink.

are ferrets! Where <u>can</u> I have dropped them, I wonder?" Alice guessed in a moment that it was looking for the nosegay and the pair of white kid gloves, and she began hunting for them, but they were now nowhere to be seen — everything seemed to have changed since her swim in the pool, and her walk along the river-bank with its fringe of rushes and forget-me-nots, and the glass table and the little door had vanished.

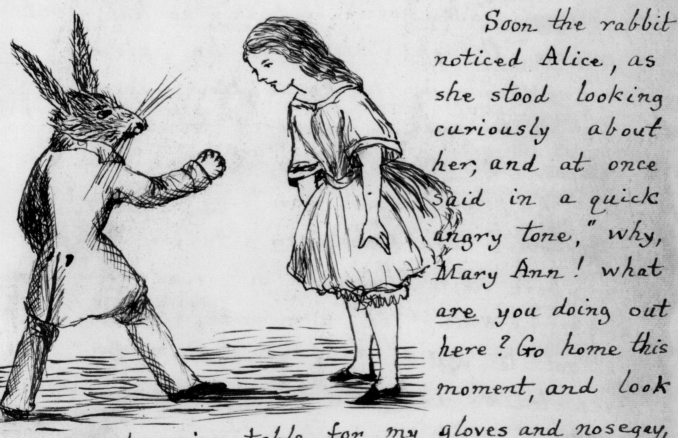

Soon the rabbit noticed Alice, as she stood looking curiously about her, and at once said in a quick angry tone, "why, Mary Ann! what <u>are</u> you doing out here? Go home this moment, and look on my dressing-table for my gloves and nosegay, and fetch them here, as quick as you can run, do you hear?" and Alice was so much frightened that she ran off at once, without

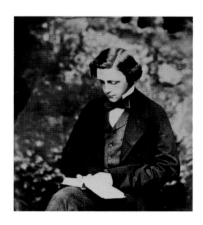

A portrait of Lewis Carroll from June 2, 1857, probably by his own hand—though it may have been carried out by Reginald Southey, a Christ Church College friend, who had encouraged the mathematics professor to take up photography.

Facing page:
From early childhood, Lewis Carroll amused himself doing illustrations in his diaries, and he continued to draw for as long as he lived. This reproduction shows how the pictures offer an important counterpart to the painstaking handwritten copy of his outlandish tale (1862). Here, Alice tries to help the White Rabbit find his missing gloves.

The muse behind the character

As Carroll recalled later in reference to a stage version of the tale, if Alice Liddell unquestionably both "commissioned" and inspired the story, she was not identical with its main protagonist. She was one of a vast cohort of child friends with whom the author, over the years, and like a collector, built up relationships based on conversation, shared experiences (often during his vacations away from Oxford, on train trips or on the beach), and letter writing. It is impossible to be sure today, but it is extremely probable that the first version as recounted on that famous day in 1862 took more account of the circumstances and of the real people on the boat trip— and so of Alice. Many of these references were to be expunged in the successive manuscript versions, while the final rewrite—much the most extended—no longer mentions a trip down a river, for example. Moreover, in the text the fictional Alice is seven years old, three years younger than Alice Liddell; the real girl's inquisitive and willful personality, on the other hand, does appear similar to that of her literary doppelganger. Other correspondences between true life and fiction subsist, with features of some of the story's characters betraying links with individuals from Carroll's donnish life. Thus, perhaps, the governess of the dean's children does lurk behind the Queen of Hearts.

When *Alice in Wonderland* was published by Macmillan on July 14, 1865, Carroll rushed off to present the first edition to his muse. The illustrations had been drawn by the celebrated artist John Tenniel, in close cooperation with the author; they present a blonde heroine physically quite unlike the young Liddell. The book was an overnight success and, some time later, Carroll planned a sequel that came out in 1871: *Through the Looking-Glass*. That story is meant to have come to him following an encounter in Kensington Gardens with another little girl, also named Alice, whom Carroll later sat before a mirror to explain to her the mysteries of image inversion. Be that as it may, the final chapter of the book contains an acrostic that forms the name "Alice Pleasance Liddell." In the second title, the eminently dreamlike nature of the Alice figure comes to the fore, undermining analyses of the text relying on biographical facts. The fantastic world through which the heroine moves possesses its own laws and is quite separate from reality; indeed, its unique nature makes all comparison with reality fruitless. Alice's world is in fact "nowhere." As Tweedledum puts it, "she is only a sort of thing in [a] dream." Thus, in the presence of her oneiric double, Alice Liddell herself recedes. If she indeed offered the creative spark for the second book, she is no doppelganger simply transposed into Carroll's universe.

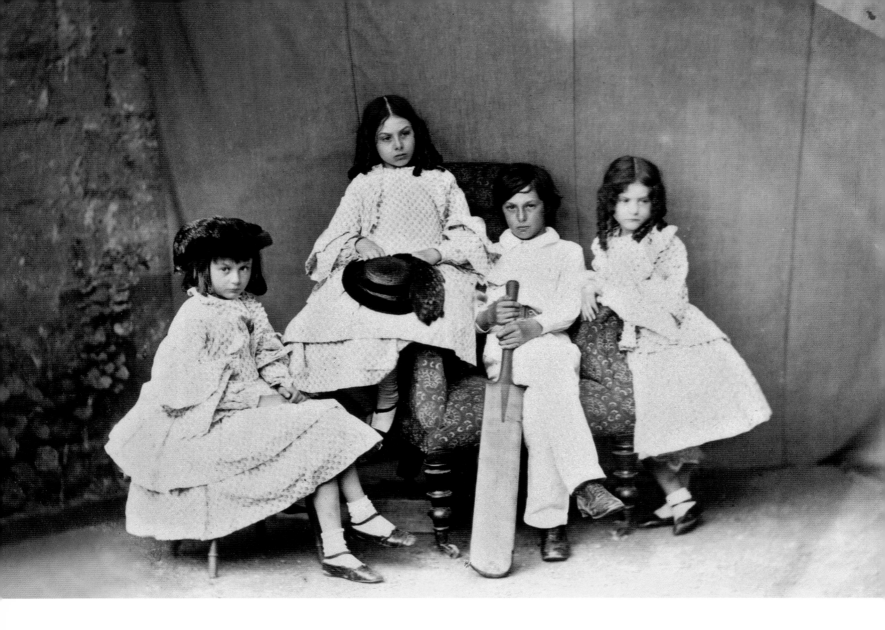

Alice, a photogenic beauty

In *The Cornhill Magazine* of July 1932 Alice Hargreaves, *née* Liddell, recounted how "We used to go to his rooms . . . escorted by our nurse. When we got there, we used to sit on the big sofa on each side of him, while he told us stories, illustrating them by pencil or ink drawings as he went along. When we were thoroughly happy and amused at his stories, he used to pose us, and expose the plates before the right mood had passed." Carroll was indeed one of the pioneers of photography in England, taking a large number of photographs of the Liddell children, who were among his earliest subjects. He first acquired a camera in 1856, using the delicate and then novel technique of wet collodion. His taste for images that might be reproduced, however, dates from the previous year, when he wrote a debut article, "Photography Extraordinary" for *The Comic Times*. He was to write four texts in all on Louis Daguerre's invention. Over the following years Carroll succeeded in becoming relatively well-known and, by the end of 1860, he was able to present Prince Albert with a dozen of his pictures for his private collection. In total he left more than seven hundred photographs, a substantial proportion of which feature young girls whose aesthetic physique captivated, not to say obsessed, him—though the

Alice Liddell (on the left), in the company of her brother and her sisters, photographed by Lewis Carroll in 1860. In 1932 she recalled how "He seemed to have an endless store of fantastical tales. . . . Sometimes they were new versions of old stories; sometimes they started on the old basis, but grew into new tales owing to the frequent interruptions which opened up fresh and undreamed of possibilities."

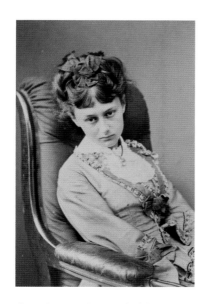

Carte-de-visite photograph of Alice Liddell as a young woman taken by Lewis Carroll on June 25, 1870. They were to see each other for the last time in 1891. *Alice's Adventures in Wonderland* was translated and published in several languages during their lifetime.

extent to which this was fuelled by latent sexual desire is today hard to ascertain. Referring to the aims of his work, Carroll, with disconcerting guilelessness, assures us that it all proceeded under the auspices of the most elevated love, going on to mention the innocent purity of bodies whose beauty glows only until the onset of puberty. His diaries contain many passages extolling what he saw as the extraordinary beauty of these little girls and his love of photographing them. The year *Through the Looking-Glass* was published, for example, he praised one particular little girl by exclaiming how he could "take a hundred photographs of her."

By the next year, 1872, Carroll had a photographic studio installed above his rooms in Christ Church and the following years were increasingly devoted to photographing young girls, initially dressed up and later in various states of undress. Alice had worn the rags of a beggar girl, while others were now draped in nightdresses or had cloths tied around their bodies in "the manner of savages." It is hard not to suspect something dubious about these photography sessions. Mothers of many of his child friends warned him—and sometimes in no uncertain terms—to keep away from their daughters (whom he would constantly importune for kisses) and his determination to destroy part of his photographic archive shortly before his death prompts many questions. It is tempting today to make hasty assumptions about Carroll's motivations, but one should steer clear of judging a personality that was undeniably complex, paradoxical, and disarming; simultaneously a specialist in logic and mathematical proofs and the creator of phantasmagorical worlds where nonsense reigns supreme.

In 1880, a year that saw so many personal links deliberately severed, for reasons still unclear, Carroll abruptly abandoned photography. He also gave up his lecturing career, becoming ever more inward-looking and isolated. In September of that same year, Alice Liddell married to become Mrs. Reginald Hargreaves. Perhaps this news finally brought an end to the hope that this shy and child-like man had entertained of living in a sheltered, parallel universe comprised of friendships with children, and the creation of an extravagant world so often the hilarious antithesis of our own. For the beguiling Alice Liddell, its keystone, had been removed.

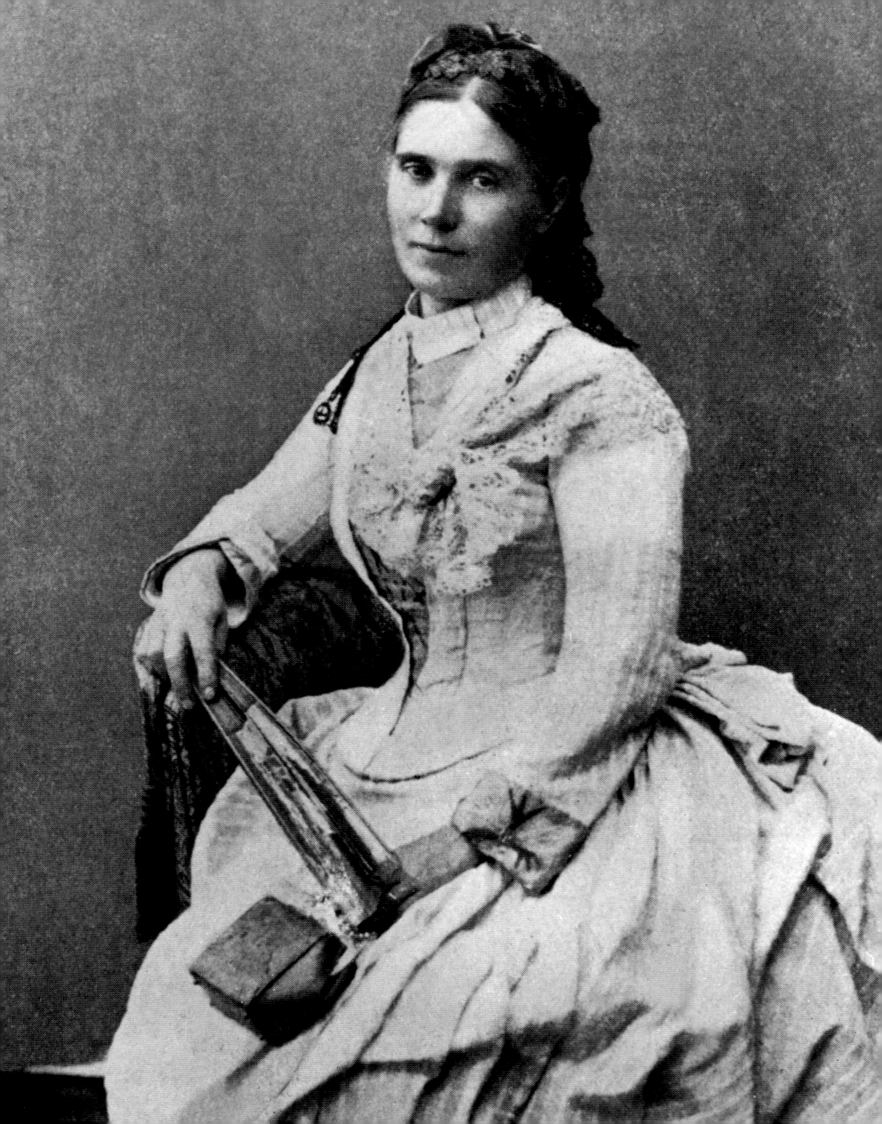

Apollinaria Suslova
Dostoyevsky's nihilist muse

In 1862, while traveling through Europe, Apollinaria Suslova met Fyodor Dostoyevsky. Despite his marriage five years previously to Maria Dimitrievna Isaeva, Apollinaria soon became his mistress and he fell ardently in love with her.

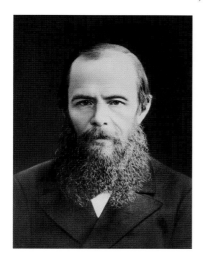

Portrait of Fyodor Mikhaylovich Dostoyevsky by Constantin Chapiro, c. 1870.

Daughter of a freed serf who had made his fortune in industry, Apollinaria was at that time a student, inspired by the feminist principles and nihilist philosophy of the time. A figure worthy of one of her lover's novels (whom eminent Russian critics were already lauding as one of the greatest writers of the period), intense and enamored of lofty ideals, Apollinaria proved to be an inspiration to Dostoyevsky, especially for the character of Polina in *The Gambler*. This literary masterpiece had been written in great haste: under pressure from his publisher, who was on the verge of revoking the rights to all his previous works, Dostoyevsky, who was still at work on *Crime and Punishment*, completed the novella in just three weeks. The autobiographical parallels are evident: just like the main character Alexei Ivanovich, the author was addicted to the gaming table; he, too, haunted casinos in various cities, playing roulette and trying to outwit chance, often losing significant sums in the process. Like his hero, Dostoyevsky was passionately in love with a creature unable to wean him off his destructive impulses (unlike the woman he had a relationship with after Apollinaria and following the death of his first wife). And, again, like Alexei, Dostoyevsky ran up considerable gambling debts.

Intense and enflamed by lofty ideals, Apollinaria was an inspiration to Dostoyevsky, especially for the character of Polina in The Gambler.

Facing page:
Apollinaria Suslova was the inspiration for the character of Polina, Alexei Ivanovich's disastrous love interest in Dostoyevsky's *The Gambler*: "She knows full well everything that's happening to me. She knows I'm aware of the absolute impossibility of realizing the dream of which she is the focus, and I'm sure this thought affords her untold joy. And this is why she's so honest, so easygoing with me. It's rather like an empress of the ancient world undressing in front of her slave."
Photograph c. 1860.

Fyodor and Apollinaria separated in about 1864. She was later to become the first wife of the philosopher Vasily Vasilievich Rozanov, an intellectual and individualist philosopher who extolled at once sexuality and family life, anti-Semitism and "organic" religion. After they parted ways, he fought continuously to divorce Apollinaria, but she refused to grant one her entire life. She was to become an author in her own right, and remained Dostoyevsky's friend until the very end.

Élisabeth Greffulhe
Proust's model for In Search of Lost Time

On the evening of Saturday, July 1, 1893, Marcel Proust was invited to a ball given by the Princess of Wagram. It was on this occasion that he observed from a distance the Countess Greffulhe, whose beauty and elegance struck him forcefully.

Photograph of the Countess of Greffulhe taken in the studio of C. Barenne, c. 1880. Her husband remarked, "My wife, she's the Venus de Milo."

The following day, he wrote to his friend Robert de Montesquiou, the countess's cousin and also one of her most ardent admirers: "She wore her hair in a style of Polynesian grace, and mauve orchids ran down the nape of her neck like the 'hats of flowers' mentioned by M. Renan. She is hard to judge, probably because judging means comparing, and she possesses not a single element that one could find in anyone else or even anywhere else. Yet all the mystery of her beauty resides in the glow, in the mystery, most especially, of her eyes. I have never seen such a beautiful woman. I did not have myself introduced, and I will not request it, not even of you, because, apart from the indiscretion it might constitute, I feel I would find speaking to her painfully awkward. But I do want her to be aware of the huge impression she made on me, and if, as I believe is the case, you see her very regularly, would you tell her as much? I hope this is less irksome to you in that it proves that I admire she whom you admire above all others, and I will henceforth admire her as you do, in your way, or, as Malebranche puts it, 'in you.'" At this time, the Countess Greffulhe, born in 1860 as Élisabeth de Riquet de Caraman-Chimay, into a great Belgian family and the French aristocracy, was the queen of all things social, artistic, scientific, and political in Paris society. The great and the good of the era all attended her salon on rue d'Astorg, which remained the height of fashion until World War I. She was one inspiration behind the characters of the Princess and the Duchess of Guermantes in Proust's In Search of Lost Time. Proust subsequently confessed that he would often visit the Paris Opera, merely to be able to admire her bearing as she ascended the great staircase.

> "She possesses not a single element that one could find in anyone else or even anywhere else."
> Marcel Proust

Facing page:
Proust described the Countess of Greffulhe in In Search of Lost Time thus: "The beauty that placed her so much above the other fabulous girls of the half-light was not materially or inclusively inscribed entirely in the nape of her neck, her shoulders, arms, waist. But the delicious and incomplete line of the latter formed the exact starting point, the inescapable origination of invisible lines into which the eye could not be prevented from extending, marvelous lines, generated around the woman, like the specter of some ideal figure projected onto the darkness."

Countess Greffulhe, who derived a certain pleasure from being the object of her contemporaries' admiration and whose beauty was immortalized by many painters (among them Paul-César Helleu, Jacques-Emile Blanche, Ernest Hébert, and Philip Alexius de László), also took up photography under the guidance of Paul Nadar, as well as drawing, and playing the piano and guitar. In spite of her social origins, and while remaining a monarchist, she joined the pro-Dreyfus camp during the affair that rocked France at the turn of the twentieth century—proof that genealogy does not necessarily determine ideology.

Marie de Régnier

Pierre Louÿs's bride manqué

Portrait of Marie de Régnier (detail) by Paul Boyer, c. 1908–09.
Pierre Louÿs, who had already known her as a child, wrote, "I watched her grow up, in braids and short skirts, I adored her, I lost her, I found her, miraculously I took her as a virgin, and now she is the mother of my only child."

The birth of Marie de Heredia on December 20, 1875, was greeted with the following lines by her father, José Maria, the poet of Cuban origin: "The day you were born / Were born all flowers / And in the baptistery / Nightingales sang." Little Marie's childhood was spent basking in the glow of literature and the admiration of many men, and her blossoming talent as a writer, and her strong character, probably stemmed from the artistic and intellectual experiences of her youth. Her love story—the first—with Pierre Louÿs, and the influence this was to exert on their respective works is unique, conveying at once the drama of an opposed marriage and the untold splendor of a secret love. Although free to indulge her passions, and in spite of the enlightened circles in which she moved, Marie was nonetheless in some respects a classic muse, trapped by convention, and remaining a victim of the bourgeois morals of the belle époque.

Queen of the "Canaquins"

Her father was a friend of many of the foremost names in the world of French literature, among them the influential Théophile Gautier, the painstaking Gustave Flaubert, the fearsome Guy de Maupassant, the celebrated poet and philosopher Sully Prudhomme. By the time Marie was ten her education was being supervised by Leconte de Lisle, figurehead of the Parnassian movement who had been inducted into the French Academy in 1887, and who dubbed her his "fellow member" in honor of her precocious writing talent. Another Academician-to-be, Jules Lemaître, dedicated a poem to her: "these are pretty words / More colorful than enamel / That she gathers as in dream."

In summer 1888, before an assembly of poets, novelists, and dramatists, she recited her own verse. "Seated on a large wicker chair, she resembled the Blessed Virgin in her niche," one ecstatic female listener recorded. Some time later, Auguste Rodin was admiring her beauty, and in 1892 the painter Jules Breton dedicated his work *Twilight* to her, accompanying it with these words: "I send the verses you allowed me to dedicate to you. I wish they were worthier of you and of your delectable talent." In 1894, she published a piece in the important journal, the *Revue des deux mondes*, while in February of the same year her father was elected to the French Academy. It was this occasion that served as the pretext for her and her two sisters (the elder Hélène and Louise, her junior) to found what they called the Kanak Academy, otherwise known as the "Canaquadémie," over which she ruled as an all-powerful sovereign. Entrance to this satirical academy was gained by grimacing and making faces, so newcomers were obliged to show the inventiveness and facial flexibility of a clown. Its members featured a new generation of talented young men, happy to carry out whatever absurd orders the "Sovereign" dictated: acting as guards of honor, swearing ridiculous oaths of allegiance, amid much joking and laughter during champagne-drenched picnics. Some of these bubbly young men were later to make names for themselves: Marcel Proust, for example, or Paul Valéry, Jean de Tinan, Léon Blum, Philippe Berthelot, and, in particular, two young men about to play crucial roles in Marie's life, Henri de Régnier and Pierre Louÿs.

The purloined marriage and a mysterious wedding

Marie's heart belonged to the latter, a dandyesque poet and pornographer, born in 1870, a descendant of lawyers from Champagne, who had embarked on a brilliant career as a writer in Paris society. By fortunate coincidence, Pierre saw Marie as marriage material, too. As he had been

Louise and Marie de Heredia. The curious destiny of two sisters, who, against a backdrop of pretense and deceit, shared a passion for the same man.

a habitué of the Heredia salon, they had known each other for a few years, and Marie occasionally received poems or madrigals he had written. Back from a journey to Spain in spring 1895, Louÿs decided to move closer to his beloved, inspiring him to write the following lines: "You see, I'm coming closer, / In silence, with rabbit's steps." They would go out together, for dinners and on picnics, starting to flirt timidly. A man of some experience with women, Pierre remained calm and collected in Marie's presence, acknowledging she was nothing like the girls for whose services he frequently paid.

But the blue skies over the promised nuptials were soon darkened by two threatening clouds. The first took the shape of an empty purse: Pierre's rapidly shrinking fortune could not possibly help the Heredias, whose financial situation was frequently worsened by the gambling debts run up by Maria's father. The second strode forth in the guise of Pierre's friend, the writer Henri de Régnier, who had also set his sights on Marie—a notion prompted, some believed, primarily by the exalted position of his potential father-in-law. All too conscious of their rivalry, they decided to play fair and drew up a pact, leaving it to Marie to seal their destinies by

Photograph (c. 1896) of Pierre Louÿs taken perhaps on the roof of a house in Algiers during one of his stays in North Africa. It was there that he met Zohra bent Brahim, a woman who became his mistress for many years and whom he brought to Paris, to the dismay of many in his circle.

choosing for herself. But in this agreement there was only one gentleman: as soon as the contract was signed and sealed, Régnier went back on the deal and sued for Marie's hand behind his friend's back. Far wealthier than Louÿs, he managed to satisfy the demands of his future mother-in-law and the wedding was arranged. Louÿs, beside himself, was furious with his former comrade, while Marie, who played no part in the affair and yet could not bring herself to break with her family, was thunderstruck—if only momentarily. In little time she had concocted a cunning strategy that she would see through to its logical conclusion. She went to Louÿs's house, undressed, and calmly offered him first refusal of her virginity. For reasons that remain obscure—despair, jealousy, embarrassment, a sense of inferiority, or one of honor—he refused the offer and sent Marie home. Marie duly returned to her fiancé, determined to make him pay for orchestrating such a heinous betrayal. Unbelievable as it may seem, Marie was able to engineer events so that the marriage was never consummated. She further arranged that it never would be—that is, if Régnier wanted to save face in society. Her flabbergasted husband had no choice but to bide his time. Thus the wedding on October 17, 1895, witnessed by everyone who was anyone in Paris, was to all intents and purposes a sham. Over the following months, Marie made repeated attempts to convince Louÿs to accept what she was keeping for him, while he procrastinated and refused to commit, believing that her intent was now common knowledge, and wishing to avoid the lead in some ridiculous farce. So, distancing himself from Marie, Louÿs went to Algeria, returning accompanied by a young mistress, Zohra bent Brahim. Marie, meanwhile took her mind off things with a number of female relationships, which, as her writings testify, she remained fond of throughout her life. But, undaunted and still infatuated with Loüys, she finally achieved her goal two years to the day after her wedding. Her own marriage still not consummated, on October 17, 1897, Marie and Loüys celebrated their "mysterious wedding," thereby marking their destinies and their works forever.

Mirrors of literature

In his 1999 book of their marriage, Robert Fleury has shown how not only the private correspondence but also the fictional writings of Louÿs and Marie often allude to key episodes in their secret trysts—though events are sometimes recast, with, for example, names changed, as is commonly the case with autobiographically influenced fiction. Their first assignation, which for a time Louÿs regarded as one of the "dearest memories" of his life, was pure and tender. The "mysterious wedding" is described in

Dedication on the back of a portrait of Pierre Louÿs dating from 1893: "To Henri de Régnier, his friend Pierre Louÿs." At this time neither of the two friends had officially declared his love for the beautiful Marie. In 1895 they made an agreement to let Marie chose whom she would marry, but Régnier took matters into his own hands.

L'Inconstante ("The Fickle Woman"), Marie's debut autobiographical novel published in 1903: "She remembered this hour with unalloyed joy. Their childish horseplay was imbued with such tenderness and camaraderie that all embarrassment, all fear, all emotiveness, evaporated." In *Psyche*, a posthumous and romanticized transcription (1927) of his relationship with Marie, Louÿs offers a decidedly more erotic vision: "All her chaste nudity, her moist, soft skin welcomed the embrace from head to toe. She turned crimson. As she lie, the deep red of her modesty and her pleasure enflamed her beautiful head. Then her eyes slowly drifted off. Psyche [Marie] could not see anything, neither outside, nor within her bedazzled consciousness." Louÿs was astonished to discover Marie's virginity, which he sanctified and mythologized: "Our adventure, an equal of the fables of Tityrus, / Is so extraordinary and of so ancient a mold / That no one would believe it if I spoke of it / Talking of our blessed love, I will pass over in silence / What made it unique, strange, and almost holy." Autumn 1897 would come to represent their honeymoon, Marie's beauty—with a particular concentration on her long brown hair—is celebrated in a number of texts. A year later the lovers, living in a small apartment on rue Théodule-Ribot in Paris, experienced what Louÿs characterized as their "apogee": the attainment of physical pleasure conjoined to an acknowledgment of total love. One finds in *Pervigilium Mortis* a passage evoking the sublimity of this epiphany: "If there exists in the life of certain lovers, a summit, an apogee, one incomparable moment where happiness alights, then Aimery [Pierre] and Psyche [Marie] experienced that miracle at this moment in this day, and only death could make them forget it." As for the cuckolded husband, Henri de Régnier did not waste much time turning his life into art, either, and was soon describing the disastrous situation in which he was mired in a debut novel of 1900, *La Double Maîtresse* ("The Double Mistress"), which expatiates on the trials of an impotent and traumatized hero, unable to honor his wife. He was to elaborate on this reproachful vein in other texts, turning his wife into something like an anti-muse.

Among the great heaps of papers and manuscripts discovered in Louÿs's house after his death in 1925, was a pornographic tale entitled *Trois filles de leur mère*, in which portraits of the Heredia women appear clearly. If it is a rollicking, indecent, and occasionally amusing read, its mix of letting-off-steam and under-the-counter provocation was surely intended to remain in the bottom drawer. It contains several passages likely to disgust even the most hardened reader. Thus does the mirror of literature sometimes turn into nightmare.

Beyond the novel: lover, father, godfather, and brother-in-law

At the beginning of the year 1898, while Louÿs was paying a visit to his brother then living in Cairo, Marie discovered she was pregnant. In spite of a fling with the writer Jean de Tinan, a friend of Louÿs and onetime member of the "Canaquadémie," Marie was sure of Pierre's paternity and showed no qualms about telling her husband, whose response was characteristically phlegmatic. At the beginning of May, Louÿs, who had just returned to Paris and was unaware of Marie's state, tried to end the affair. When informed of the situation he quickly rejoined her, all the while fending off the advances of Maria's younger sister Louise, who, blissfully in the dark, had set her sights on him. Wheels within wheels.

On September 8, Marie gave birth to a son, Pierre Marie de Régnier, naming the child after his biological father. Louÿs accompanied Henri de Régnier to register the birth, when he was unhesitatingly appointed godfather. In an attempt to simplify matters, Loüys promised to wed Germaine Dethomas, and sent his mistress, Zohra, back to Algeria. But things were not that straightforward, and in October 1898, Marie, her husband, and her lover left together for a few days in Amsterdam. Passions, understandably, ran high: "As soon as he had his back turned, we embraced in front of everyone," Louÿs rejoiced in a letter. By December, a prospective wedding between Louÿs and Marie's sister was very much on the cards. Moreover, as Marie ventured to suggest in a letter dating to this period, the arrangement would allow the lovers to live in even closer proximity. She henceforth played a significant role in paving the way for Pierre's union with Louise. The engagement took place the following May, the wedding ceremony on June 24. Subsequently, however, rather than becoming closer, the couple gradually grew apart. Marie embarked on an intense period of writing, while Loüys turned increasingly to photography. Their relationship finally dissolved in 1902, while Loüys was seeing the singer and actress Émilie Marie Bouchaud (known as Polaire), a woman well known for her romantic escapades. For Marie, the end of this significant chapter in her life heralded a new dawn: that of her work as a novelist—and this time under a male pseudonym, Gérard d'Houville, since the names of her husband and her family already loomed large in French literary circles. Under this penname she was to publish dozens of books, obtaining for her oeuvre the Grand Prix for literature from the French Academy in 1918. However, Marie had no intention of settling down and conducted a steady stream of extramarital affairs, with a marked predilection for writers, such as the playwright Henry Bernstein and Italian writer Gabriele D'Annunzio. Louÿs's end was truly terrible: blind, a physical wreck, and a social outcast, he died alone in June 1925. It is said that a visit from Marie a few months previously had so upset him that he determined to put an end to his life.

Photograph of Marie de Régnier, aged sixteen, by Count Giuseppe Primoli in 1891. Louÿs met her a few years later and fell for her at once. In the course of their passionate love affair, he, too, took many photographs of his mistress—including erotic nude shots— immortalizing her beauty.

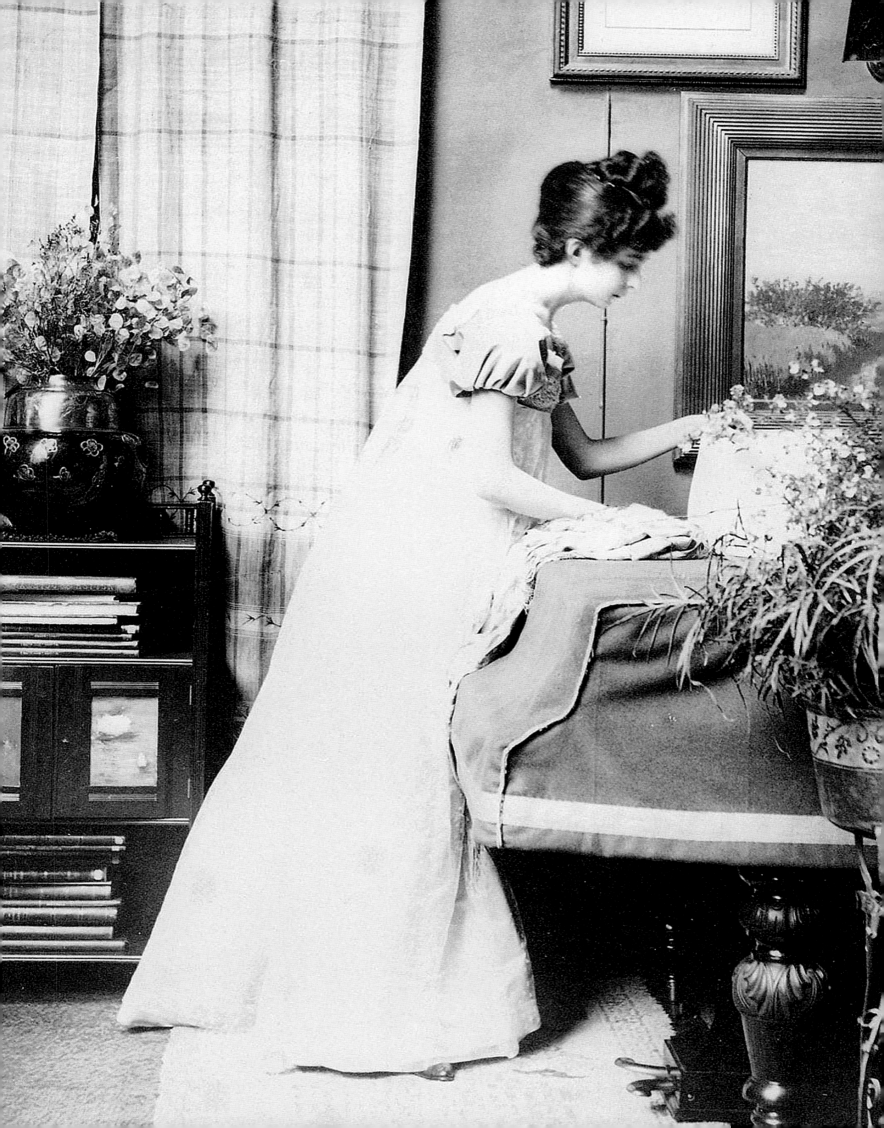

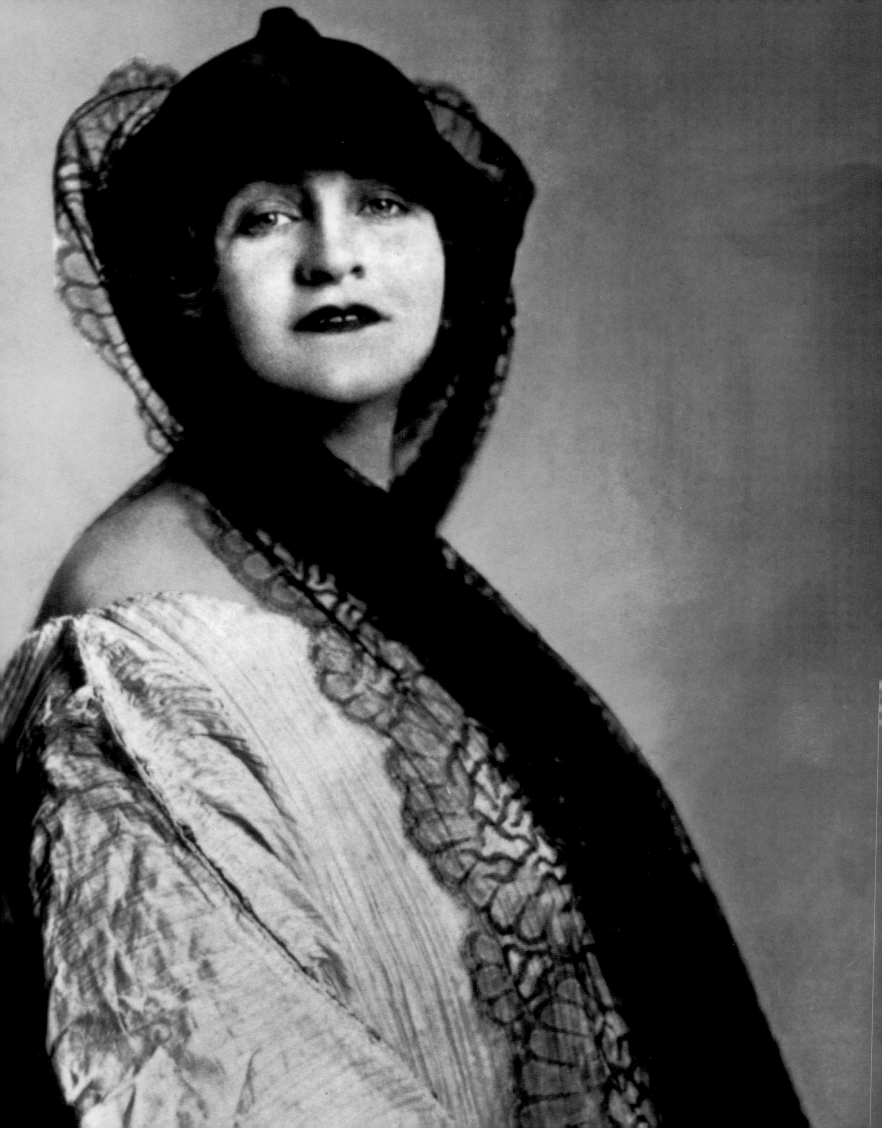

Alma Mahler
Wife to the Arts

Alma Mahler, née Schindler, was born in 1879 into an erudite and artistic Viennese family. Her father was a celebrated landscape painter who was acquainted with some of the greatest creative minds in Austria, such as architect Otto Wagner and writer Arthur Schnitzler, as well as Gustav Klimt, with whom, at just seventeen years old, Alma began a love affair that went no further than a kiss.

Self-Portrait with Lover, a 1913 drawing by Oscar Kokoschka. The girl in his arms is Alma Mahler, with whom he had a relationship lasting a year. Throughout this period the figure of Alma dominated the portrayal of the feminine in his work. The best-known work by Kokoschka from these years, *The Bride of the Wind* (aka *The Tempest*), depicts them embracing in a blue cloud. At one time, the picture was to be entitled *Tristan and Isolde*.

A promising and gifted pianist, she began improvising and composing at the age of nine. In 1901, she met Gustav Mahler at a soirée: "From the very first moment, Mahler observed me intensely, not only because of my face, which might have been thought of as 'beautiful' at the time, but also because of my rather spiky attitude. He studied me through his spectacles thoroughly and at length." They were married the following year, when, at the command of her husband, she ceased composing. He, however, was sufficiently inspired by her to dedicate his Eighth Symphony to her, which premiered in Munich, in 1910, and the influence of Alma is discernable in many other works. Before his death in May 1911, Mahler had a change of heart, and allowed Alma to return to composition, even permitting her to revise some of his own pieces. It was during this period that she fell into the arms of the architect Walter Gropius, the future founder of the Bauhaus, and shortly afterwards embarked on a passionate liaison with the painter and playwright Oskar Kokoschka, inspiring many of his paintings. In 1915 she married Gropius, who discovered her affair with Kokoschka when he came across a painting of Alma by his rival, in which the subject's state of dress left little to the imagination. In 1929, she abandoned the architect to marry the playwright, lyric poet, and novelist Franz Werfel, who, thanks to Alma's efforts, enjoyed a second flowering of his literary career. Before the outbreak of World War II, the couple emigrated to the United States, where Alma continued to move in artistic circles in the company of writers such as Sinclair Lewis. Werfel died in 1945, just after putting the finishing touches to *Star of the Unborn*. Alma died in New York in 1964, having devoted her life to loving other creative minds. Leaving to posterity just fourteen lieder, she never truly made the most of her own talents.

Facing page:
Portrait of Alma Mahler taken in 1920 by an unknown photographer. Gustav Klimt fell under her youthful charm when she was seventeen: "Alma is beautiful, intelligent, witty. She possesses everything a man could possibly desire, and that in abundance. I believe she'll be a mistress among women wherever she goes in the world of men."

La Goulue

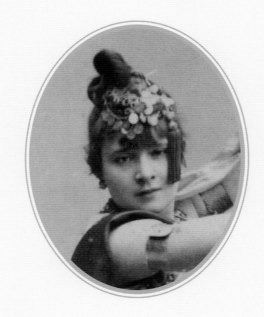

Lautrec's cancan muse

On January 29, 1929, in the Hôpital Lariboisière in the northeast of Paris, a poorly dressed old woman, who gave her residence as a horse-drawn caravan in the Saint-Ouen district north of Paris, passed away after suffering a fainting fit. Her funeral a few days later in the cemetery at Pantin attracted few mourners. If she died practically forgotten by all, during her heyday in the late nineteenth century La Goulue (The Glutton), as she was known for her insatiable appetite and her outrageous behavior, had been a household name. A major attraction of Parisian nightlife, she had acted as model for many painters, and was immortalized by Toulouse-Lautrec. In the 1890s, the Queen of the Cancan, as she was known, was adored by crowned heads and bohemian artists alike and had acquired great wealth and celebrity. After 1867—the year acrobatics, elaborately costumed spectacles, and public dancing were finally authorized—cabarets became all the rage. A few years later, Paris entered a golden age of singer-songwriters, café-concerts, dance halls, and the great revues of the Butte Montmartre. There, where high society rubbed shoulders with laborers, prostitutes, and riffraff of the worst kind, La Goulue, in her own way a key figure in the birth of modern showbiz, made her name with her banter, frenetic quadrilles, and naked, high-kicking thighs.

Portrait of La Goulue in stage costume (detail) by an unknown photographer, c. 1890.

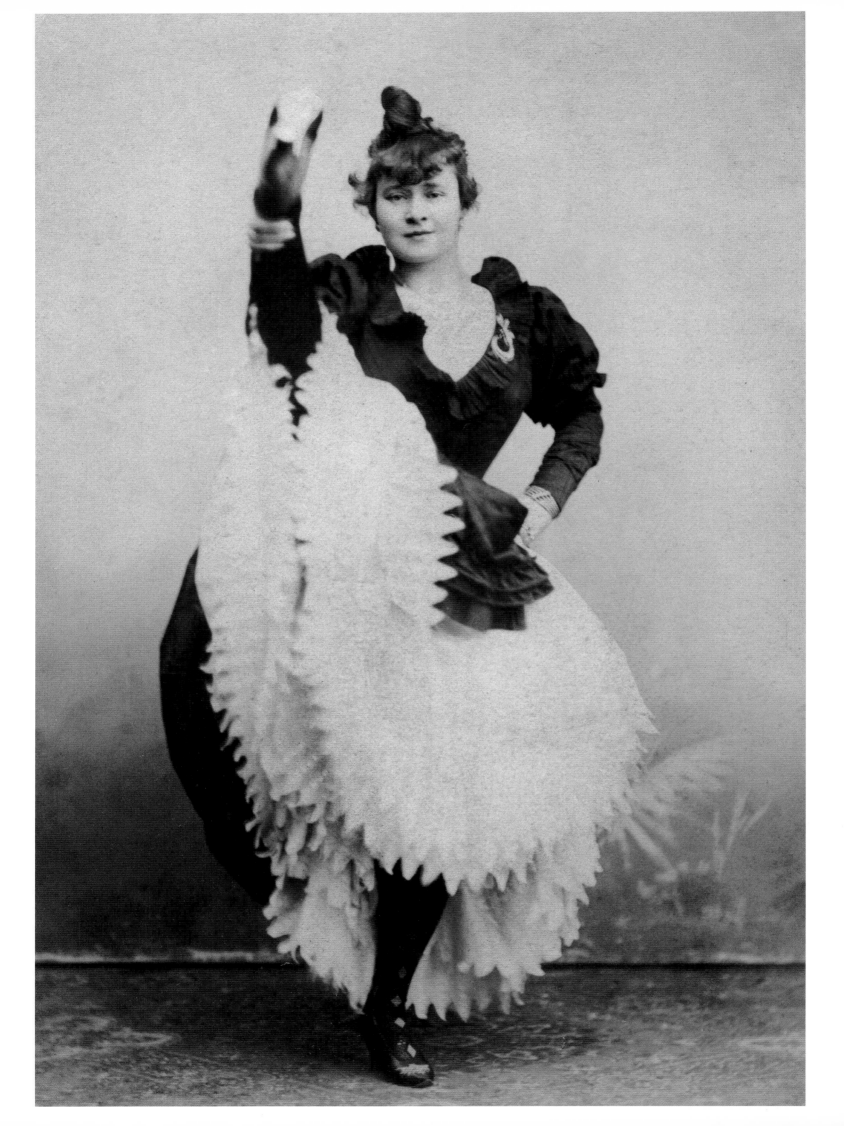

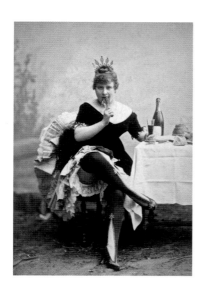

La Goulue in about 1890, in a scene designed to show the insatiable appetite for life on which her legend was built. She recounted how, in the course of private soirées at the height of her glory, men would slip her gold coins to get her to dance and drink champagne.

Facing page:
La Goulue demonstrating the cancan around 1890. A contemporary journalist, Octave Lebesgue, employing the pseudonym Georges Montorgueil, described her in the following terms: "Everything she did was spontaneous and sincere; she was that splendid girl with no sense of prudishness or restraint, whose nature, overflowing with the sap of pleasure and carnal vitality, bursts forth as an artless yet perverse flower."

Louise Weber becomes La Goulue

La Goulue was born Louise Weber in Clichy-la-Garenne, on July 13, 1866, to a working-class Jewish family from Alsace. Her mother ran a laundry and her father drove a horse-drawn cab. After dabbling in various street trades (flower seller, washerwoman, etc.), Louise began dancing in various Parisian dance halls, such as the Bal Bullier on boulevard du Montparnasse, one of the busiest venues since its opening in 1847. In all probability an occasional prostitute, Louise also danced at the Moulin de la Galette in Montmartre, there meeting Charles Desteuque, an "impresario" who launched her into the "high life." Nicknamed the Intrépide Vide-Bouteille (Intrepid Bottle Emptier), this fearsome drinker was a founder member of and columnist on *Gil Blas*, a daily newspaper that often emblazoned her name across its pages. Exposure in the press was, then as now, far from irrelevant to the nascent careers of emerging celebrities such as La Goulue. She danced at Les Ambassadeurs and at the Alcazar, where she became acquainted with the dancer and choreographer Grille d'Egout (her colorful moniker Drain Cover derived from her gappy teeth), who, in 1883, set up one of the earliest courses in the cancan in Montmartre. It was there that La Goulue learnt to dance the new-style quadrille.

In 1889 at the Scala, she appeared in the routine "Frou-frou" (refrain: "*Frou frou, frou frou*—a woman, with her petticoat / *Rustle, rustle, rustle*, she perturbs the soul of man"), accompanied by the song of the same name written for her with music by Henri Château and reprised by Juliette Méaly, who later claimed it as her own. Performing song-and-dance routines at the Concert Parisien, La Goulue lived a double life amid the show people—a community to which she would return in a subsequent incarnation as a wild animal tamer. She danced at the Moulin de la Galette and the Élysée Montmartre with a troupe of gloriously named professionals including Grille d'Egout, Brin (Sprig), Louisette, Nana Sauterelle (Nana Grasshopper), Fernande, Rayon d'Or (Ray of Gold), the Torpille, and the loose-limbed Valentin le Désossé (Boneless Valentin), her favorite stage partner. Pierre Mac Orlan wrote of her later, "La Goulue was not pretty, and was very different—though not just in this respect—from her partner, the extraordinary Jane Avril, dubbed Melinite [a type of dynamite], in keeping with the rather vulgar taste of the period for dancers' nicknames to evoke the sewer, bistro accessories or, as here, artillery materiel." La Goulue's contemporary, the singer Yvette Guilbert, however, was to note in her memoirs "At first blush, she seemed pretty, with an impish charm; fair, with a fringe of hair cut straight along the forehead that stopped, dead, at the eyebrows." By any standards, La Goulue seems to have made the most of the fleeting beauty of her youth.

Goddess of the *chahut*

At the Élysée Montmartre, La Goulue would make her appearance sporting a dress adorned with fruit to the accompaniment of a band led by Dufour. There she would dance the *chahut*, the cancan, and the French quadrille. The *chahut* (uproar) consisted of lifting the leg and was the precursor to the cancan—which consisted of lifting the skirt. In the early decades of the nineteenth century the quadrille had been a square dance, performed chiefly in popular venues. In about 1850 a variation emerged known as the "naturalist quadrille," the heir to the onetime *contredanse* of the previous century. The various steps of the quadrille boast richly evocative names: "little bouquets," "stormy tulip," and "pantaloons." The last was performed freestyle, with the dancers improvising movements that often concluded with the girl kicking her leg up so high that she could knock off an onlooker's hat. As for the cancan, this is considered by some to a watered-down variant intended primarily for foreign tourists.

La Goulue and Grille d'Egout represented an intermediate generation of dancers; initially self-taught, they contributed to the professionalization of the cancan that was then moving from communal dance halls to paying venues. In the nascent leisure industry of the late nineteenth century, music-hall and variety shows were being established, with their corresponding stage stars. By 1889, the year of the World's Fair and the erection of the Eiffel Tower, Paris was booming. The Moulin Rouge, with a stage in its garden, opened its doors on place Blanche on October 6 of that year. The gymnastically erotic movements of the *chahut*, cancan, and quadrille reached their zenith there in an unusual, pseudo-Moresque set, in a vast ballroom equipped with electric light (a particularly attractive innovation), surrounded by a promenade and decked out with bunting and streamers. Just a few months after it opened, La Goulue was top of the bill. Now at the summit of her career, she was invited to some of Paris's most high-society salons and embarked on a journey to the United States. Such was her renown that another singer, Anna Held, performed a number in her honor entitled *Le Pantalon d'La Goulue*. In 1890, La Goulue appeared triumphantly at the Palais des Arts Libéraux, on the Champs-de-Mars, accompanied by some two hundred musicians. Many sovereigns of the period (Grand Duke Alexis of Russia, the Prince of Wales, King Milan of Serbia) went to her show at the Moulin Rouge, which had become a must-see for the wealthy elite on their trips to Paris. (Some, surely, availed themselves of other talents of hers.)

In 1891, the management commissioned the poster from Toulouse-Lautrec that would make him famous. It was an advertisement for a show

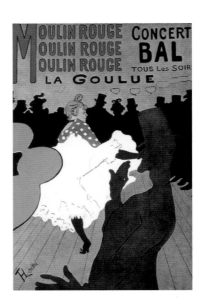

Poster of 1891, *Moulin Rouge Concert Bal—La Goulue*, to a design by Toulouse-Lautrec. In October 1889, the celebrated Paris cabaret of that name opened its doors on boulevard de Clichy, and La Goulue and Valentin le Désossé (who appears here in the foreground, in front of his partner kicking up her leg) were soon regularly on the playbill. Toulouse-Lautrec made his name as a poster artist thanks to orders of this type.

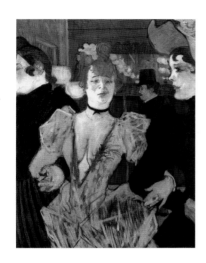

Toulouse-Lautrec, *La Goulue Entering the Moulin Rouge*, oil on cardboard, c. 1891–92. With her hair sticking up in the air and sporting a plunging neckline, here she is probably accompanied by her sisters or by her friend Môme Fromage. At this time, she would have danced mazurkas, polkas, and waltzes. Even the composer Jacques Offenbach took inspiration from the cancan.

with La Goulue and Valentin le Désossé, who appear surrounded by the outline of an audience, like in a shadow theater. The poster hit the streets in time for the Moulin Rouge's new season at the end of September. Its success was immediate: in a novel departure, the image was paraded through the grand boulevards on a cart. It made the name of Toulouse-Latrec synonymous with life in Montmartre, and La Goulue into the national symbol of the cancan.

Lautrec and the others

From the very beginning of her career as a dancer, La Goulue posed for many painters and photographers, including Achille Delmaet. Renoir and naturalist painter Robert Noir, stalwarts of the Moulin de la Galette, both took inspiration from her. In 1885, she was depicted in a drawing by Roedel in *Gil Blas*, already under the caption "The Legend of La Goulue." She was then hired by the art dealership Goupil as a painter's model and shuttled from studio to studio. She most probably sat for Louis Legrand for the illustrations in Érastène Ramiro's ballet manual, *Le Cours de danse fin de siècle*, published in 1892. She reappeared in *Les Étoiles de 1893* in a sketch by Lunel. Much later, in 1954, the character of La Goulue haunts Jean Renoir's *French Cancan*, a movie that refers in turn to the famous picture *Le Bal du Moulin de la Galette*, painted in 1876 by the director's father, who had met the dancer at that very place. If she was above all the muse of Toulouse-Lautrec, La Goulue was an enduring inspiration to a considerable number of other artists. In 1926, the writer Félicien Champsaur, for example, devoted a chapter of *L'Amant des danseuses* to her, while as late as 1989 Evane Hanska published a novel freely inspired by her life, *La Romance de la Goulue*. No one knows quite how many drawings and canvases by Lautrec she appeared in: on his death, it seems that around a hundred ostensibly immoral pieces were burned on the orders of the painter's mother at the family residence. In the 1880s, Lautrec, a habitué of both cabarets and brothels, painted portraits of *Fat Maria* and the *Venus of Montmartre*, as well as painting a scene at the Cirque Fernando where La Goulue also performed. He was fascinated by the world of the dance hall and especially the cancan. In 1886, he made a drawing showing *The Quadrille of the Chair Louis XIII at The Élysée Montmartre*, and over the following years he returned time and again to the Moulin de la Galette and above all to the Moulin Rouge (where La Goulue was often to be found) as subjects for his paintings. As the art historian Henri Perruchot writes: "In the feverish atmosphere of the dance hall, while the quadrille dancers went berserk… the painter sketched their gestures, attitudes, and forms

with his pencil." Lautrec, after a friendship of many years with this peppery and rough-and-ready muse, observed: "In her, there's a faith that no other has, sometimes jaunty, sometimes timid, forward or feline, as supple as a glove." When on the dance floor, the partnership of La Goulue and Valentin le Désossé captivated Toulouse-Lautrec.

In 1895, the Queen of the Cancan morphed into a belly dancer, leaving the Moulin Rouge to perform in a fairground stall that Lautrec decorated with a pair of panels to her specifications. The one on the left recalled the steps of the quadrille she performed with Valentin le Désossé and Jane Avril, while the right-hand section evoked the "orientalism" of her new routine. Although surrounded by "exotic" musicians and decor, La Goulue is still depicted, anachronistically, kicking up her legs. The figure with the scarf, the smallest in the group, can only be Toulouse-Lautrec himself. The whole scene has a valedictory feel; a farewell, perhaps, to the old world of Montmartre. Lautrec took his final bow in 1901, leaving many followers, such as the Dutch painter Kees van Dongen, who, in 1902, produced a *Portrait of La Goulue* that heralds the art of fauvism.

Monsieur Toulouse Painting Monsieur Lautrec-Monfa. Photomontage by Maurice Guibert, c. 1890. Clearly a pleasant companion, the painter forged genuine friendships with the performers of Montmartre and shared in their everyday existence. From a wealthy family, Toulouse-Lautrec was an eccentric night owl, at once party animal and creative artist. La Goulue, grateful for the respect he showed her, thought the world of him.

It was here, at the Moulin de la Galette, that La Goulue's dancing career took off when she met Charles Desteuque, alias the Intrépide Vide-Bouteille, an "impresario" who introduced her to the high life. His paper, *Gil Blas*, did much to enhance the fledgling performer's reputation in Paris. Photograph from 1903.

Underclothes and glimpses of flesh

The brash spontaneity of La Goulue, her repartee, and the attraction of her working-class slang on Paris audiences were clearly great assets in her success. In 1889, she played the role of a Parisian with a colorful command of language in a revue entitled *En Selle*. And yet, the fame of the "Princess of the Leg" was due less to her wit than to her easygoing exhibitionism, a provocative physicality that was half saucy, half rugged, conveying an intoxicating, good-natured sexuality. She exposed her lace bloomers, with a surreptitious, calculated flicker of an inch or so of naked flesh above the garters, with her see-through underclothes hinting at the rest. Nudity, the body itself, became the spectacle. On the fringes of prostitution, but without its venality, La Goulue—by sashaying and swaying, by sticking out her stomach, by shaking her loose hair (other dancers performed with their hair "done")—adopted and conveyed a new vision of female sexuality. Artists like Lautrec recast this sensuality into a new aesthetic, seeing it as a libertarian form of pleasure—while, hypocritical as ever, bourgeois morality savored it and condemned it in the same breath. Behind closed doors, it was lapped up; officially, it was denounced. Even the suppleness of the performers' bodies was found suspect, as an 1898 guide to "the

pleasures of Paris" suggested: "An army of girls are on hand to dance the divine Parisian *chahut*, as its reputation demands … with an elasticity when kicking their legs up high in the air which hints at morals of equal flexibility." In their own way, La Goulue and her dancehall colleagues flouted a moral code enforced—literally, it should be recalled—by a municipal guard complete with regulation two-cornered hat and great-coat, ever on hand to ensure public decency and taking down the names of those wearing unauthorized split bloomers. The song "Les Gardes municipaux" recalls how "In the dance halls of Paris / In the heart of Saturnalia / Evenings they're at their post / In the name of decency, / And if one, by chance, sees too much / Of La Goulue's undies / They cry out at the sight / And hazard a second look." The issue thus revolves at once around the body and the gaze, around prohibition and concupiscence, around freely offered girls and stolen looks. The "kick at the moon," the "flying splits" were steps in which the private parts of the woman escaped, as it were, from the furtive world of crotch and gusset, and were revealed before the eyes of the world.

An isolated caravan in the middle of nowhere

In 1929, just weeks before La Goulue's death, Henri Danjou, a journalist working for the weekly news magazine *Vu*, ventured onto a caravan site out on the fringes of Saint-Ouen. There, the long-retired dancer eked out her days in depressing, alcohol-fueled poverty, in the company of her dog, Rigolo, and other stray beasts she liked to take care of. Indulging in a kind of poetic nostalgia, the columnist wrote: "Luckily, it's all been forgotten—the high jinks at the Moulin Rouge, where La Goulue, like an impure Circe, appeared, heedless of sidelong glances. You are no more, Jean Tinan, Jean Lorrain, and you, Toulouse-Lautrec, who once attended on her in search of the poetry of vice and villainy. God was good in letting you die without seeing your idol in her dotage." More than half a century later, thanks to her descendants, the Queen of the Cancan was buried anew—this time with all the trimmings. In 1992, the then mayor of Paris, Jacques Chirac, ordered her ashes to be transferred to the cemetery at Montmartre, a ceremony celebrated by the "Republic of Montmartre" and other local associations. Her great-grandson Michel Souvais pronounced the funeral oration before a host of celebrities, TV cameras, and an admiring crowd. The glorious past of this daughter of the people, who had died alone and in poverty in the middle of nowhere, reappeared as clear as day, officially recognized as the incarnation of the mythic image of the joie de vivre and pleasures of the Paris night.

By the end of her life, in the 1920s, La Goulue was living in a caravan in Saint-Ouen on the outskirts of Paris, close by her friend, a ragman, and surrounded by animals of every species. She would occasionally still venture into Montmartre. Photograph by Maurice-Louis Branger taken shortly before her death in January 1929.

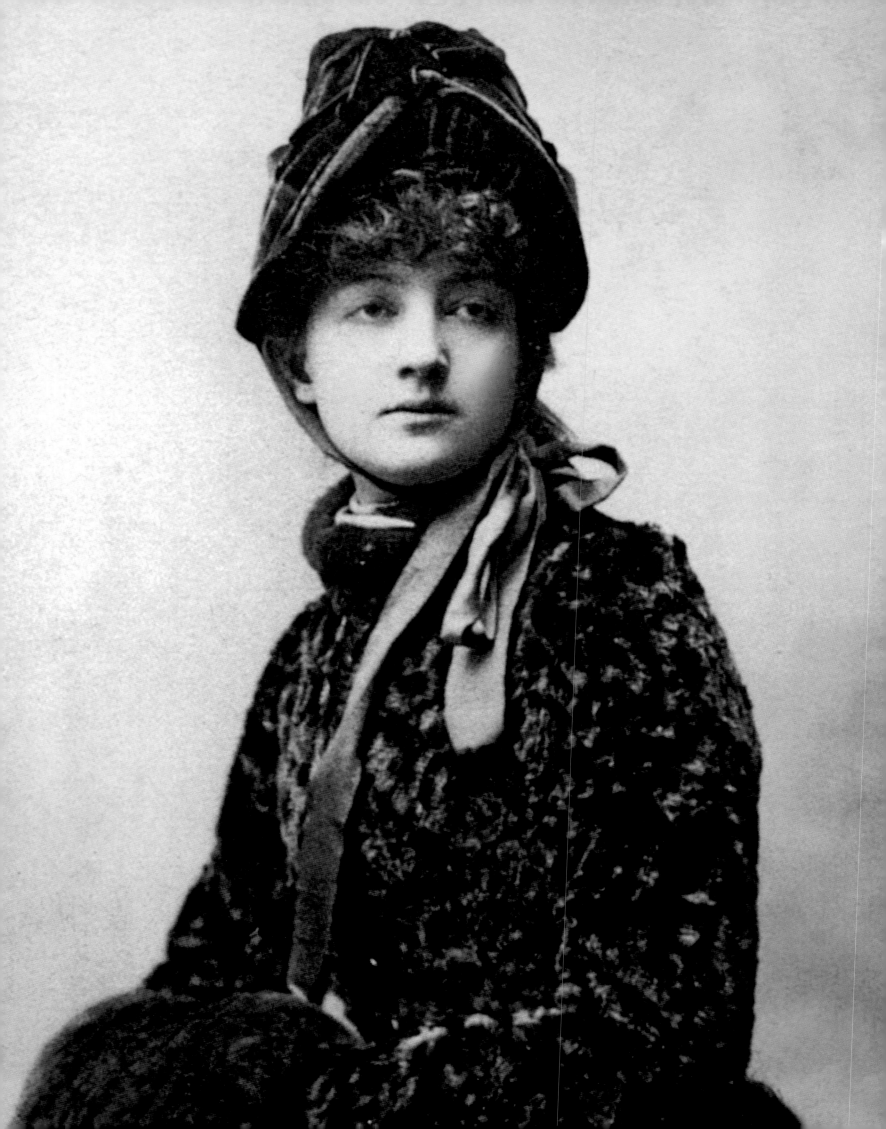

Dagny Juel
Muse of the Zum schwarzen Ferkel café

Dagny Juel was born in Kongsvinger, Norway, in 1867. Second daughter of Dr. Hans Lemmich Juell, mayor of her birthplace, while still young she dropped an "l" from her name. Good at school, she was educated in a private establishment run by Anna Stang, a feminist who undoubtedly contributed to her pupil's adoption of ideals of free love a few years later. In 1882, Dagny began studying music in Erfurt, Germany, before moving in bohemian circles in Christiana (today Oslo) and meeting Edvard Munch. She chose to pursue her studies in Berlin, where the painter was invited to work in autumn 1892 by the city's art association. Munch's first exhibition, quickly closed down by the police, created a scandal that made him famous and encouraged him to settle in the German city.

August Strindberg, c. 1880.
About fifteen years after this photograph was taken, Dagny Juel had a brief affair with the writer, who played a leading role in a group of intellectuals and artists in Berlin. Dagny was the central female figure.

Facing page:
Portrait of Dagny Juel taken in about 1890, by an unknown photographer. The German critic, writer, and art dealer Julius Meier-Graefe, who saw a lot of her at one time, described her as having "the silhouette of a fourteenth-century Madonna and a laugh that could drive men mad."

In 1893, Dagny joined him among the coterie at the café Zum Schwarzen Ferkel ("At the Black Piglet"), becoming its muse. It was there she was given the nickname "Ducha," Polish for "soul," which well conveyed her extraordinary aura and the fascination she exerted over her entourage. A literary group led by August Strindberg and Stanislaw Przybyszewski, its members were all adepts of Schopenhauer, Nietzsche, and Wagner, and the figure of woman and the role of Eros formed the center of their concerns. The artists spent many a drunken and even drug-fueled evening passionately discussing a vast range of subjects such as occultism, spirituality, and psychology. Dagny had a fling with Strindberg, and Przybyszewski—a friend and admirer of Munch and a brilliant intellectual, "decadent," and jack-of-all-trades, who, having studied both architecture and neurology, was a writer of reviews, prose poems, novels, and plays—eventually became her husband. Munch, who probably also enjoyed intimate relations with Dagny—who often posed for him, as she did for other Scandinavian artists, in the nude—also painted the couple together. In 1894 the group launched the journal *Pan* under the direction of critic Julius Meier-Graefe, but only two years later the adventures of Zum schwarzen Ferkel came to an end. Dagny and Przybyszewski left with their two children to live in Cracow, where they initiated other artistic currents before sinking into alcoholism and destitution, with Przybyszewski eventually committing suicide for love of Dagny in 1901 during a banquet thrown in his honor by one of his Polish admirers. In June 5 of the same year, Dagny was invited to a squalid flophouse, ironically dubbed the Grand Hotel, in Tbilisi in the Caucasus, by her lover, a certain Emeryk. There, he shot her in the head in front of her son, before turning the weapon on himself. The murderer left a suicide note declaring that Dagny "was not a creature of this world," but "the incarnation of a goddess," and, more simply, "God."

Munch had continued to correspond with Dagny until she met her dreadful end.

Lou Andreas-Salomé

Rilke's soul mate

Portrait of Lou Andreas-Salomé (detail), probably taken in Munich in 1897 at the Studio Elvira, notable for being run by two homosexual feminists, Sophie Goudstikker and Anita Augspurg, both friends of Lou's.

The novelist and essayist Lou Andreas-Salomé was thirty-six when she met the poet Rainer Maria Rilke in Munich, in May 1897; he was fourteen years her junior. The daughter of a German general of Huguenot origin from the Baltic States and a mother of mixed Danish and north German ancestry, Lou was born in St. Petersburg on February 12, 1861.

Her striking looks, independent intelligence, and the acuity of her writings had turned Lou, often against her better judgment, into something of a femme fatale. In April 1882, the philosopher Friedrich Nietzsche, having made his way to Tautenburg for a summer sojourn dedicated to philosophical conversation, wrote: "From what stars have we fallen to come across each other here?" Though a lonely figure, a solitary thinker, and far from a ladies' man, Nietzsche plucked up the courage to ask for her hand, but was promptly rebuffed. In 1887, she married the linguistics scholar Friedrich Carl Andreas instead, but their union was never consummated. By the time Rilke fell for her, Lou was a widely published author, having brought out nearly a dozen works.

A meeting of minds

Rilke was born in Prague in 1875. A former soldier, his father had made a career for himself on the railroad, while his mother's family were tradespeople. The couple separated when Rilke was eight years old. By the time of his encounter with Lou, Rilke had edited three issues of an avant-garde literary review and written three collections of poetry. For one who seemed to have suffered from chronic existential angst, discovering a soulmate like Lou amounted to a sign from heaven. In the spring of 1897, he sent her several anonymous letters before revealing his identity. Struck by the resemblance between "Jesus the Jew" that Lou had published the previous year and some of his own texts entitled *Visions of Christ* (a sequence of eleven poems that had languished in a drawer), he confessed, "You see, my dear Madam, I had the feeling that, thanks to the relentless rigor, to the unremitting power of your words, my work has received a consecration, an endorsement. I was like someone who watches a great dream being realized—together with its share of good and ill—because your essay was to my poems what a dream is to reality, what a desire to its attainment." Prior to her liaison with Rilke, Lou's sex life does not seem to have been especially rewarding: some biographers even contend that she remained a virgin at the age of thirty. If her relationship with the young poet began as an intellectual union under the aegis of devotion and poetical synchronicity, it soon expanded beyond the spiritual affinity that had until now cemented her associations with men. She could not, this time, confine herself to the kind of platonic friendship she maintained with her other suitors—often to their obvious distress. She also felt desire and completeness in the company of this lover on whom, like a fairy above a cradle, she bestowed a new nom de plume, which he would continue to use throughout his life: Rainer. Like a monk taking religious orders, Rilke entered into a symbolic marriage with Lou, sanctified by love and by a meeting between like souls. At the beginning of June he wrote to her: "One day, many years hence, you will completely understand what you are for me. What a mountain spring is for the thirsty." The incarnation of life and of good auspices, a nourishing muse, Lou sometimes took on the role of goddess and saint, other times of a protective and regal mother.

Russian episodes

On April 25, 1899, Rilke, Lou, and her husband Andreas left by train for Moscow for a trip that would last nearly two months. Lover and husband remained on friendly terms. For Lou, who had grown up among the German-speaking community of St. Petersburg and carefully prepared for the

Lou emphasizes the bonds that linked her to Rilke: "But to me what seemed most important was the rather odd fact that, even if we had not seen each other for a long time, when we met again—at our house, or in his in Munich, or elsewhere—we each had the impression of having in the meantime traveled the same path, evolved in the same way."
Photograph taken with the German Jugendstil artist August Endell, in 1897.

Rilke's splendid penmanship on the original manuscript of poem 29 from *The Sonnets to Orpheus*.

Facing page:
Rainer Maria Rilke and Lou Andreas-Salomé at the home of the peasant-poet Spiridon Dimitrievich Drozhzhin, whom they met in the course of their second journey to Russia, during the summer of 1900. The end of this sojourn saw their relationship deteriorate beyond repair.

voyage by immersing herself in Russian culture, the trip signaled a return to her origins. Once in Moscow they met important personalities from the world of arts and letters and soon received an invitation from Tolstoy. The traditional, idealized image they had forged of the country beforehand, though, was quite out of step with the progressive aspirations of Tolstoy and the meeting was a disaster, as if their modernism, though usually reasonably pronounced, had deserted them. Once back in Berlin at the end of June, there was only one thing on their minds—to set out again, but this time just Lou and Rilke. Under the influence of their Russian experiences and reciprocal intellectual stimulation, the period proved a fertile one for literature: Rilke finished the first volume of *The Book of Hours*, continued his *Stories of God* and, in one electrifying night, completed his celebrated *The Tale of the Love and Death of Cornet Christophe Rilke*. As for Lou, she embarked on a new novel that would turn into *Im Zwischenland* ("The Land Between"). She defined its subject, one very close to her heart, in this way: "Transcending the love she feels for her male partner and her children, a woman hurls herself into the loftiest spheres of religion." That is, she goes beyond the question of the flesh and dispenses with the restrictive contingencies of sexual instinct. Perhaps, as one of her biographers, Dorian Astor, contends: "The adult Lou felt the need for the symbolic death of her lover, for the death, too, of all desire to procreate, so as to attain a higher form of love. Something is amiss with Lou's relationship with Rilke and it will have to come to a head soon; the second journey to Russia provides the pretext."

They spent the first weeks of their trip, in May 1900, in Moscow. Their incomprehension before the upheaval then rocking Russian society to its foundations was painful to witness and they remained fascinated by the mystic aura of everyday life, with their shared literary fantasy explaining a second unrewarding visit to Tolstoy on June 1. Then they progressed to Kiev, before descending the Dnieper. By the end of the month, they were in Saratov, traveling up the Volga towards Nizhny Novgorod, before deciding to spend a few days in an *isba* at the confluence of the Volga and the Kotorosl, just as Old Russian peasants had done since time began. With the same pastoralist purpose, they met Spiridon Dimitrievich Drozhzhin, a peasant poet Rilke would translate into German. Suffering from bouts of mania and depression, during the tour Rilke tried to reconcile himself with the world and its creator, but the separation of the couple was inevitable. At the end of July, Lou left alone for Finland to visit members of her family. Rilke, tormented by her departure, traveled to St. Petersburg where he impatiently awaited her return. Although they returned to Berlin

together on August 26, Rilke promptly packed his bags to join the artistic community in Worpswede the following day, during which time he met the sculptor Clara Westhoff, a former pupil of Rodin's. The two journeys to Russia played a crucial role in the intellectual development of both Lou and Rilke, forming a nourishing autobiographical breeding ground. But during the winter at Schmargendorf, Rilke, reeling from the blow of their breakup, fell into a deep depression.

"One last appeal"

The rift between them continued and Rilke decided to marry Clara Westhoff. The grand finale to their breakup was voiced in a letter from Lou entitled "One last appeal." Appearing almost as a command, in this text Lou adopted the role of a mother with advice to offer, pleading with Rilke to fight against his mood swings and sudden alternations between lethargy and exaltation. She regarded the poet, often subject to fits of rage, as a patient she must encourage to find a remedy. In the same manner, their separation, she felt, should be taken as an opportunity for him to show greater maturity; as Lou saw it, in this newfound freedom he would thus attain the summits of his art. Their union, she maintained, was incompatible with his literary development, and, more broadly, with the realization of his essence: "I know with a seer's clarity, and call to you: take the same path towards your dark god. He can provide what I can no longer provide for you—and for so long have not been able to provide with full dedication: the grace to reach the sun and ripeness." Is this really love sacrificed on the altar of creation—or is a noble sentiment being used as a pretext to end their relationship? Probably both at the same time, because one should not underestimate Lou's exasperation with the multifaceted personality of the poet. Rilke was a tormented companion who dragged his whole entourage into an infernal spiral; fragile, immature in many ways, and entirely dependent on the more energetic Lou. But she, in spite of it all, respected both the man (she would remain a faithful friend) and the writer, and freely acknowledged the power of his oeuvre.

Conserving a sincere and fraternal affection for one another, in their way they never parted. Rilke aggrandized the relationship, exalting their synergy, and dedicating a cult to his muse whose ideals were not that unlike the courtly love of the medieval poets. His enthusiasm remained unqualified and Lou evolved into a Madonna at whose feet the poet laid all his books. A few years after their separation, he wrote these lines to her: "And I would like to be permitted to come one day and place the prayers—the short stories—which have seen the light of day since then

Nietzsche had the idea of ordering this photograph from his friend Jules Bonnet, shortly after Lou turned down his offer of marriage, on May 13, 1882, in Lucerne. Here they are depicted in a curious arrangement dreamt up by the author of *Thus Spake Zarathustra*, together with his friend the philosopher Paul Rée who stands in the foreground and whose proposal Lou, with her unbounded desire for freedom at this time, had similarly "rejected." Seated on the cart, domineering and with a wry smile, she brandishes a whip entwined with lilacs, while the two men seem little more than draft animals.

Facing page:
Portrait of Lou Andreas-Salomé, probably taken in the Studio Elvira in 1897.

next to the others, in your home, between your hands, in your peaceful abode. Because, you see, I am an outsider and a poor man. And I am only passing through; but all that one day might have become my homeland had I been stronger should by rights repose in your hands." On the other hand, in her correspondence Lou revealed the paradox of a simultaneous sense of nearness and estrangement, of a categorical remoteness, a severing of the kind she nearly always experienced with respect to her male friends.

Twenty-five years of intellectual and spiritual friendship
Their three-year affair spawned an epistolary friendship that lasted twenty-five, punctuated by the occasional reunion. Indeed, distance did not mar a familiarity that remained intact to the very end. In April 1901, Rilke did indeed marry Clara Westhoff; a daughter, Ruth, was born in December. *Ruth* was also the title of a novel written by Lou at the end of 1882 and published three years later, which tells of an affair between a girl and her teacher. Clara, a great admirer of Rodin, encouraged Rilke to study his work. The poet left for a meeting with the sculptor in 1902, becoming his secretary a few years later and thus finding himself a new master. In 1903 his essay on Rodin was published in Berlin and it is Lou's judgment that matters more than any other: "To learn that my little book on Rodin has gained such importance in your eyes, Lou, causes me inexpressible joy. Nothing could give me more confidence and hope than your acknowledgement of my most adult work to date." In their correspondence Lou continued to encourage Rilke to become make his peace with the world, and, as far as possible, to throw off his depression. He would hail the role she played in his transformation as the "antithesis of all my doubts."

"You see, my dear Madam … your essay was to my poems what a dream is to reality, what a desire to its attainment."
Rainer Maria Rilke

In 1904, Lou embarked on a new novel, *The House*, the story of a relationship with a maternal dimension not unlike their own, and which also incorporated passages from one of Rilke's letters. They met again in 1905, the year that saw the publication of *The Book of Hours*, bearing the following dedication: "Deposited in Lou's hands." They spent more than a week together at a friend's in the Harz Mountains, but the sublime scenery did little to calm the painful fits of angst that assailed the poet.

Rilke in June 1919. He spent part of the spring of that year with Lou. His health soon deteriorated fatally and he died at the Valmont sanatorium, in Switzerland, on December 29, 1926, in all probability still in love with Lou.

From 1911, Lou turned to psychoanalysis, meeting Freud at the end of the following year. In spite of his various neuroses, Rilke did not follow her down that route, although for her Rilke represented an interesting object of study in the context of her explorations of the unconscious. In July 1913, after a lengthy separation, they met up again in Göttingen. Lou's diary of the time gives the impression their affair had been rekindled: "One day, at twilight, Rainer stood near the gate and, before even speaking, our hands met above the trelliswork in the garden. I was so happy all the time he spent here!" A few weeks later they together attended the International Congress of Psychoanalysis in Munich, at which Rilke met Freud. World War I separated them again, but they managed to spend the spring of 1919 in each other's company. At the beginning of the 1920s, however, Rilke's health degenerated. In agonizing suffering, the writer was afflicted by what would turn out to be leukemia, diagnosed only a matter of days before his death on December 29, 1926, in the Valmont sanatorium in Switzerland. Sixteen days previously, Rilke had written one last letter to Lou. It ends with these words in Cyrillic script: "Farewell, my darling." Two years later, Lou published her memories of the poet in *Rainer Maria Rilke*, as if addressing him from the other side of the grave: "In us, it was not two halves that sought each other: our astonishing unity recognized itself, trembling, in unfathomable oneness. Thus, we were brother and sister— but, as in some remote past, before incest became a sacrilege."

Annie, Marie, Louise, Madeleine, Jacqueline

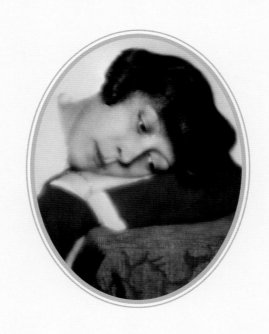

Apollinaire's muses

In the heart of Guillaume Apollinaire, muse followed muse, each utterly unlike the other. And yet, in the way of lyrical tribute, he was capable of sending a poem composed with one of them in mind to two other members of the elect. Perhaps through them, the poet, famously *mal-aimé*—"unhappy in love"—sang the praises of one and the same woman. The first girl to make Apollinaire's heart beat faster was the young Maria Dubois, the daughter of a café owner from Stavelot, the small town in Wallonia where Apollinaire was vacationing in 1899. Though fleeting, the infatuation was nevertheless celebrated in verse: "Me, I loved her with true Love; as for her, who knows?" Two years later, he was dedicating stanzas to Linda Molina, a sister of one of his friends and unresponsive to his advances. That same year, he was taken on as tutor to the daughter of the wealthy Viscountess of Milhau, and he was soon besotted with the governess in the great house, Annie Playden. His celebrated collection of poems *Alcools* bears the imprint of his passion. By 1908 it was the turn of the young artist Marie Laurencin, met at an art dealer's, to turn his head. This new ardor spawned the deep suffering distilled in the wistful sighs of "Le pont Mirabeau," among other poems. At the end of 1914 Apollinaire fell head over heels for the supremely chic Louise de Coligny-Châtillon. Mobilized at the beginning of World War I, he left for the front and was quickly forsaken by "Lou." After devoting several melancholy poems to this turn of events, he had meanwhile met Madeleine Pagès, to whom, following an ardent correspondence, he became engaged. The couple became estranged by the war, and Apollinaire embarked on a new idyll with Jacqueline Kolb, whom he wedded shortly before his premature death in 1918, two days before the Armistice was declared.

Portrait of Marie Laurencin by Dora Kallmus (Madame d'Ora), c. 1927. Apollinaire heaped praise on Marie's paintings. The couple sometimes appeared together in her pictures, as in *Group of Artists*, with their friend Pablo Picasso (a work of 1908 now in the Baltimore Museum of Art).

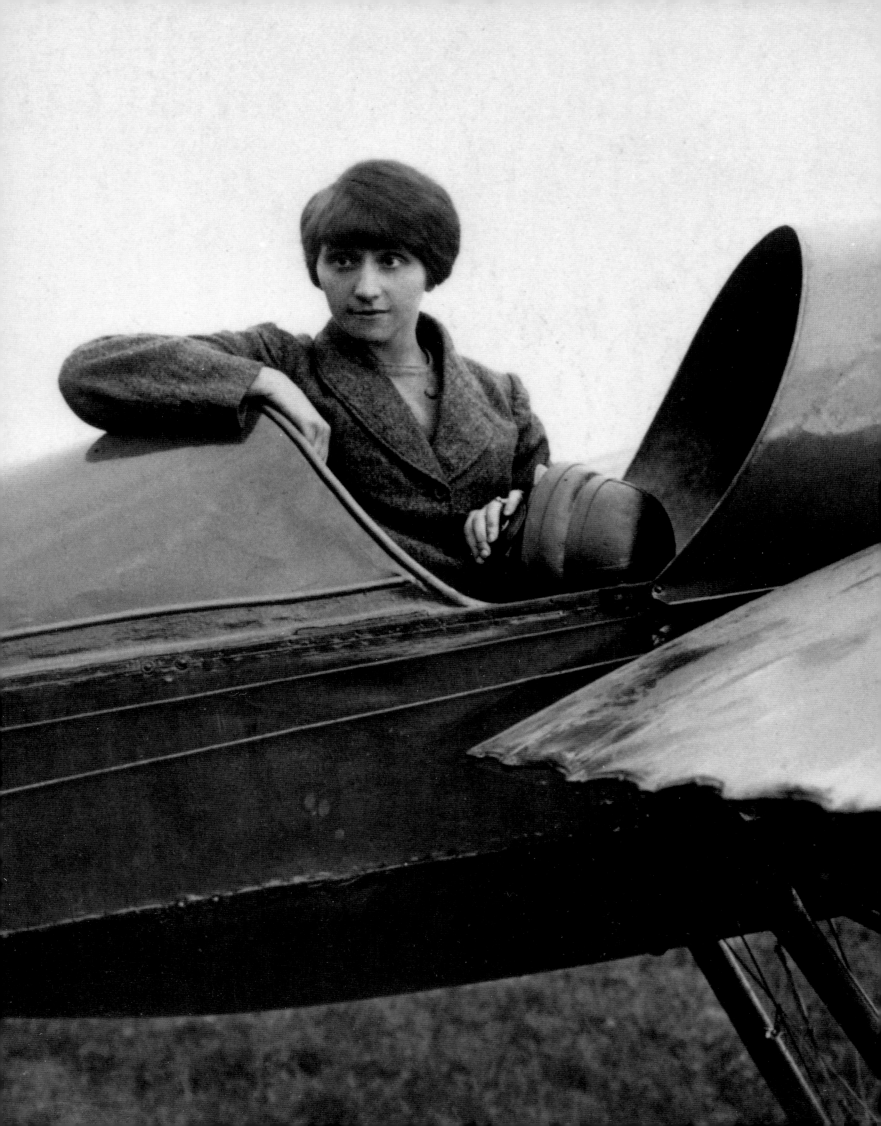

Guillaume Apollinaire and Annie Playden, with whom he was conducting an affair. He was sorely disappointed when she rejected his proposal of marriage, though she became the inspiration behind his poetry collection *Alcools*.

Facing page:
Countess Louise de Coligny-Châtillon, known as "Lou," seated in a Deperdussin (from the name of one of the most famous pre-World War I plane manufacturers). She was a pioneering aircraft pilot around the year 1910.

Annie: the indifferent English girl

Born Wilhelm Albert Włodzimierz Apolinary Kostrowicki in Rome in 1880 to a young Polish woman, the poet who would call himself Guillaume Apollinaire was schooled at the Collège Stanislas in Cannes. Although he failed his baccalaureate in 1897, he nonetheless read voraciously and worked as a ghostwriter and an author in his right. In 1901 he was hired as a tutor at the Viscountess of Milhau's household. There, he promptly fell for the charms of the English governess, Annie Playden, who quickly reciprocated. In July of that year, he wrote gleefully: "I'm seeing all Germany and sleep with the English governess, twenty-one years old, with impressive tits and what an ass!" However, his high hopes were soon dashed, as described in the sequence of nine poetic texts entitled "Rhénanes" in the 1913 collection *Alcools*. In these, Annie hides behind the mythological mask of the Lorelei, the enchantress. "O, beautiful Lorelei, with eyes full of precious stones / What magician taught you such sorcery?" Apollinaire, since earliest childhood, had been fascinated with fairytales, traditional legends, and stories of chivalry. He also seemed to have made a habit of falling for young women and then scaring them off with the intensity of his desires. Annie refused his proposal of marriage and broke off their liaison, but the poet remained determined to regain her favor. Crestfallen, he returned to Paris at the end of summer 1902, moving in with his mother and brother, and scraping a living as a bank clerk. But he could not forget Annie and, in September 1903, he set out to London to win her back, with no success. In May of the following year, he once again visited the English capital—once again in vain. Not long afterwards, the young woman, perhaps in a desperate attempt to shake off the limpet-like Apollinaire, emigrated to the United States without leaving a forwarding address. "Farewell false thwarted love / With the woman who disappears / With she whom I lost / Last year in Germany / And whom I will never see again" he wrote in his celebrated poem of that year, "La Chanson du mal-aimé" ("The Song of the Poorly Loved") This new scar was long in healing and Apollinaire lamented the wait. Later he remarked that, when he had written the poem, he was unaware that his "love resembling / The beautiful Phoenix, if it dies one evening / Is reborn in the morning." And this rebirth was effectively to take place in the person of the piquant Marie Laurencin.

Marie: the painter who inspired "Le Pont Mirabeau"

In *The Poet Assassinated* the poet recalled how he fell for the then little-known artist, soon praising her work in eulogistic critical articles. In his book of art criticism *The Cubist Painters* of 1913 (trans. 1949), he wrote,

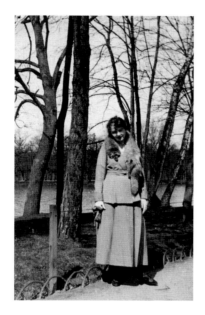

Jacqueline Kolb married the poet in April 1917, in the church of Saint-Thomas-d'Aquin, Paris. She was the inspiration for "La Jolie Rousse," a poem at the end of *Calligrammes*. Guillaume Apollinaire died a matter of months after their wedding.

"As an artist, one can place Mlle Laurencin between Picasso and Le Douanier Rousseau. This is no mere indication of hierarchy; simply a statement of kinship." For a time, their worlds overlapped: Marie portrayed the poet in several works, accompanied by herself or flanked by some of their friends. At the same time, Le Douanier Rousseau painted a full-length portrait of Apollinaire in a bucolic setting with a pen and a blank sheet of paper in hand, and accompanied by a woman, entitled *The Muse Inspiring the Poet*. Marie inspired a considerable number of poems, an eponymous one reading: "Yes, I want to love you but love you only just / And my pain is exquisite." Even the question of marriage was aired, but Marie's family was utterly opposed to the idea, following the few days Apollinaire spent in police custody during the affair of the theft of the *Mona Lisa*, in which he had been implicated. The couple separated in 1912, at the behest of Marie, who, though often pestered for details, never breathed a word about their life together. Experts in Apollinaire's work have unearthed allusions to their breakup in one of his best-loved poems, "Le Pont Mirabeau." Apollinaire and Marie were to cross paths several times over the next two years, until, in 1914, she married the German painter Baron Otto von Waetjen, with whom she moved to Spain. Later in a letter addressed to one of his subsequent muses, Madeleine Pagès, Apollinaire contended that he never really loved Marie or wanted their union to become official. In any event, as biographer Claude Bonnefoy puts it: "[Apollinaire] fed his work with his passions. The moments of happiness, the worries, doubts, sorrows provide the merry or sad coloring to each poem, and appear, metamorphosed, even made fun of, in his stories. He could not live without relating what he lives through.... His loves pass; the poet remains."

But with what gentle memories do you mix,
Lou, my far-off love and my divinity,
Suffer this worshipper to adore your beauty!
Apollinaire, Poèmes à Lou

Louise: inspiration for *Calligrammes*

Apollinaire met Louise de Coligny-Châtillon in Nice through an acquaintance, the painter Robert Mortier, and the poet started courting her during the autumn of 1914. The descendent of a long line of aristocrats whose noble origins fascinated the poet, Louise was independent, recently divorced, and, during this period, shared the feverish first flights of aeronautics in the company of the pilot Jane Herveu. The writer and artist André Rouveyre, who knew her some time before his friend Apollinaire,

Facing page:
Apollinaire and Madeleine Pagès, photographed by Madeleine's sister in Oran, December 1915.

described Louise as "witty, jaunty, frivolous, on edge, rather frantic, as it were." After she refused him, in December Apollinaire joined up, enlisting as lance-bombadier in the thirty-eighth artillery regiment in Nîmes. The flighty Louise agreed to join him a few days after he was posted. Sneaking out of barracks, he would spend the night with her in the Hôtel du Midi. Throughout December, their affair blossomed, before rapidly flickering out. On December 17, he wrote, "But close to me I am always seeing your picture / Your mouth is the searing wound of courage." By the beginning of the following year, Apollinaire was little more than a memory for Louise, who made her way back to Nice, but he pursued her with an elegiac ode with erotic overtones. In a mix of reminiscence and desires, the man now in uniform and packed off to war sang: "Ah! Ah! there you are once more, stark naked, / Adored captive, you, the last to come, / Your breasts have the pallid taste of persimmon and prickly pear / Your thighs, candied fruits, I love them, my darling, / The sea foam from which is born / The goddess reminds me of one born from my caress." The most accomplished poems to Louise appear in the collection *Calligrammes*, written at a time when Apollinaire was under fire almost daily. Their last meeting, which took place on March 29, was, in his eyes, a fiasco. He headed back to the front only to recall their parting in poetry: "Farewell, my girl, o, Lou, my only love / O, my fleeing slave, / Our love which knew the sun, not the rain, / Was but an instant all too brief." Yet, in the course of the steady flow of letters he was to send her over the following months, Apollinaire immortalized the conflagration of this love.

Madeleine: all the beauty in the world

At the very beginning of the year 1915, Madeleine Pagès, a woman with a passion for the arts and poetry, bumped into Apollinaire on a train. He was on leave, while she was making her way back to Oran after a vacation in France. During the ensuing conversation on the brief rail trip, they exchanged addresses, promising to write to one another. Three months later, their epistolary conversation began, devoted mainly to literature and theories about love. Apollinaire was able to send her a letter from the front and their correspondence blossomed, on his side accompanied by poems laden with sexual desire. On this occasion, then, Apollinaire's desire was built on language; the object of that desire, meanwhile, remained unseen and far away, as if the encounter on the train served merely as the pretext for an image of perfect love. The woman, thus idealized, existed in a timeless, literary space. Texts informed by this unique form of adoration can again be found in *Calligrammes* (the first poem, "Reconnaissance," is addressed and dedicated to Madeleine; Lou had received the same poem),

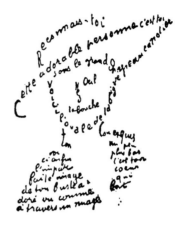

Calligramme taken from a poem of February 9, 1915 in *Poèmes à Lou*: "See for yourself / This adorable person is you / Beneath this large boater / Eye / Nose / The mouth / And here the oval of your face / Your exquisite neck / Here finally the imperfect image of your adored bust seen as through a cloud / A little lower, there's your beating heart."

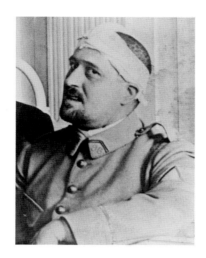

On the front in March 1916, a piece of shrapnel pierced Apollinaire's helmet. He underwent surgery and was repatriated to Paris. On May 9, he was trepanned by Dr. Baudet. Following the operation, he wrote, "The beautiful Minerva is the child of my head / A star of blood has crowned me forever."

while the majority, chiefly intimate letters penned over a one-year period, appeared together in the 1952 collection, *Lettres à Madeleine, tendre comme le souvenir*. After several months of almost daily correspondence, Apollinaire officially asked to marry her. On September 30, he sent her the poem, "Il y a" ("There is"), in which, interleaved with descriptions of the horrors of war, there is a confession: "*There is* that I'm pining for a letter from Madeleine." Promoted to the rank of second lieutenant, by autumn he was back in the trenches. On December 26, Apollinaire managed to obtain leave to visit his fiancée in Oran, where they passed a blissful fortnight together. Their hope was to marry at the end of the war, but fate decided otherwise. In March 1916, three days after bequeathing all his worldly goods to Madeleine in a premonitory letter, a piece of shrapnel pierced Apollinaire's helmet, striking him near the right temple. After an operation he was repatriated to the Hôpital Italien on quai d'Orsay in Paris, where he was found to require more surgery. The wound and the resulting operations put paid to their love, and with no official reason—if not a profound, and comprehensible, personal trauma—the wedding was cancelled. Up until now Apollinaire's correspondence had been full of paeans to his beloved: "You are the feminine aspect of the living world that is to say you are all the grace all the beauty in the world / You are still more since you are the world itself the admirable universe according to the lights of grace and beauty." But war finally extinguished the protean splendor of Apollinaire's powerful inspiration.

Jacqueline: the pretty redhead

Jacqueline Kolb had already crossed the poet's path in 1914 at a mutual friend's house, but they did not meet again until April 1917. A little more than a year later, they were married at the church of Saint-Thomas-d'Aquin in Paris, with Picasso and Vollard as witnesses. At the end of *Calligrammes*, the poem entitled "La Jolie Rousse" ('The Pretty Redhead') is plainly a tribute to Jacqueline: "She comes and attracts me like the magnet does iron / She is charming to look at / An adorable redhead / Her hair is of gold it looks like / A beautiful flash which lasts / Or those flames that parade / Within fading tea roses." But, after so many abortive love affairs, Apollinaire had only a short time to savor his new life with Jacqueline. Seven months later, on November 9, weakened by his surgery and suffering congestion of the lungs, he died of the Spanish flu, a pandemic that ravaged Europe at the time. In all these passions for these multiple muses—and in the works in which he celebrated them—the *mal-aimé* seems to be adoring but one and the same woman: a perfect creature, an ideal beauty, at once near and far off, inaccessible, unknowable, yet complicit.

Yvonne Printemps

Guitry's diamond

In 1905, a number of inhabitants from the town of Ermont, outside Paris, set up a theater troupe called the Amicale de la Vallée. That Christmas Eve, they put on a little show in a barn. On the bill: the eleven-year-old Yvonne Wigniolle performing "Madame Arthur," a popular song from the end of the previous century by the famous music-hall singer Yvette Guilbert. Today the words of the song sound prophetic: "She had a host of lovers, / Everyone wanted to be loved by her, / Everyone courted her. Why? / Why, because without being especially pretty, / She had that 'certain something'!" The audience was in raptures over the girl who recalled later how, when "aged four [and] asked 'What do you want to do when you grow up?' answered, 'I'll go on the stage'. I'd never even been to one. I'd barely seen a circus act."

In 1908, Yvonne was treading the boards at La Cigale—a famous Parisian theater with a reputation for satirical stand-up and semi-nude females—playing Little Red Riding Hood in a revue called Nue Cocotte. This signaled the start of the career of the girl from the sticks, who soon earned the nickname, "the Nightingale." A muse to some of the greatest actors and playwrights of the twentieth century, Yvonne was the quintessence of 1930s Parisian elegance.

Yvonne Printemps photographed by the Studio Harcourt in 1943.

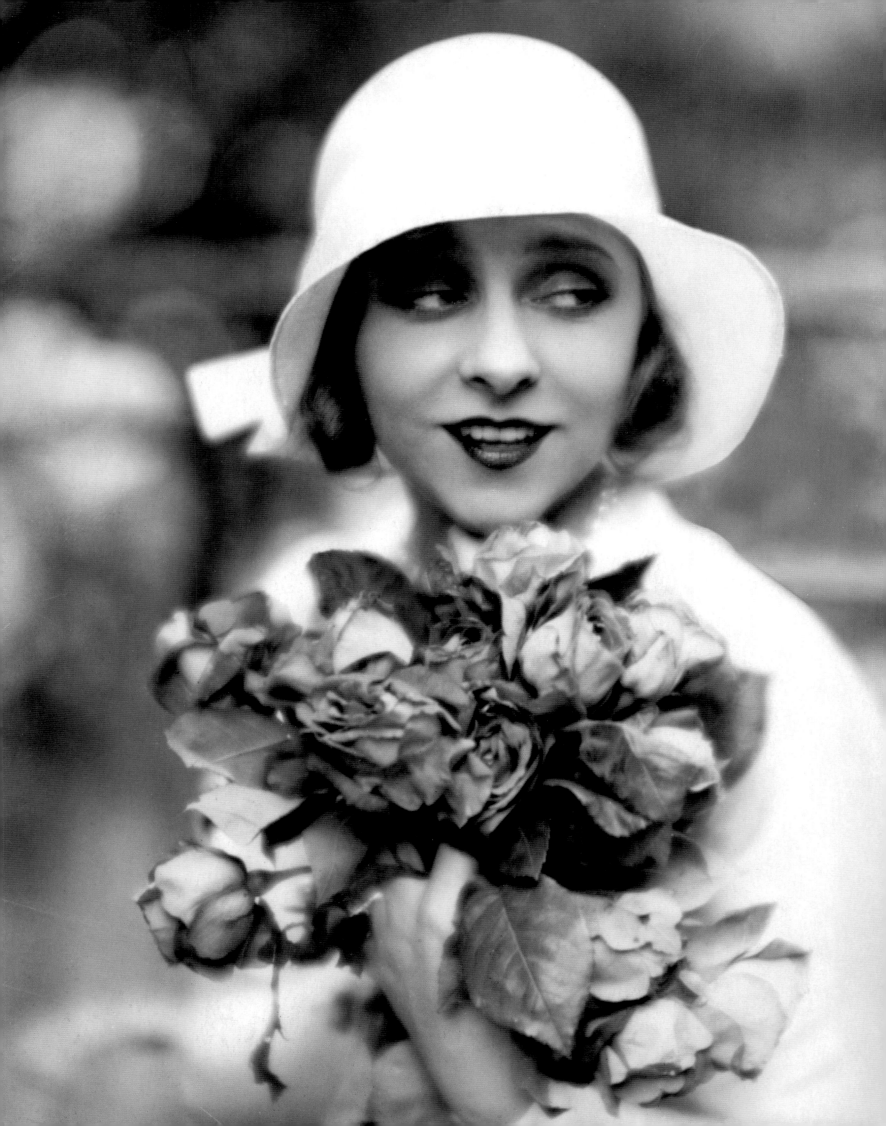

The birth of "Spring"

Closely supervised by Paul-Louis Flers, a theatrical impresario with an eye for a star, and chaperoned by a mother ever prepared to look the other way (Yvonne was brought up without a father), some time later Yvonne appeared at the Alcazar, where she slipped on the garish costumes of Cyrano de Bergerac and the child Louis XIV. She then joined the dance troupe at the Folies Bergère. With her singing talent, supple physique, and grace, she attracted a crowd of admirers anxious for any sign of her favor, however small. At this time she also acquired a talent for amassing lovers. In 1912, in an act that was to be auspicious for her, she performed a clever parody of the high-flown style of the famous actor and playwright Sacha Guitry.

At this time, although not for much longer, another exceptional woman was to be seen every evening on the stage at the Folies Bergère: Colette. Then a specialist in scantily clad "Oriental" mime, the writer-to-be envisioned a future full of promise for her colleague, who had by now adopted the seasonal stage name of Printemps (Spring). "That little Spring," wrote the author of *Chéri*, "what a temperament she has! How natural she seems! She'll become a star, if she doesn't do *too* many silly things; but will she be able to avoid doing just that!?" After appearances at the Paris Scala and the Théâtre des Capucines, Printemps revealed herself to be an acrobat at heart, and could be seen suspended from a trapeze in the great auditorium at the Olympia, piping away in her soprano voice, "Je sais que vous êtes jolie." ("I know you are pretty.") Shortly afterwards she was spotted by the musician Félix Fourdrain, who offered to take her away from these variety acts and find her a niche in the less plebeian entertainment of light opera. In December 1913, and cross-dressing again for the dress rehearsal, she took on the role of Prince Charming. The critics were unanimous in their praise. As Joy de Brux, among many other positive reviews, wrote in the theatrical daily *Comédia*, "One nightingale does not a Spring make, as the proverb has it. Still, 'Mademoiselle Printemps' does do the nightingale very well indeed. What a steady, crystalline voice, with such timbre, and so skillfully carried off."

The master and his "sketch"

By the outbreak of World War I , Yvonne was playing in *Revue 1915* at the Théâtre du Palais-Royal, taking patriotic roles designed to boost troop morale. At this time Sacha Guitry, exempt from military service, was no less fired with national fervor, as the title of one of his forays with his musician friend, Albert Willemetz, demonstrates. Called *Il faut l'avoir*, the implication was that "One Has to Have" a French victory. Acting on what

Yvonne Printemps in Sacha Guitry's play *Désiré*, which premiered at the Théâtre Édouard-VII in April 1927. Its author adapted it for the cinema following their separation some ten years later.

turned out to be the ill-judged advice of his first wife, Charlotte Lysès, one evening Guitry paid a visit to Yvonne in her dressing room. Perhaps it is not quite irrelevant—in a context already worthy of a script for some dizzy farce—to mention that this self same wife (who had played in premieres of nineteen of Sacha's plays and in whom his interest was perhaps beginning to flag) had previously been the lover of her husband's father, the celebrated actor, Lucien Guitry. It was literally love at first sight for Guitry junior, who was thunderstruck following his first meeting with Yvonne, appearing to him in her dressing room like an angel. A potential setback—Yvonne's lowly origins, perceptible in her casual speech patterns—did not deter Guitry, who explained later in *The Illusionist*: "There are no differences and no classes among those who tread the boards. There are good ones and bad ones, and that's it." On her side, the rising young star was impressed by an individual who seemed far friendlier that his reputation might lead her to believe, and a few weeks later, she was engaged by Guitry at the Théâtre des Variétés, learning extracts from a selection of operettas. Yvonne, however, was sworn to another, and was passionately in love with Georges Guynemer, a young fighter pilot and hero of the dogfights then illuminating the city sky. Guitry started to court her, showering her with bouquets and love letters. By mid-April 1916, Yvonne seemed to have yielded to his increasingly insistent and passionate advances, without relinquishing her pilot. Her heart swung back and forth between the heroic aviator and stylish thespian, with Guitry writing to her daily, until fate made up her mind for her.

On September 11, 1917, the flying ace was shot down from the sky. For a time afterward Guitry enjoyed a monopoly over Yvonne's heart, with her role as theatrical muse becoming more significant, while he in turn adopted the part of a Pygmalion figure—as these grandiose lines from their correspondence testify: "Not for an instant do I think of you as a woman. . . . You know how, before embarking on a picture, great painters produce a sketch? And you know how it sometimes happens that they do the sketch and never paint the picture? You must know. But do you know that in the oeuvre of the greatest artists, these sketches tend to be the most moving, brilliant, and uncontested statements of their genius? Well, you are such a sketch. . . . You have all its charm, lightness, grace, and freedom. One doesn't correct sketches, and I think you cannot be improved. You are the sketch for a picture, for a woman, that ought not to be made!"

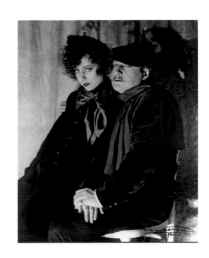

Yvonne Printemps and Sacha Guitry in *La Revue de Printemps*, written by the latter in collaboration with Albert Willemetz, at the Théâtre de l'Étoile in 1924.

Facing page:
Yvonne Printemps and Sacha Guitry during their sojourn in London in 1929. Photographs of their everyday life parallel those taken during performances: their poses and expressions tell of a couple that was never "off stage."

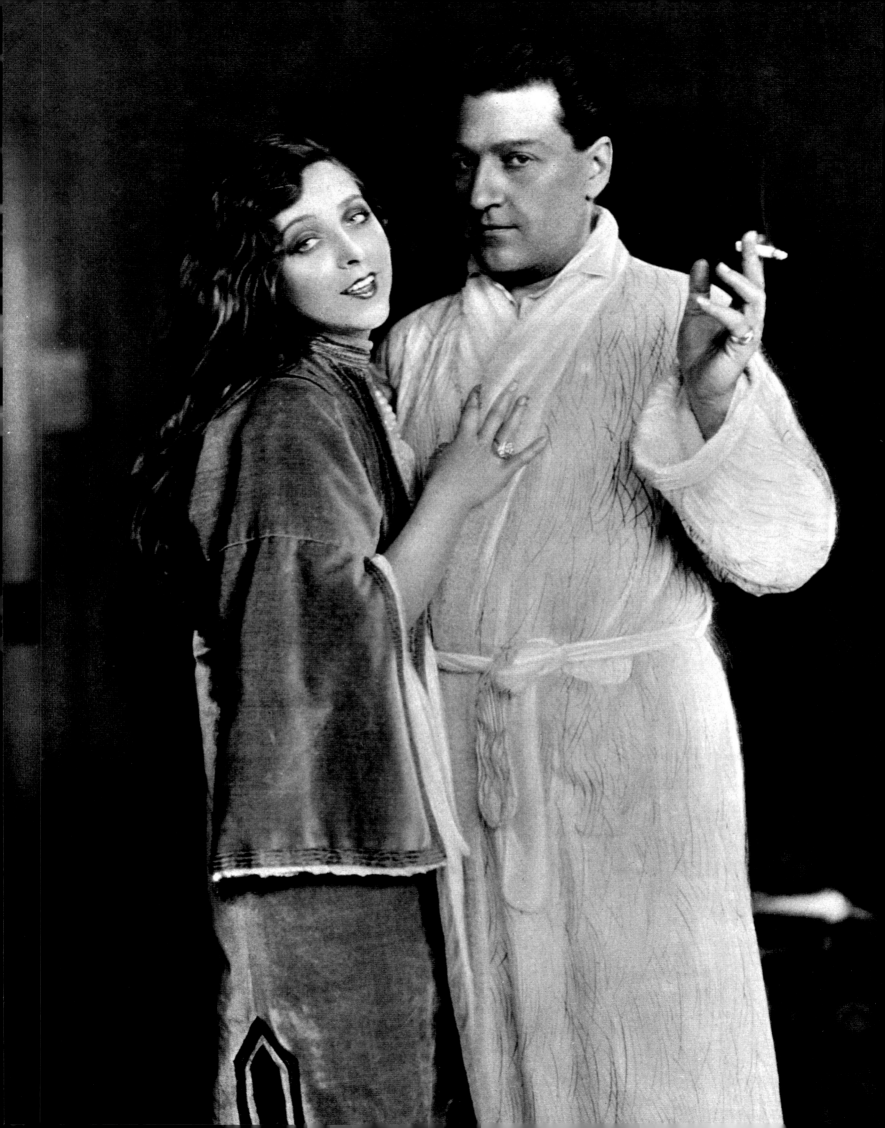

A nightingale in a gilded cage

The betrayed and all-too-aware wife, the husband, and his mistress all appeared for a time on the same stage for *Jean de La Fontaine*, before the superfluous member of the trio pulled out. The Guitrys finally divorced on July 17, 1918. That same year, and once again together with Albert Willemetz, Guitry wrote *La Revue de Paris* for Yvonne. Successively she played the roles of "Fantaisie"; one of Degas' little dancers; Manon Lescaut; a "tax on luxury goods"; a refugee escaping the war and, to cap it all, the "Spanish Flu," then scything its deadly path through Europe. In spite of Guitry's already very obvious jealous nature, barely had they begun living together than Yvonne accepted his proposal of marriage. On April 10, 1919, with as witnesses the crème de la crème of theaterland—Sarah Bernhardt, Georges Feydeau, Tristan Bernard, and Lucien Guitry—the couple married in Paris, in the town hall of the elegant sixteenth arrondissement. Slowly but surely, as other artistic collaborations followed, Guitry tightened his grip on his wife, forbidding her to dance at soirées, preventing her from venturing out alone in the street, from shopping, or going for a walk, insisting she was always accompanied by his chauffeur, and, even when taking a break at the beach, only reluctantly agreeing to let her go for a swim. Once the ring was firmly on his wife's finger, the tremulous lover transformed into a tyrannical and jealous spouse, choosing her jewelry, furniture, and cars, and sticking to her like a leech. If Yvonne did not need encouragement to seek solace with somebody else, her husband's insane possessiveness could hardly have helped. The first pair of arms into which she fell—of those known to history at least—belonged to the photographer and painter Jacques-Henri Lartigue.

Out and about: onstage and out on the town

In his biography of Yvonne Printemps, music historian Claude Dufresne suggested the following theory: "Did Sacha derive a sort of morbid pleasure from transposing episodes from his love life onto the stage? He relapsed into the habit often enough and seems to have taken pleasure in unpacking his life in front of an audience." Guitry certainly possessed exhibitionist and narcissistic tendencies, as well as a malicious streak. In mitigation, this weakness might be seen as a form of infantile emoting: thus, the line between public and private became blurred in his quest for literary fame (or at least for what he considered literary fame). Or perhaps, even—in further exoneration—his megalomania led him to siphon off material from his private life as a source of "creativity"—a drive clearly more imperative for him than any other. There are plenty of examples of

Guitry and Printemps created the illusion that their life was one long party. In this carefully stage-managed existence, their attire played a significant role. Each of Sacha Guitry's five wives was assigned her own couturier: for Yvonne Printemps it was Lanvin.

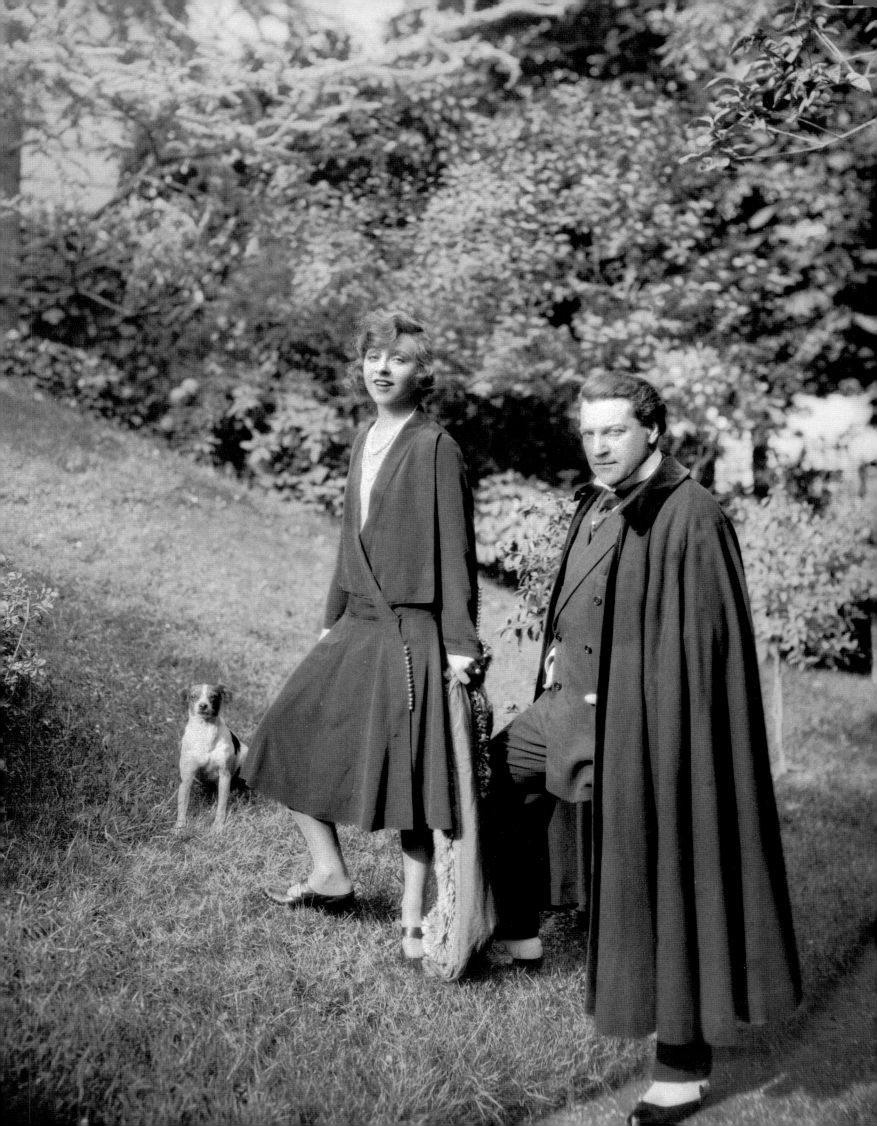

this tendency throughout his life. As if it were already written in the stars (and without malice aforethought on his part), symbolically speaking this ambivalence between fiction and reality had been in evidence from the very outset of his career—in the title of the show *Il faut l'avoir*. During their very first collaboration, it was Yvonne who the playwright was doing everything in his power to "have." The show *Jean de La Fontaine* cited words and sometimes whole phrases from their correspondence—from the time he would gaze open-mouthed at the miracle of femininity that was Yvonne and their affair had to remain a secret. In *Le Mari, la femme et l'amant* ("The Husband, the Wife, and the Lover"), written in 1918, the husband says of women: "You will always be unfaithful. You have a gift for it and you do it wonderfully. The two-timing telephone call, the word spoken as one door closes and another opens, and every lie on earth— that's what you're best at!" He would soon experience this exact situation in his personal life. Once married, Yvonne naturally played the female

Yvonne Printemps, Sacha Guitry, and a group of friends at a concert, on June 8, 1928, during their stay in London.

A still from Yvonne's debut feature in 1918, *Un roman d'amour et d'aventures* by René Hervil (the original footage is no longer extant); the script had been written by her partner and they were to marry the following year.

leads in her husband's comedies. For *Faisons un rêve* ("Let's Dream") in 1921, she took the part of the wife—just as Guitry's first spouse had—and just as his third, Jacqueline Delubac, was to do in a screen version in 1936. A triumph at the Théâtre Édouard-VII in 1923, the operetta *L'Amour masqué* ("Love in a Mask"), which was to have been called *J'ai deux amants* ("I've Two Lovers") had striking parallels with the early days of their romance. In a libretto Guitry had written especially for her, Yvonne took the part of a self-seeking, unfaithful wife. Adding insult to realism (in an "operetta-*vérité*"), Yvonne deceived Guitry during the run of this very play—this time with an up-and-coming actor who was thereafter to enjoy a successful career in the movies: Henry Garat. He resurfaced in *L'Accroche-coeur* (also known as *Riviera Express*), a film by Pierre Caron that came out in 1938, based on the play of the same name by Guitry in which (by yet another improbable coincidence), Jacqueline Delubac played the female lead.

But to return to *L'Amour masqué*; it is a piece laden with innuendo. It is hard, for instance, not to see the following lines—which in passing point up the heroine's lack of education and lower-class background—as a portrait of Yvonne: "People like to say about her: 'It's true, / She's no / Bright spark, / Her chin's a touch out of true, / Her blue eyes have a greenish tinge, / She's this, she's that . . . / And I reckon she's a real ignoramus . . . / Of course, of course, but, but, /—She's *so* cute!'" Critics praised Yvonne's performance,

which made her name as an operetta star. In 1924, the title of Guitry's stage tribute was an obvious pun on the singer's name: *Revue de Printemps*.

Freedom!

While Sacha knitted his brows, Yvonne pursued her adulterous adventures with impressive panache. Tensions continued to rise. In fits of jealous rage, Guitry would threaten to imprison Yvonne; during a tour of the United States, he actually locked her in her room. The couple was clearly on the rocks—they started occupying separate bedrooms in 1926—but Guitry seemed to prefer this than to agree to a final separation. Onstage, however—and on the social round through which they glided ostentatiously—their official image was one of togetherness, laughter, and harmony; born actors, they were never truly offstage. Such artificiality compounded a true-life situation that itself bordered on illusion: after all the smoke and mirrors, the denouement was bound to be dramatic. By now international successes and prisoners of their image as the ideal couple (a composite of artiness, humor, anecdotes, and luxury, they had become a kind of mascot for the French and, more particularly, Parisian identity), the two protagonists found themselves trapped in the personas they had created. Guitry was still in love with Yvonne; and she shilly-shallied, finding it hard, despite everything, to throw off the dual yokes of domination and security he provided. In 1927, however, Guitry took on a young actor, Pierre Fresnay, for a part in *Un miracle* at the Variétés, a play in which Yvonne did not appear. It was Fresnay who would play the role of the real-life prince charming and rescue her from the clutches of the rapacious ogre that was her husband Guitry, who continued to air every detail of their separation and subsequent score-settling (jealousy, regret, betrayal, farewell) in his work, up until the end.

At the beginning of summer 1932, Yvonne left the marital home definitively to embark on another life, far from fashionable frivolities. Although deeply hurt, Guitry did not take long to find a replacement muse in the person of Jacqueline Delubac, who became his wife in 1935. Young enough to be Guitry's daughter, she was to play in dozens of his plays and in eleven films, as did Geneviève de Séréville, who was to succeed her in 1939, and Lana Marconi, his fifth (and final) wife. However, all the later women, who became actresses after meeting the playwright, were less resoundingly successful and historically significant than Yvonne, who holds the record for parts played and who was surely the most important of all the women who inspired Sacha Guitry.

Playbill for *L'Amour masqué*, a three-act musical written by Sacha Guitry with music by André Messager, and performed by Yvonne Printemps at the Théâtre Édouard-VII in Paris in 1923.

Facing page:
Yvonne Printemps in the countryside one summer morning in the 1940s. Anatole France encapsulated her in a single phrase: "She is Gavroche [street urchin] and the Lady of the Camellias rolled into one."

Lili Brik

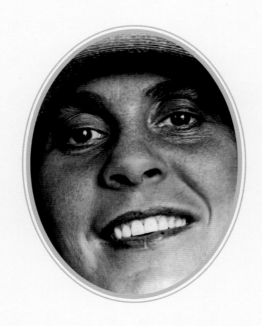

Mayakovsky's muse and mentor

Portrait of Lili Brik by Alexander Rodchenko (detail), in 1924.
A good friend, the celebrated constructivist artist often photographed Lili in the 1920s, incorporating her image into geometrical and abstract montages, and thus turning her into an icon of the Russian avant-garde.

Arriving like pilgrims to worship her memories, visitors to Lili Brik's dacha in the 1970s could not fail to observe two gold rings hanging from a chain round her neck. Those who were aware of the story of her legendary relationship with Vladimir Mayakovsky knew that she had worn them constantly since his tragic death in 1930, the couple having exchanged them fifteen years before. Each bore the other's initials: the one belonging to the futurist poet was engraved with the name "Lilya," while hers was inscribed "*L-Iu-B* [Liublu] *Volodya*"—"I love Vladimir" in Russian. In a farewell letter written two days before fatally shooting himself in the chest on the morning of April 14, 1930, the poet had pleaded: "Mother, my sisters, my friends, forgive me, this is not the way (I recommend it to no one), but there's no other possible way out for me. Lili, love me!" Lili Brik followed this final injunction to the end of her days, for she did not just wear his ring; she also devoted her existence to promoting the work of "the poet of the Revolution," as he was called by Stalin, some of which was dedicated to her and in which she had played such a significant part.

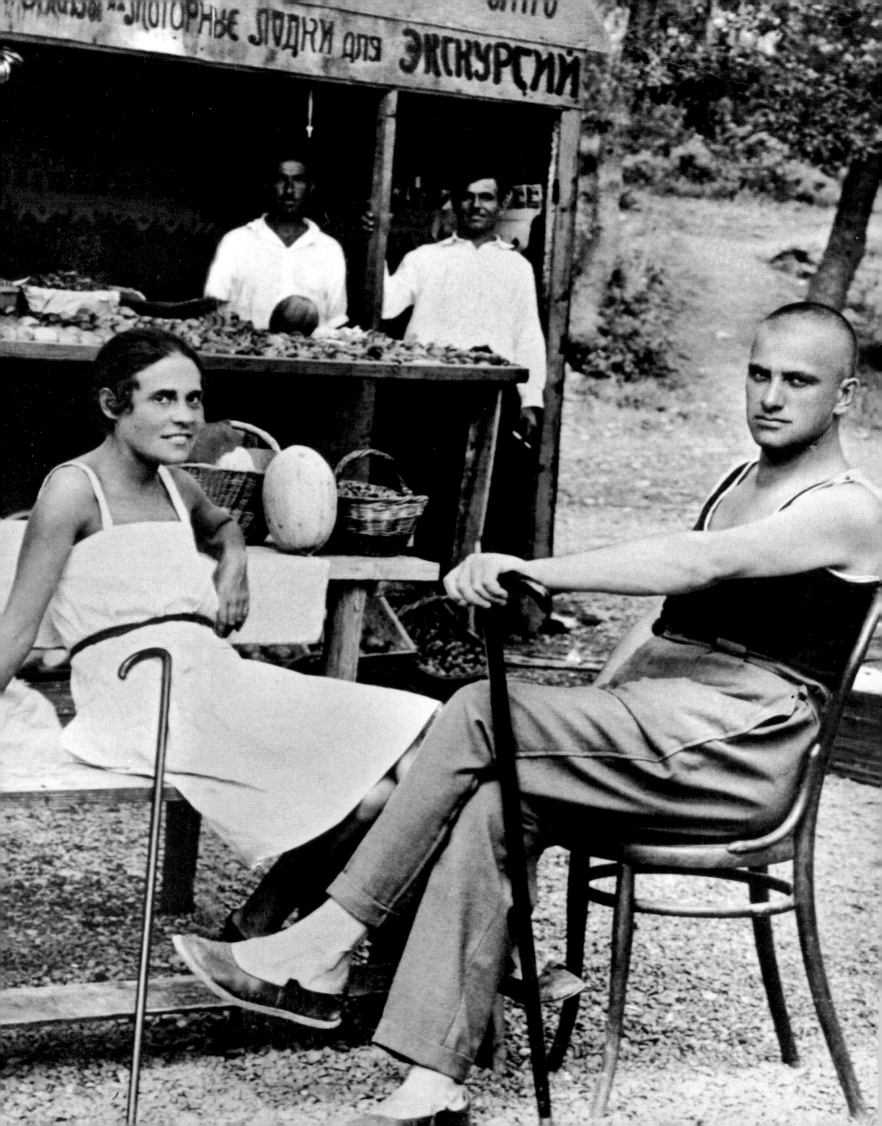

Lili Brik with Raisa Kusner and Luella Krasnoshekova in 1924. Photograph by Alexander Rodchenko.

Facing page:
Lili Brik and Vladimir Mayakovsky in Yalta, summer 1926. Still close at this time, they had nevertheless embarked on other love affairs. Up until his suicide, however, Lili would continue to wield considerable influence over the poet.

"A Cloud in Trousers"

Lili (Lilya) Brik, *née* Kagan, was born into a cultured Jewish family on November 11, 1891. Her father, a lawyer, was a stalwart of literary and artistic circles, while her mother, after studying at the Moscow Music Academy, devoted her time to bringing up her children. Five years after Lili, her sister Elsa was born—the future novelist and companion of Louis Aragon, Elsa Triolet. Lili acquired her enthusiasm for innovative art at a very early age, meeting Osip Brik when just thirteen. After several affairs (one of which led to a backstreet abortion that left her sterile) Lili married the budding writer in 1912. Two years later all desire in their marriage had evaporated, though this did not prevent them sharing a life enriched by intense intellectual understanding.

In 1913, her sister Elsa in Moscow became involved with a dashing young poet named Mayakovsky. Two years later, she introduced him to Lili, who at first was not especially keen on this larger-than-life show-off, nor on the poetry he made her read. Sometime later, after the funeral of their father and as the liaison between Elsa and Mayakovsky was petering out, the poet visited the Briks in Moscow. It was at this time that he declaimed his great text, "A Cloud in Trousers." As Lili Brik was to later write: "We couldn't take our eyes off this miracle. Mayakovsky struck a pose and held it throughout the recitation, his eyes lost in space. He beat his breast, waxed indignant, begged, put on airs, played the hysteric, and let the pauses speak for themselves." The assembled spectators were enthralled: all recognized themselves in every verse. Lili was thunderstruck. That same evening, the poet dedicated the much-admired text to Lili, having decided that evening to abandon all his other affairs for her. Osip agreed to fund the printing of a thousand copies of the poem no publisher would touch. The entire group lent a hand, with Lili at the helm. When the book left the printers, Lili copied out by hand the passages that had been cut by the czar's censor. Her own copy was luxuriously bound, like a saint's relic. This was just the first in a long line of texts written for Lili, such as "The Backbone Flute," "Don Juan," "Man," "Mystery Bouffe," and "War and the Universe," as well as entire collections. Thereafter, Lili's influence increasingly dominated Mayakovsky's work.

Along with the equally fascinated Osip, all three engaged with the lively artistic and literary current of the time, immersing themselves totally in every facet of the avant-garde. If the growing passion between Lili and the poet left Osip unmoved, the same cannot be said of Elsa, who was still in love with Mayakovsky. It was not until 1917 that she embarked on a new love affair with a French officer on mission to Moscow, André

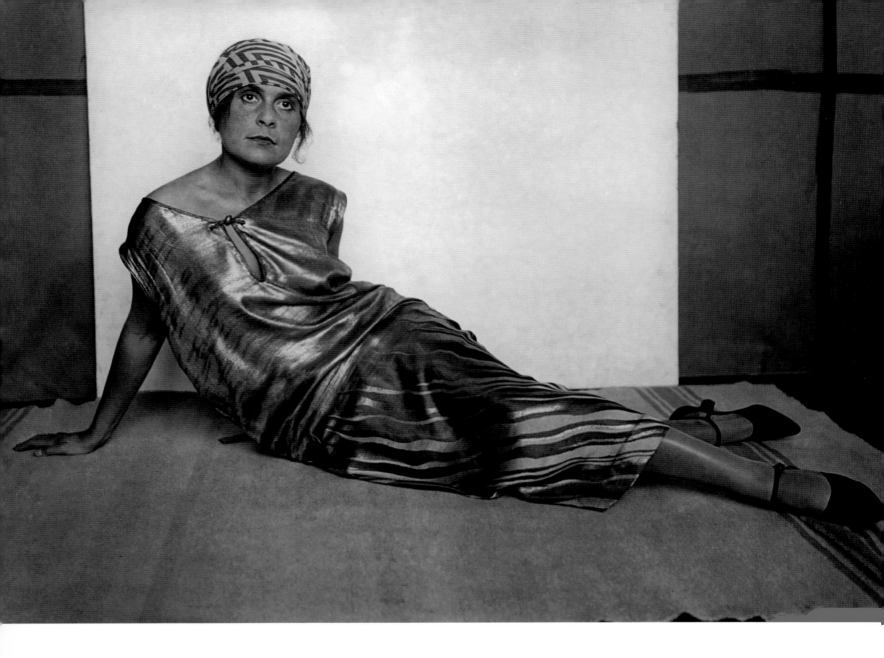

Triolet. Shortly before the October Revolution (a further influence in their story), Lili and Mayakovsky founded a politico-artistic group, which attracted many of the major talents of the era. Mayakovsky had a history of political militancy: his Bolshevik tendencies led him, in 1908, aged fifteen, to join the Russian Social Democratic Labour Party, before being elected to the Moscow Committee. He was arrested on several occasions and spent eleven months in Butyrki Prison, but, being underage, was not deported.

In 1918, the writer, now involved in a string of love affairs, agreed to write a film for Lili at her request. The resulting film, *The Captive in the Film* remains unfinished. Early reels, later destroyed in a fire, told the tale of a ballerina—a movie heroine—who bewitches a painter with a gift for seeing into a woman's true soul (in 1918, Lili had thought of beginning a career as a dancer). The fictional ballerina character stepped out of the screen to live with the artist. Mayakovsky and Lili played the roles, a veritable *mise-en-abyme* of the artistic incarnation of the muse. Finally, the young dancer had to abandon her suitor and return to the land of enchanted dreams.

Lili Brik posing for Alexander Rodchenko in a gold lamé gown in 1924. Several pictures from this session are known. The Bolshevik Revolution was an era of upheaval in the arts that foregrounded modernity, abstraction, and new technologies, as exemplified by the work of Mayakovsky and his peers.

February 28, 1923, at 3 p.m.

Pooling their resources, Lili, Osip, and Mayakovsky settled in Petrograd. Lili spent her time running up and down the stairs, since Mayakovsky rented a servant's room above the Brik apartment. In March 1919, they returned to Moscow and all three, plus the new addition of a puppy, shared a one-room apartment . After a few months, Lili could not bear everyday life with Mayakovsky, whom she regarded as "petit bourgeois," and the atmosphere turned poisonous. Mayakovsky left the apartment, though the relationship limped on. In 1920, Osip Brik was named legal consultant to the Cheka, the organization charged with stamping out "counter-revolutionaries." During the Red Terror cruelty was the order of the day and more than one hundred thousand people perished. This demands the question: how can sincere and cultured individuals slide unconsciously into ideologically driven horror? Osip never sought to conceal the atrocities he witnessed and the subject was sometimes broached at artistic soirées.

From this period on, and in parallel with artistic activities under the aegis of the ROSTA telegraph agency, Lili and the poet began a dubious sideline in intelligence work, especially when on trips to Western Europe. Buoyed by the Bolshevik Revolution, Osip, Mayakovsky, and Lili initiated a "cultural-ideological current" they called the "Communist Futurists." Known as the "Komfuty," it was in their name that Lili—whose ambition and drive for success remained unhindered by her egalitarian pretensions—suggested dispatching a copy of Mayakovsky's most recent collection, *150,000,000*, to Lenin in person. But the dictatorship of the proletariat had no interest in the arts and the piece was stigmatized by the president of the Central Committee as a "farrago, [of] monumental and pretentious idiocy."

In the decades to come, purge after purge destroyed all lingering hope of the artistic revolution Mayakovsky yearned for. At the end of 1922, after trips to Paris and Berlin, the couple was struck by a new crisis. Lili maintained that their daily routine was marring the authenticity and truthfulness of Mayakovsky's writing. As a remedy, she stipulated that they should separate for exactly two months—that is, until 3 p.m. on February 28, 1923. On that day, the plan was to go together to Petrograd by train. The distraught Mayakovsky tried unsuccessfully to get round the diktat, sending Lili letters and attempting to visit her house, but she was already seeing someone else. He spent his time in the wilderness writing "About This," a dystopia on the future of love. In one of the missives addressed to Lili during the enforced absence he wrote: "On the 28th you will see before you an entirely new man." As for his poetry, Mayakovsky,

was true to his word: hardly had they taken their train seats on the day of their reunion than—"transported" in every sense of the word—he began reciting his most recent piece, before breaking down in tears. As Lili later described the scene: "More than once, during those two months, I had reproached myself for leading a normal life while Volodya was suffering all alone. I went out, I saw lots of people. Suddenly, in this train, I felt happy. The poem I had just heard would never have been written had I not treated Mayakovsky as my ideal, and an ideal for all humanity. These are grand words, I realize, but they were the truth at that moment." The "truth at that moment" reappears on Lili's face in a photograph by their friend, the celebrated Alexander Rodchenko, in her saucer eyes staring out at the reader from the cover of the first edition of "About This" published that same year. Aware that her companion's talent transcended the idealism it expressed, she managed to convince Mayakovsky, who rejected recognition and success as "bourgeois," to hand over the manuscript and drafts of the poem. Thus, to the immeasurable benefit of future students of literature, if hardly in keeping with the artist's iconoclastic attitude, the muse began building the Mayakovsky archives of tomorrow.

"Lili, love me!"

The Briks and Mayakovsky were once again living under the same roof. Then in 1924, the latter set out on a whistle-stop reading tour of Russia, before returning to Paris. He dreamed of visiting the United States and made his way there via Mexico. Once in the New World, the poet embarked on a string of love affairs (including one with Elizabeth Siebert, who, though she gave him a child, never really supplanted Lili), while Lili herself became involved with filmmaker Lev Kuleshov.

Back in Paris in 1928, Mayakovsky started a new adventure with a twenty-two-year-old Russian called Tatyana Yakovleva. Unlike so many of his other affairs, theirs left an enduring mark on his oeuvre. Until Tatyana, Mayakovsky's work was dedicated only to Lili, but now, to the latter's consternation, a rival muse rose to prominence. In January 1929, Mayakovsky published a lengthy poem, "A Letter from Paris to Comrade Kostrov," inspired by Tatyana: "Love is no delightful paradise, / love is when it blows through you / and when the rusty engine of the heart / ignites anew." Eventually, however, Tatyana, too, ended her relationship with Mayakovsky, probably because of pressure from Lili. At the end of the year Lili organized a major exhibition devoted to the artist, which was hailed by Stalin during an evening dedicated to the anniversary of Lenin's death, although some Party officials were less fulsome. Lili then

Above, top:
Photomontage and photograph by Alexander Rodchenko of 1926 used as an illustration for Mayakovsky's poem "Pro Eto" ("About This"), written in 1923.

Above, bottom:
The montage *Books*, realized in 1925 from a photograph of Lili taken a year earlier by Alexander Rodchenko. The enduring attraction of this image is proved by the fact it was reused in 2005 to illustrate a CD cover by post-punk band Franz Ferdinand.

introduced Mayakovsky to an actress, Veronika Polonskaya, whom he pursued assiduously, in spite of a nervous breakdown during which he became prey to outbursts of violence. Long dogged by the specter of suicide, Mayakovsky ended his days in April of that year, while Lili and Osip were in Amsterdam.

Remote and possessive, thoughtful and passionate, independent and, in her own way, faithful, Lili was to state later, "Many years have passed since Volodya's death. 'Lili, love me!' I do love him. Every day he speaks to me through his poems." In 1978, suffering from a terminal illness, she, too, committed suicide.

Lili Brik at the Plaza Athénée Hotel, in Paris, in 1976, two years before she killed herself and some forty-eight years after the suicide of Mayakovsky.
Photograph Martine Franck.

Gala

The apple of Dalí's eye

In 1913, in a sanatorium at Davos in Switzerland, a young Russian woman known as Gala (real name, Ivanovna Diakonova) met the Frenchman Eugène Émile Paul Grindel. In two years he would become better known as Paul Éluard, but at the time of their meeting the budding poet was just eighteen years old, the feisty Slav a year older. The pair shared a passion for literature and soon fell for one another. Gala had been born into a cultivated, music-loving Muscovite family, although the identity of her father remains uncertain. A brilliant pupil, she became subject to nervous disorders at an early age and never managed to rid herself of her aggressive impulses. Wholly convinced of her fiancé's talent and calling herself his "disciple," she wrote a foreword under a pseudonym to his debut collection of poetry, *Dialogues des inutiles*. The couple married in 1917, while Paul was in the army; their daughter, Cécile, was born a year later. However, Gala quickly abandoned both the infant and the monogamy of her marriage. Éluard was himself unfaithful and flighty, accepting and even sometimes abetting his wife's affairs in the name of a peculiar conception of personal freedom; he thought nothing of sharing Gala with the German painter Max Ernst, who left his family to live with the couple in 1924. Together with other betrayals, this fatal triangle prepared the ground for a breakup that came to pass in 1929, the year Gala met the decidedly promising Salvador Dalí. Long after they separated, the inspirational power of his first wife remained evident in Éluard's work and, elevated into the icon of a great lost love, she was sanctified in many verses.

Detail of a photograph of Gala from the 1950s.

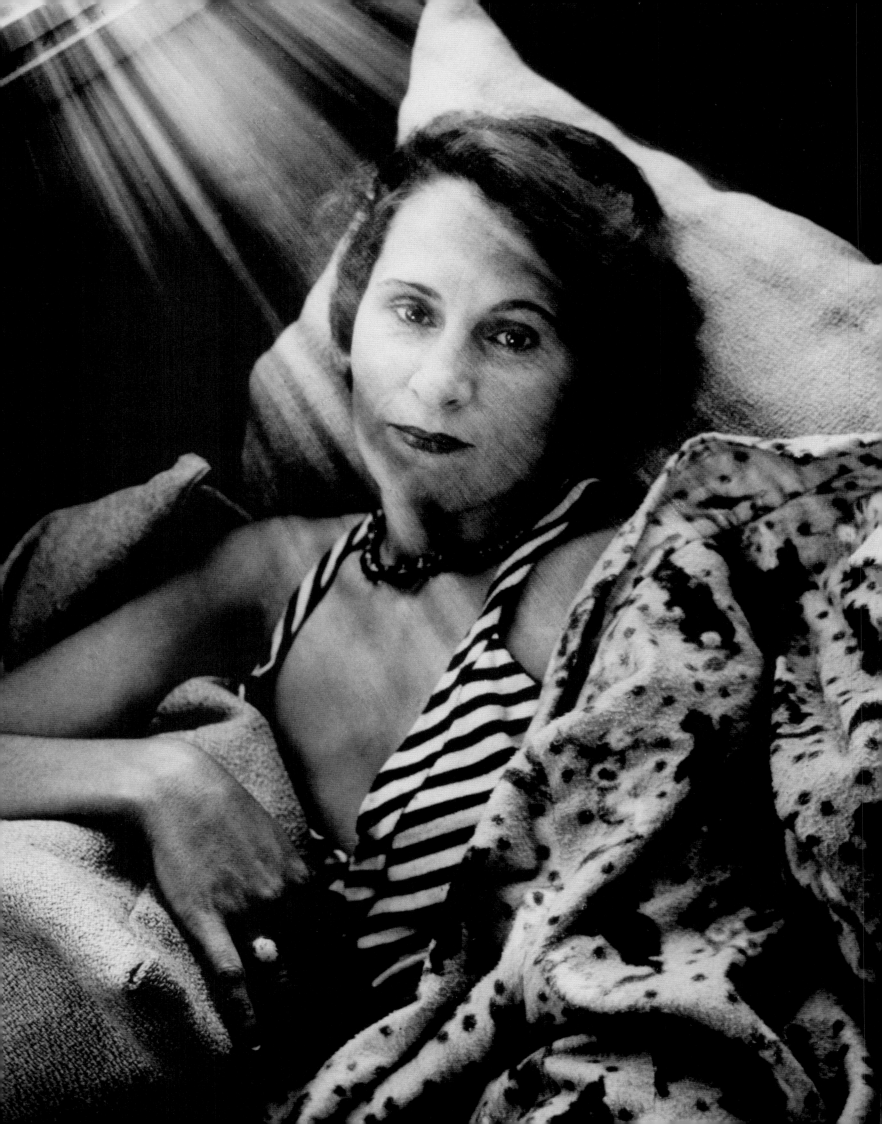

Leda Atomica. **Salvador Dalí considered this oil on canvas of 1949 a key work. As in other paintings drawn from Greek mythology, Gala posed for days on end before the master's easel, often unclothed.**

Facing page:
Portrait of Gala by Brassaï, c. 1932–33.
The writer Anaïs Nin said of her, "She blithely assumed we all were there to serve Dalí, the great, the indisputable genius."

Surrealist initiator

Dalí was born into a notable family from Figueras, a small town in the Spanish province of Catalonia, in 1904. In 1926, he discovered the work of the surrealists, whose interest in dreams and automatism chimed with what was his already unusual outlook. Three years later, he had carved out a place for himself as a leading artist in the movement, thanks to his paintings and a film, *Un Chien andalou*, co-written with Luis Buñuel. That summer Dalí invited some of the members of the movement (gallery owner Camille Goemans, René Magritte, Luis Buñuel, and the Éluard family) to Cadaqués. Dalí and Gala met for the first time over aperitifs in a local hotel. It was not an auspicious beginning, however: Gala found Dalí's attitude absurd and his manner effeminate. As Dalí recounted, the next morning, in a desperate bid to attract Gala's attention, he shaved and painted his armpits blue, cut holes in his shirt, plastered himself with fish glue and goat excrement, hung a bead necklace around his neck, and stuck a sprig of jasmine behind his ear. Gala, highly amused, was far from put off by Dalí's getup and, as the artist described it, "the very next day, as her laughter subsided, she took my hand. Then she said to me gravely: 'My little one, let's stick together,'" and promptly ousted Dalí's sister as muse. She also rid the artist of his penchant for autoeroticism and masturbation. With his phobia of venereal disease, up to that point the painter had lived in a world without women. (Certain historians contend, however, that he had had a liaison with the poet Federico García Lorca during World War I—an allegation he denied.) After some initial misgivings, the relationship with Gala took a decidedly sexual turn, revealing uncharted horizons. Thus did Dalí discover that he was, in his words, "normal."

If Éluard accepted their dalliance without batting an eyelid, the same could not be said of Dalí's family, and his father cut him off. Did Gala even then sense the inchoate and possibly still malleable potential for genius of her lover? Though others disagree, the psychiatrist and critic Pierre Roumeguère believes so: "She met a pathetic invalid and she was going to create one of the greatest personages of the time—along with Picasso— literally inflating herself with Dalí's personality while all the time filling his, because—though she has been much criticized—I personally believe that she is the source of his life, his mother, sister, inspiration, wife, lover." This is all open to question: one can also see Dalí, whose acute intelligence was quite beyond doubt, as a man conscious of his weaknesses and of his priorities, as well as of the help a woman like Gala could offer him. Thus, while she played the essential role—by providing material perfectly adapted for the art of the chimerical artist and by acting as a buffer

zone between his magnum opus and the public—in the end they were, miraculously, made for each other.

When later they moved to the United States, she also acted as his translator, providing English-speaking specialists with keys to the interpretation of his pictures. One of Gala's more recent biographers, Bertrand Meyer-Stabley, has rightly said of Dalí, a man far less unhinged than might first appear, that he "takes from surrealism—and perhaps this should itself be seen as provocative—the very interpreter he needed. It is Gala who will remain the intermediary—essential and polymorphic. Thanks to her, to the love they constructed together, continuity is assured between Dalí's creativity and the mechanisms of his imagination. There is rigor too, and structured organization: the need for a medium, the discovery of a medium, the systematic use of a medium." Whatever the reality behind this intricate situation, nothing could tarnish their mutual adoration. Some time after they met, the couple withdrew for a few weeks to a hotel in the south of France away from prying eyes. Referring later to the life they shared at Port Lligat, Dalí was to say that they "were clamped one to the other like two cancers, one in the stomach, the other in the throat of Time." And yet this was how they spent more than half a century together.

Gala, artistic mentor

Dalí contended that "it is Gala who unearths and brings me all the essences I transform into honey in the hive of my spirit. Without Gala, the world would have no genius at this time: Dalí would not exist." Soon, he dubbed her his "Gradiva," after a bas-relief of a woman from antiquity and the name of a character in a novel published in 1903 by the German writer Wilhelm Jensen. It concerns an archaeologist who becomes obsessed with the figure to the point that she enters his life in a dream. Dalí painted Gala in this guise in many canvases: in *William Tell and Gradiva* and in *Gradiva Finds the Anthropomorphic Ruins,* both in 1931. His autobiography, *The Secret Life of Salvador Dalí,* published in 1942, bears the dedication "To Gala Gradiva, she who advances" (the translation of her moniker from the Latin). They began building their home in Port Lligat in August 1930. In a patch of cement at the end of the road along the seashore appear the hand- and footprints of Gala, the "divine protein" of the whole architectural enterprise. She was to have a say in every aspect of the creative life of the artist, who was soon to become her husband. (The civil ceremony was held in 1934, while the church wedding took place some twenty-four years later, as if the couple was to be born again through its solemnization.) Gala acted as his assistant, supporting him, reading aloud to him in the studio,

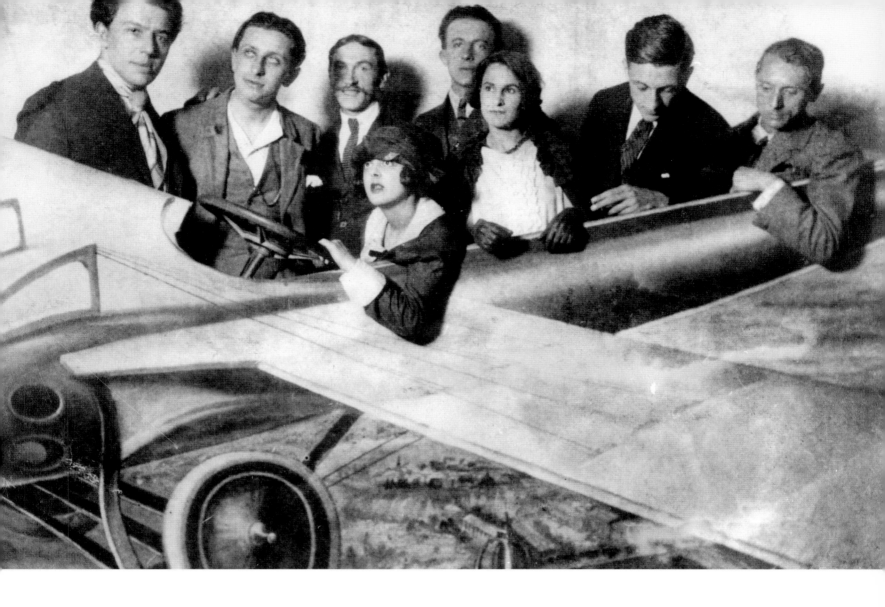

choosing frames, keeping his spirits up, and furnishing the master with all kinds of materials—overseeing his writings, even. Her eyes in a photograph by Man Ray appear on the cover of Dalí's book, *The Invisible Woman* (1930). These are the eyes Éluard described as being able to see through walls (although his expression, *"perceur de murailles"* also has connotations of thievery). Gala exercised a significant role in the transitions between the painter's various periods and creative paths. She was, for instance, key to his break with the surrealist movement in 1934. Generous with details regarding Gala's role as a muse, Dalí declared that she loved painting more than painters, and that the first thing a decent artist aspiring to create authentic masterpieces should do was to marry her. When she was asked one day what place Dalí occupied in contemporary art, she answered straight off, "He is at the very top, the greatest of all." And, standing next to her, Dalí added, "I agree."

In the Dalí counting house

While still with Éluard, Gala had already made some clever investments in paintings and ethnic artworks, often traveling to view them herself and arranging deals that suggested an element of financial speculation. Their friend, the surrealist poet René Crevel, often acted an intermediary between the Dalí-Gala tandem and aristocratic art lovers. The Prince of

Gala and the surrealists "in" an airplane. This marvelous photograph of the artistic family was taken at a fairground in about 1925. At this time, Gala was married to the poet Paul Éluard. From left to right: André Breton, Robert Desnos, Joseph Delteil, Simone Breton, Paul and Gala Éluard, Jacques Baron, and Max Ernst, who, with her husband's blessing, had an affair with Gala.

Faucigny-Lucinge, a major collector, noted Gala's liking for lucre, adding that, in her eyes, "Dalí had the look of a gold mine and she didn't want *that* to slip through her fingers." They also became friends with the Viscount of Noailles and his wife—a very wealthy and influential couple in 1930s avant-garde circles. Tireless and methodical, Gala dealt with every aspect of the painter's everyday and professional existence: household duties, accounts, shopping, and correspondence, as well as developing a network of contacts for sales and exhibitions. She oversaw the negotiations and for years did her utmost to raise Dalí's "profile" on the art market. As the photographer Brassaï averred: "she took up the 'Dalí phenomenon', and his dazzling success is chiefly her doing. A remarkable businesswoman, it was she who framed and signed the contracts." In a way, the situation must have suited the artist, as he could thus spend all his free time relentlessly pursuing his work, often at a frantic pace.

"She was the source of his life, his mother, sister, inspiration, wife, lover."
Pierre Roumeguère

Early on in their career, in an effort to make her companion's work more widely known among Parisian galleries and collectors, Gala had been the brains behind a series of "spinoffs" born of Dalí's madcap imagination, including, for example, kaleidoscopic glasses or false nails. If this forward-thinking idea initially met with limited success, the couple's marketing strategy involved maintaining a delicate balance between appealing to the aristocracy (with its foible for eccentricity) and to the nouveau riche alike. In 1934, while they were still in straightened circumstances, the offer of an exhibition provided them with the opportunity to visit New York. There, rubbing shoulders with billionaires and throwing sumptuous surrealist or just plain offbeat parties, their situation improved and soon the days of financial insecurity were over. Dalí's provocative style and imagination, his disguises and moustache, became the trademarks of a recognizable brand that was soon exploited to the hilt. Intervening in fields as diverse as film, illustration, fashion (Dalí designed neckties), and opera, everything formed part of a money-making machine in which the preferred manner of payment was hard cash (Gala had a peculiar mania for walking about with suitcases bulging with dollar bills). Orchestrated by Gala, but with Dalí's approval, the anarchic and most surrealistic of the surrealists (and diehard fan of Lanvin chocolate) morphed into a brand name, while, on the political level he began to voice a fascination with pro-Franco fascism.

Gala and Dalí met under the aegis of surrealism: on their very first date, Dalí appeared adorned in a miscellany of bizarre objects. Dalí not only accepted but amplified the sway Gala later exerted over him, placing her at the center of his art. Photograph from the early 1930s.

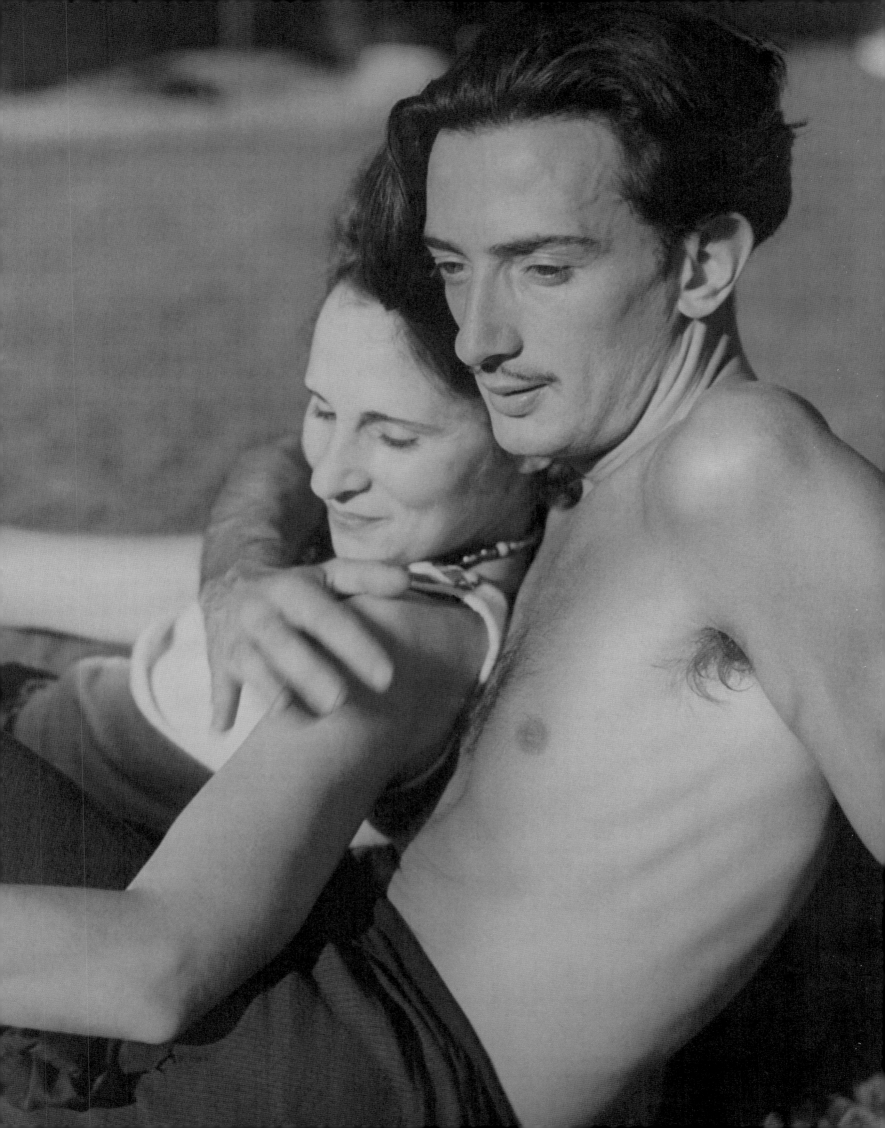

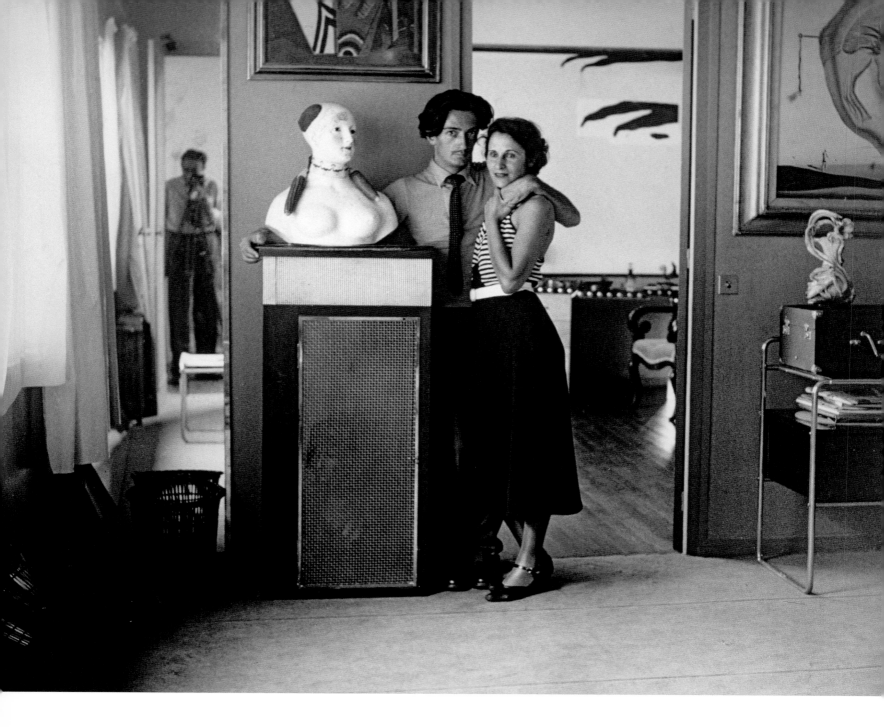

Mother and healer, witch and liberated woman

Early on in their relationship, Gala succeeded in calming Dalí's outbursts, his doubts, and paranoid fears. She was "the healer of terrors, the conqueror of [his] deliriums, the loving lover of [his] vertical forces." She even managed to liberate him from a still deeper trauma, the recurrent obsession with a dramatic event. This was the premature death of an elder brother (whose first name he inherited), a kind of double that needed to be eliminated. He was, as Dalí explained, "Castor and I was his Pollux, I became his shadow. She returned me to the light by the love she offered me." She protected him, cured him from a sort of impotence, conserving this consoling, discreet role and reining in the exhibitionist and megalomaniac outlandishness to which Dalí remained vulnerable throughout their life. After an initial phase of alleviating, deeply felt love, the painter— thanks to the maternal support of a woman who proved so unmotherly to her own offspring and

Gala and Salvador Dalí in their Paris studio in the Villa Seurat by Brassaï, c. 1932–33. As Dalí observed in typically cryptic vein, "One of the secrets of my influence has always been that it remains a secret. The secret of Gala's influence was that it is kept doubly secret in its turn. But I had the secret of remaining secret. Gala had the secret of keeping secret in my secret with me. People often think they've discovered my secret: wrong! It isn't mine, but Gala's!"

whose personality appeared paradoxically masculine—came into his own. Many contemporaries noticed the great change affecting the painter, remarking how he was now less indecisive, less awkward.

More than one surrealist saw Gala as an outright menace; the by poet Philippe Soupault called her "the Pest." Victor Crastre later wondered if this charming young "witch" might not be possessed by an "evil genius," weaving magic spells and spreading discord in her wake. Often criticised for her coldness, her absence of sensitivity and empathy, not to say her violence, she could terrify friends and acquaintances alike. The director of the Knoedler Gallery remembers that, "if she didn't get what she wanted, she'd physically hit you; she'd walk towards you, fists raised."

Gala also had a weakness for superstition and divination. Acting the muse almost to excess, she also played the role of the ancient sibyl—a combination of intuition, omen, and instinct. There exists an astonishing contrast between her gentleness with and devotion to Dalí, and the confidence and optimism she afforded him, and the brutality she showed to those who stood in the way of her overriding ambition. For Gala, however, sexual satisfaction was to be had outside her relationship with the master, who was perhaps not, after the harmony of the early days, particularly exciting. Her many lovers and the young Spanish fishermen she would meet during daily walks near her home assuaged her pronounced carnal appetites, while her patently bisexual husband gave his blessing. Even at a very advanced age, she was not above flirting like a teenager.

Omnipresent object of veneration

As soon as they met, Dalí felt "Gala [would] become the salt of my life, the quenching of my personality, my beacon, my double—ME." Thus began the story of the veritable cult the Spanish painter was to devote to his wife his entire life. He painted *The Enigma of William Tell* after the break with his father, portraying him as a monstrous figure threatening to crush a Gala figure seated on a shell. The first names of the two lovers soon merged in signatures on his pictures. It was she who blazed Dalí's path to glory, and the painter, in return, offered her a place in his pictorial pantheon equal to that of a divinity. During his first trip to the United States in 1934, he declared that his favorite canvas was *Portrait of Gala with Two Lamb Chops Balanced on her Shoulder*. He placed her at the center of his oeuvre, riding roughshod over convention and even flirting with blasphemy—as in *The Sacrament of the Last Supper* (1955), where she sits in the place of Christ. But before appearing in Biblical themes— she also donned the mantle of the Virgin—in the 1940s Gala embodied

many figures from myth. Her splendid form is full of significance in one of the painter's major works, "the key Painting of our lives," as Dalí called *Leda Atomica* (1949), where she sits for the figure of Leda. According to myth, after yielding to Zeus, who had appeared to her as a swan, Leda produced two eggs: from one, two children emerged, Helen and Pollux, and from the other, two further offspring, Clytemnestra and Castor. The Catalan painter repositions this classic art-historical subject at the intersection of three paths: autobiography and the double (in relation to the dead brother whom he called Castor); the figure of the muse, who is the model for the mother of legend; and the history of painting, whose long line of masters he joins.

> *"It is Gala who unearths and brings me all the essences*
> *I transform into honey in the hive of my spirit.*
> *Without Gala, the world would have no genius*
> *at this time: Đalí would not exist."*
> *Salvador Đalí*

Judging by the innumerable pictures portraying her, Gala must have had to pose for countless hours, nude or in costume, before Dalí's easel, with certain parts of her anatomy (her face, back, and breasts) particularly in evidence. He would explore "Gala with the meticulousness of a physician and of an archaeologist fired by amorous delirium," as André Parinaud noted. Without vanishing entirely (to the very end, she would remain *the* muse), her influence began to wane towards the end of her life, making room for a few young women who spent time with the painter and sat for him, such as Isabelle Collin-Dufresne in the early 1950s (also known as Ultra Violet, who also inspired Andy Warhol), and Amanda Lear in 1965. The latter even came to live in the house, providing the gossip columns with extensive copy on several occasions. Gala tried unsuccessfully to summon back Amanda Lear when the younger woman moved away from Dalí, going so far as to propose Amanda marry the painter after her death. When she did indeed pass away, on June 10, 1982, Dalí moved into the castle at Púbol where Gala reposed in the crypt. Then, near the woman with whom he would "commune to the cry of life," he slowly withered away.

Gala and Dalí—sometimes together with "extras"—were in the habit of staging surrealistic "performances" that often highlighted her role as his muse. Here Dalí prepares Gala for such a performance. Photograph by Philippe Halsman, 1942.

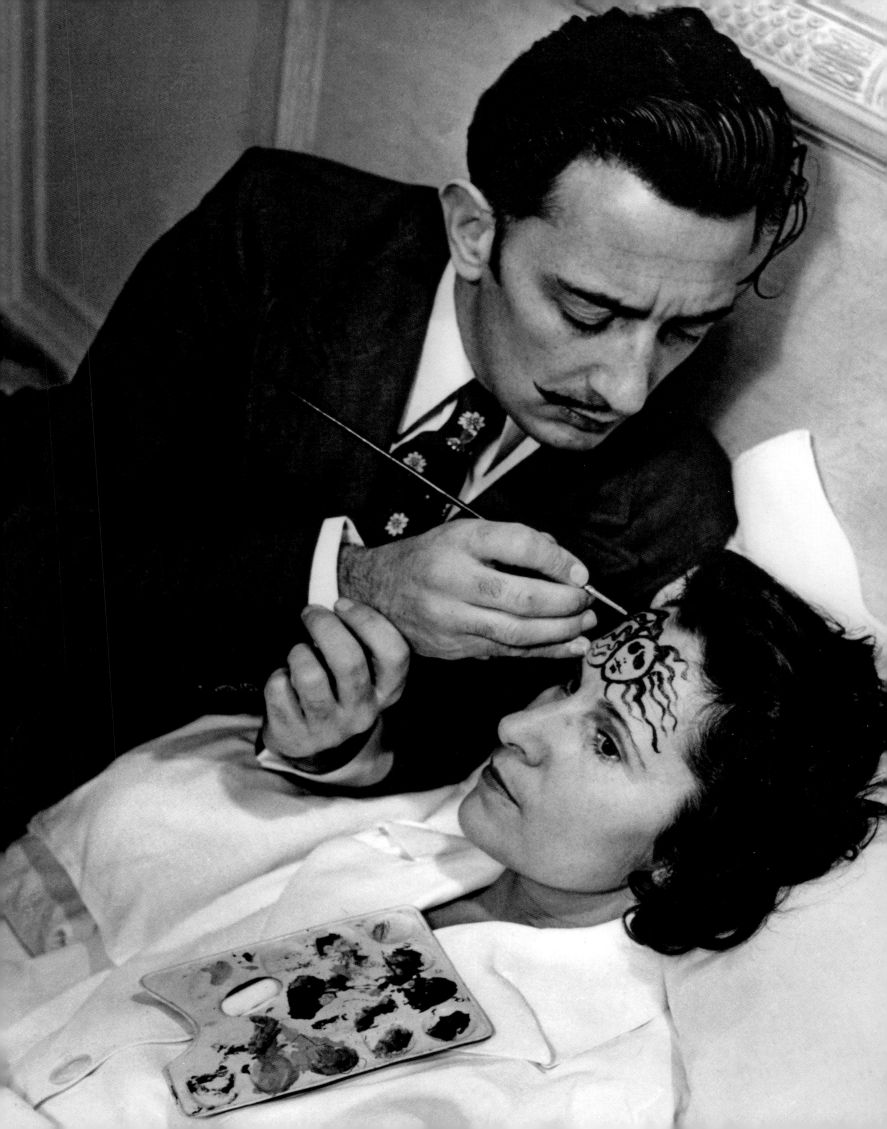

Dora Maar

Picasso's captive queen

"Everything they say about me is false," affirmed Dora Maar in her later years. The following pages do not claim to sort the cast-iron facts from the fantasy, but according to the many biographers and personal testimonies describing her relationship with Picasso, the overwhelming impression is one of bitterness. The unfolding story recounts the breakdown of a serious, passionate, temperamental, and complicated woman, equally dogged and fragile, submissive and rebellious, who found herself fatefully confronted with a self-centered genius and unrepentant macho. One of the very first episodes of their relationship took place against a backdrop of sacrifice and blood.

In October 1935, in the Deux Magots Café in Paris, Picasso was having a drink with some artist friends when Dora made her entrance. Struck by her looks, the master turned his magnetic gaze on her, staring deep into her unblinking eyes. She took a seat, removed her black gloves trimmed with little pink flowers, and placed her left hand flat on the table. She then took a knife out of her handbag and, in a flash, traced close around her hand with the blade, carving its outline on the table. She cut her fingers deeply and they bled. Picasso accepted her sacrifice and asked for the glove of her wounded hand, before leaving abruptly. He kept it for as long as he lived. By presenting him with her hand, Dora signed a pact that—after a period of time standing on the great painter's pedestal— would end with her disappearing entirely from the eyes of the world.

Portrait of Dora Maar with a cigarette holder (detail), by Izis, 1946.

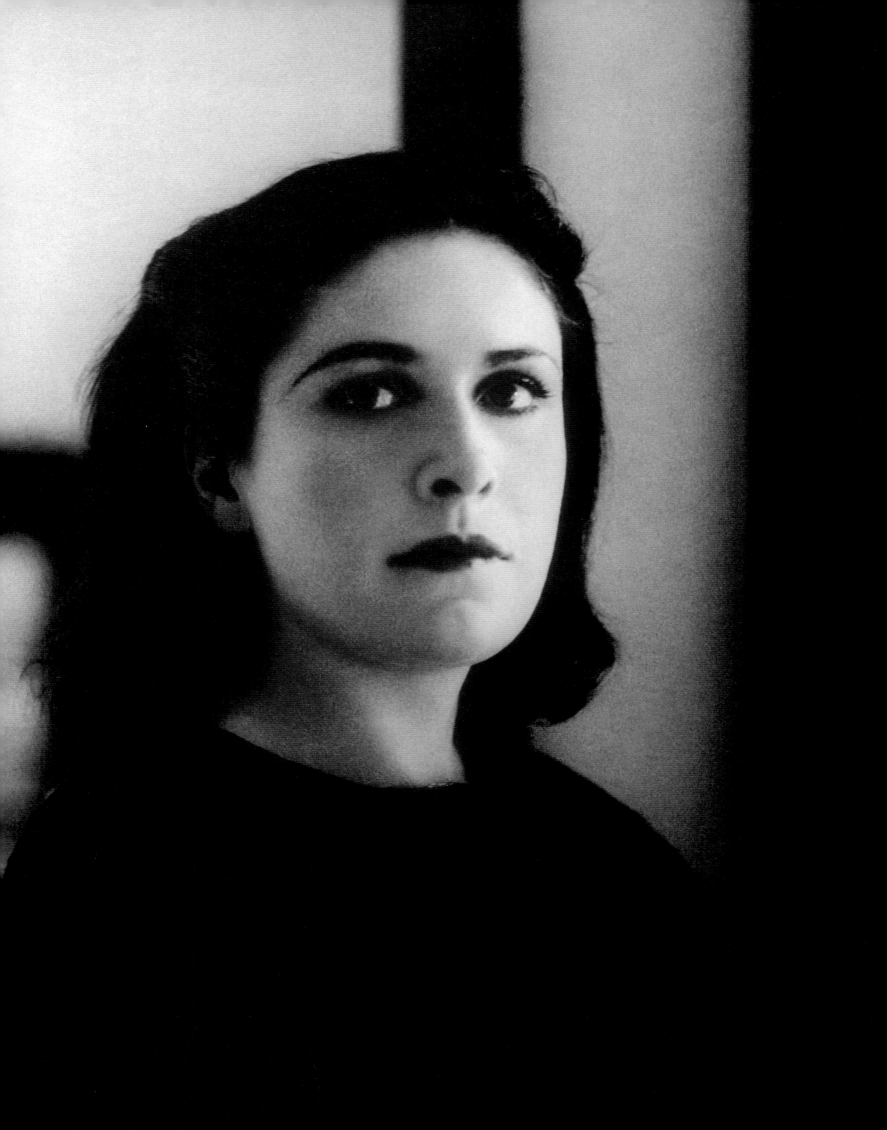

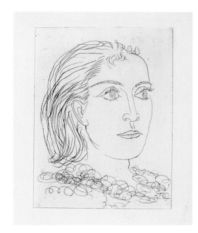

Portrait of Dora Maar by Picasso. The face in this print does not express suffering, though it was engraved in Mougins on August 15, 1937, in the middle of the period that saw the series of works entitled *The Weeping Woman*, for which she posed for him daily.

Facing page:
In 1936, Paul Éluard described Dora Maar thus in "Les Yeux fertiles": "Face of burning and untamed power / Black hair whence runs towards the South / Uncompromising immoderate / Useless / This health builds a prison." Photograph by Rozsa Klein, known as Rogi André, c. 1937.

A young surrealist photographer

Henriette Théodora Markovitch was born on November 22, 1907, in Paris. Daughter of Joseph, an architect of Croatian origin, and Julie Voisin, from the Touraine, she spent her childhood in Argentina. In 1920, she returned to the land of her birth with her mother, continuing her schooling in Paris at the Lycée Molière, before going on to study at the prestigious Union Centrale des Arts Décoratifs. A regular in the cafés of Saint-Germain-des-Prés, in 1927 she registered at the Académie Julian art school and then for courses with the painter André Lhote, whose studio was located in Montparnasse, then the center of the artistic avant-garde. Under guidance from Emmanuel Sougez, one of the founders of the review *L'Illustration*, who encouraged many young people in their vocation, she took up photography. Armed with a Rolleiflex, early in the 1930s she opened a studio in Neuilly, west of Paris, with one of her friends, and was soon doing fashion shoots, portraits, and nudes, some of Assia Granatouroff, another famous muse of the time. Dora also became acquainted with writer Georges Bataille, with whom she was to have a sporadic liaison several years later; she may have inspired one of the characters in his sulfurous novel *Blue of Noon*. She then became the assistant to the Polish photographer Meerson, meeting Brassaï and Henri Cartier-Bresson, and seeing much of the poet Jacques Prévert and his boisterous friends. A great traveler, she frequently returned to Argentina, and made trips to Barcelona. Now exhibiting her work, she published her photographs in journals, did advertising work, and fulfilled private commissions, becoming a full-fledged professional and forging friendships with the surrealists, as well as joining militant left-wing groups, such as Octobre and Masse, and the Union of Intellectuals Against Fascism. She was clearly influenced by the aesthetic theories of André Breton, as demonstrated by her famous 1936 photo of an armadillo fetus entitled *Portrait of Ubu* in homage to Alfred Jarry's loathsome anti-hero. Prior to the episode at the Deux Magots, she had already briefly crossed Picasso's path, and had been introduced to him by Paul Éluard at the première of Jean Renoir's *The Crime of Monsieur Lange*, a movie for which she provided the stills. Bataille's then wife (who subsequently married psychoanalyst Jacques Lacan, her physician in the darkest days of World War II) played a part in the production, and the whole entourage, with Éluard in the vanguard, so arranged things that Dora bumped into the womanizing painter, already impressed by her talent behind the lens.

The coronation

Picasso was born in Malaga in 1881. He was fifty-four when he met Dora, twenty-six years her senior, and at the apex of his fame, considered the greatest painter of the twentieth century, with his paintings worth a fortune. He had had stable relationships until now, with Fernande Olivier from 1905, and then with Eva Gouel, who inspired several canvases, before her death in 1915. The following year, penniless and still unknown, he designed the sets and costumes for *Parade* by Serge Diaghilev, the director of the Ballets Russes, and fell in love with one of the dancers, Olga Khokhlova, whom he married in 1918.

After this, his financial position had improved significantly and his first child, Paul, was born in 1921. Six years later Marie-Thérèse Walter became his mistress, providing him with a daughter, Maya, in 1935. Though in the throes of a great passion with Marie-Thérèse (whom he frequently painted asleep), he did not separate from Olga until June 1935. The affair with Dora Maar began in Saint-Tropez in August 1936. Concealing the recent arrival of his daughter, of whose existence Dora would only learn years later during the war, they spent the remainder of the summer together in the Vaste Horizon Hotel, where they would take rooms again the two following years. Of these early days, during which Picasso painted her endlessly, Dora would say: "I was crowned queen." In 1937, they moved into a large townhouse on rue des Grands-Augustins, in Paris.

At the end of April, the Luftwaffe, in collaboration with Franco's Nationalists, bombarded the Basque village of Guernica. On May 1, Louis Aragon published pictures of the carnage in his newspaper *Ce Soir*. Picasso was among many horrified by the incident, and not long after the attack, the Spanish Republican government commissioned a canvas for the Paris International Exhibition to be held the same year. This commission became *Guernica*, completed in mid-June. Dora was by now virtually Picasso's assistant and was a privileged witness to the evolution of the painting, with all its reworkings and revisions. She was briefed to photograph the work in progress from every angle, producing images that would be invaluable to future generations of art historians. Some critics, like her biographer Alicia Dujovne Ortiz, have even discerned the features of Dora in one of the female profiles. Ortiz also stressed how Dora's participation—she explained, for example, how best to light the picture—went far beyond the role Picasso usually assigned to the women in his life. "A mass of instructions—and coming from a woman. If she'd thought she could save herself by becoming, not a mute muse, like Marie-Thérèse, but a *pasionaria*, endowed with the gift of speech, she could not

Picasso unveiling portraits of Dora Maar in his studio on rue des Grands-Augustins, Paris. Their relationship was at this time at its lowest ebb. Dora felt like a captive, her friend, Lili Masson, declaring, "Dora told me that Picasso was the devil." Photograph by Franck Raux, 1939.

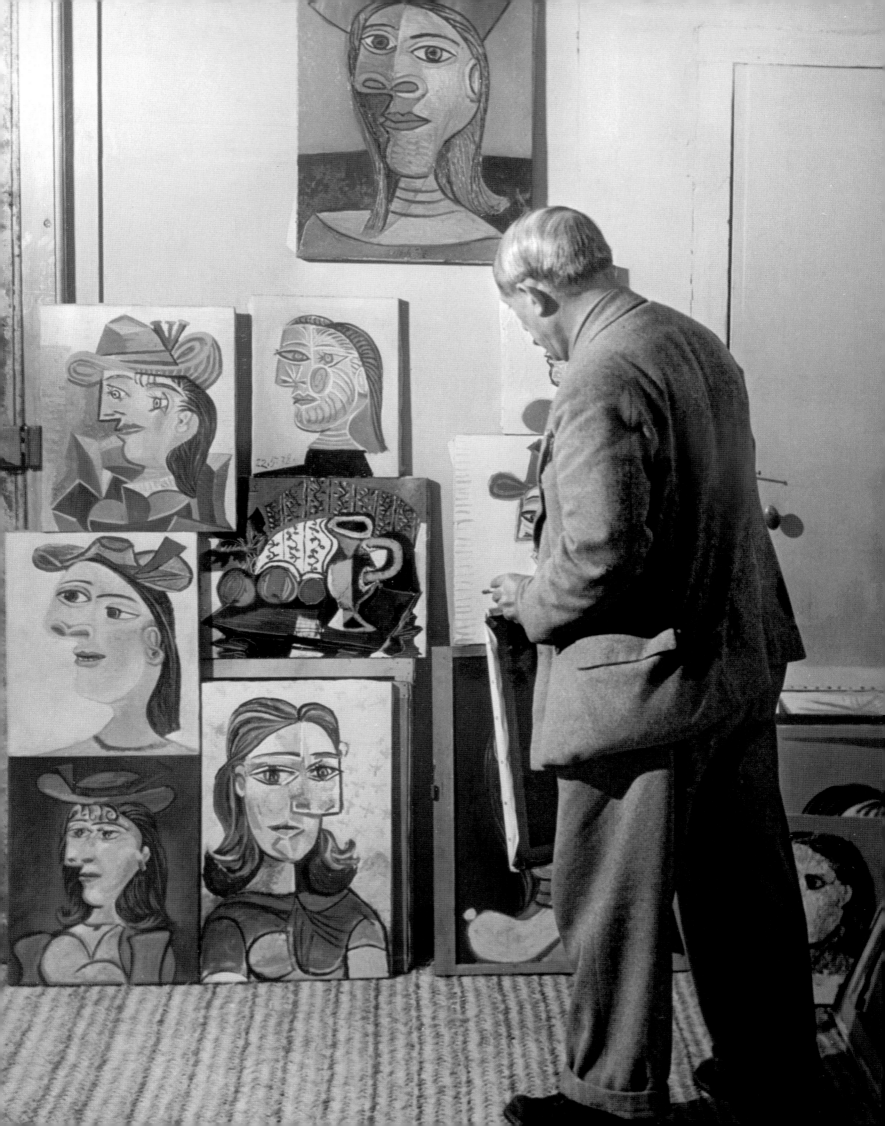

have been more wrong. Picasso did not accept gifts." After he and Dora argued violently, Marie-Thérèse reasserted her position as mistress. Dora meanwhile turned down the painter's proposal to become his exclusive photographer and, after this brief artistic collaboration—as if she had been exiled— she simply gave up photography. Henceforth she would turn to painting. And Dora, once Queen, now became the Weeping Woman.

The Weeping Woman

A substantial number of Picasso's pictures of Dora are titled *The Weeping Woman*. From June to October 1937, she would be his preferred, almost obsessive subject. She, too, with disconcerting mimicry, addressed the subject in her early forays into painting. Picasso once told André Malraux that if, over the years, he endowed Dora with such a tortured form, it was not through sadism or morbid delight, but because that was the vision of her that had stuck in his brain. He thought of her as a "Kafkaesque creature," sharing his life while he was forever telling her he was not in love. But this simply twists the knife: their letters of that time show that the "weeping woman" was no mere pictorial subject; she corresponded to the reality of their situation, since there is evidence to suggest the artist was physically abusive.

Throughout the summer 1937 in Mougins, she sat for him daily, the image of her suffering face—as a queen who had seen her crown slip, but who clung to her throne—displayed to an appreciative audience. Perhaps that is why, in 1938, Picasso depicted her wearing a two-cornered hat, seated in a chair bound with rope. Picasso's lack of humanity may be apparent, but Dora—though clearly the victim—participated fully in this martyrdom, accepting it, and affording it her blessing, as the following passage in her diary betrays: "I could spend my whole life without ever seeing him again and still love him. This I can see clearly. Our meetings at mealtimes. His charity is bewitching and I am his prisoner." At the beginning of the Occupation, they took refuge in Royan, a resort Dora had known as a child, and Picasso's portraits of her become increasingly monstrous. Sources show, however, that at this time he still had lingering feelings for her, blowing hot and cold, with declarations of love alternating with rejection and mockery. By now Dora knew she was unable to have children, and thus would never be able to attain the status of "mother-mistress," providing a reassuring presence in the corner of the painter's life, like her rival Marie-Thérèse. In 1941, Picasso completed his bawdy surrealist play, *Desire Cought by the Tail*, with the role of Skinny Anguish written especially for Dora. Certain descriptions of a "Hispanic Slavic slave"

Dora Maar behind her easel in her studio on rue de Savoie in Paris, where she was to live after she separated from Picasso. She was unquestionably a finer photographer than painter. "An accomplished photographer whose photos showed originality and a surrealist vision," Man Ray said of her. Little by little, she withdrew into solitude. Photograph taken in the 1950s.

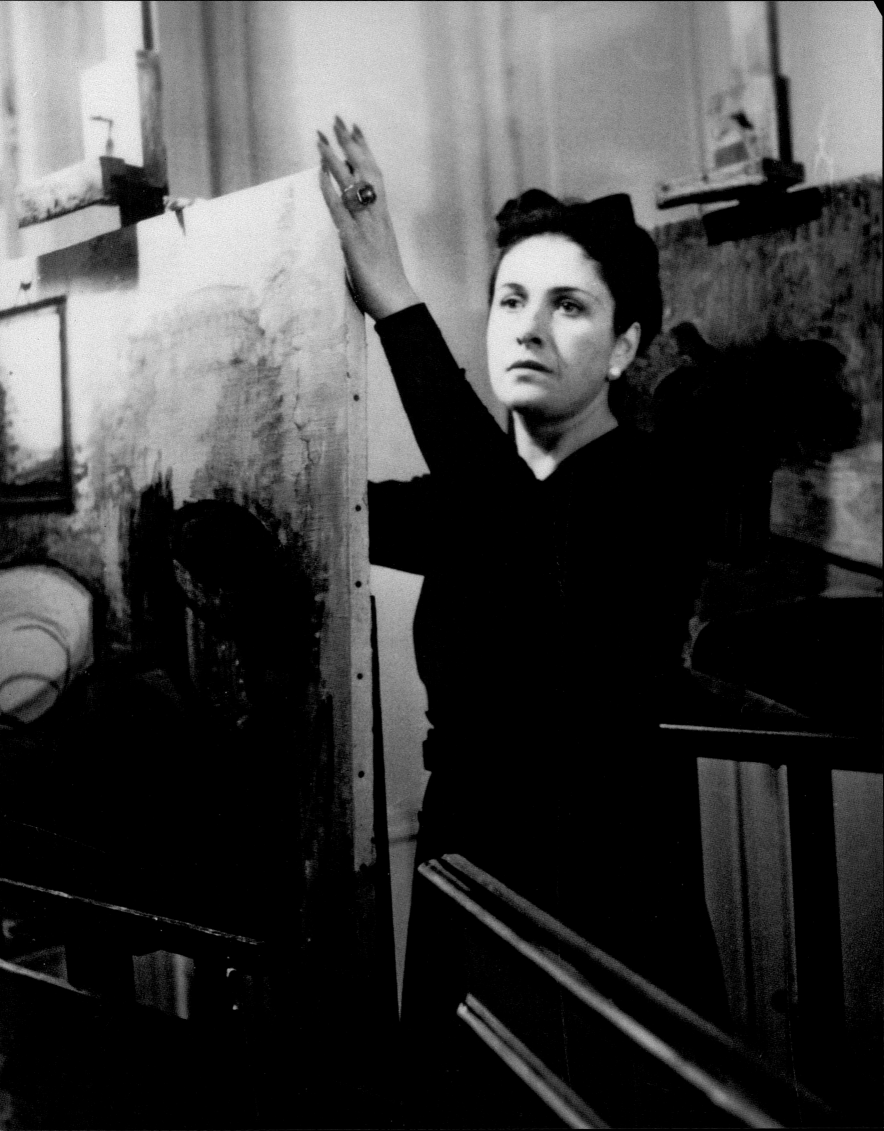

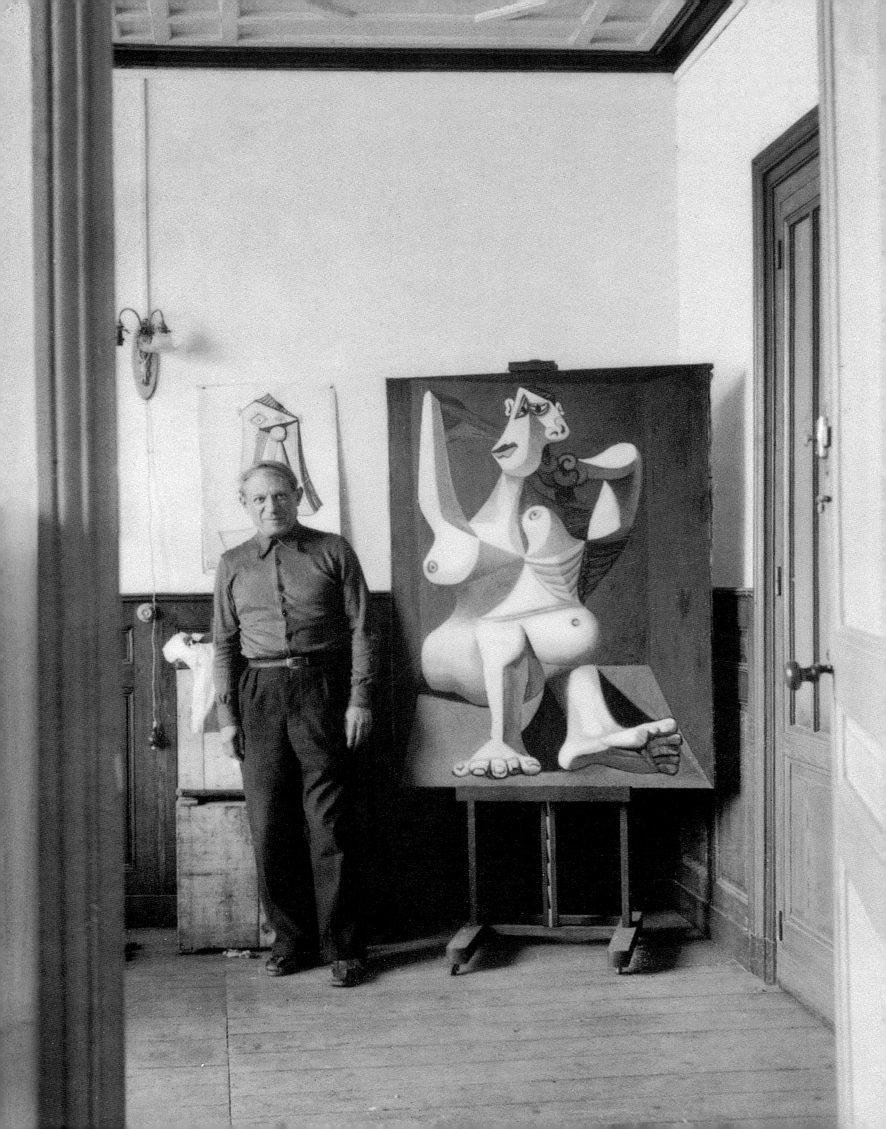

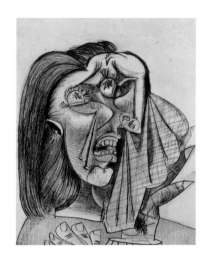

Picasso never tired of representing Dora as the suffering partner, ensnared in their love. This aquatint and etching print of July 2, 1937, represents the seventh state of *Weeping Woman I*.

Facing page:
Photograph of Picasso taken by Dora Maar in his studio in the Villa Les Voiliers, Royan, summer 1940. The picture behind him is *Woman Dressing her Hair*.

are also reminiscent of her. In May 1943, Picasso met his next partner, Françoise Gilot, then a young student. During the Paris insurrection in August of the following year, he lived at Marie-Thérèse's, pursuing his liaison with Dora, and continuing his affair with Françoise.

On May 15, 1945, Dora finally tipped over into madness. Brassaï described her having an outburst in a restaurant while Picasso alleged she went around calling herself "Queen of Tibet." Accompanied by Éluard and assisted by Lacan, the artist had her committed for a few days in the Hôpital Sainte-Anne, during which she is believed to have undergone electric shock treatment. Despite this, the affair still dragged on for a time. In July, they went to Cap d'Antibes together and Picasso presented her with a house at Ménerbes, but, by autumn, Françoise had moved in with him. Unseated, Dora now embarked on a sorry odyssey of exile and loneliness.

Disappearance

Between 1946 and 1958, Dora seemed to live a normal life, occasionally exhibiting her work, though there is no record of any new relationship. After that period, however, she spent some forty years alone in an apartment on rue de Savoie. Severing all contact with the outside world, she retired, surrounded by a unique Picasso collection made up of souvenirs, writings, pictures, drawings, restaurant tablecloths with sketches, and memories. Dora had felt the pull of mysticism and religion from the 1930s and now it exerted itself. Faithfully attending morning service in the church of Saint-Sulpice, after Picasso (or "the Devil," as she once called him), Dora thus turned to God—and also, less predictably, to the wilder fringes of the extreme right. It is said that a copy of *Mein Kampf* stood in full view in her apartment and that on several occasions she gave vent to the most virulent expressions of anti-Semitism as well as of her hatred of the world in general. This was indeed a depressing denouement for a woman who had once been a militant antifascist and a surrealist artist who had trumpeted freedom. As was noted in the press, Dora's funeral in July 1997 was sparsely attended, unlike the sale at which her treasures—the spoils of a lost war—went under the hammer at the end of the following year. *The Weeping Woman* reached 37 million francs. But this is not the only image history left of Dora. The British sculptor Raymond Mason, who met her on moving to France in 1946, contradicts the legend. After describing her as clear-sighted, dignified, perfectly self-controlled, and far from mawkish, he referred to her humor and astuteness before rounding off his portrait by calling her "the most intelligent of Picasso's women."

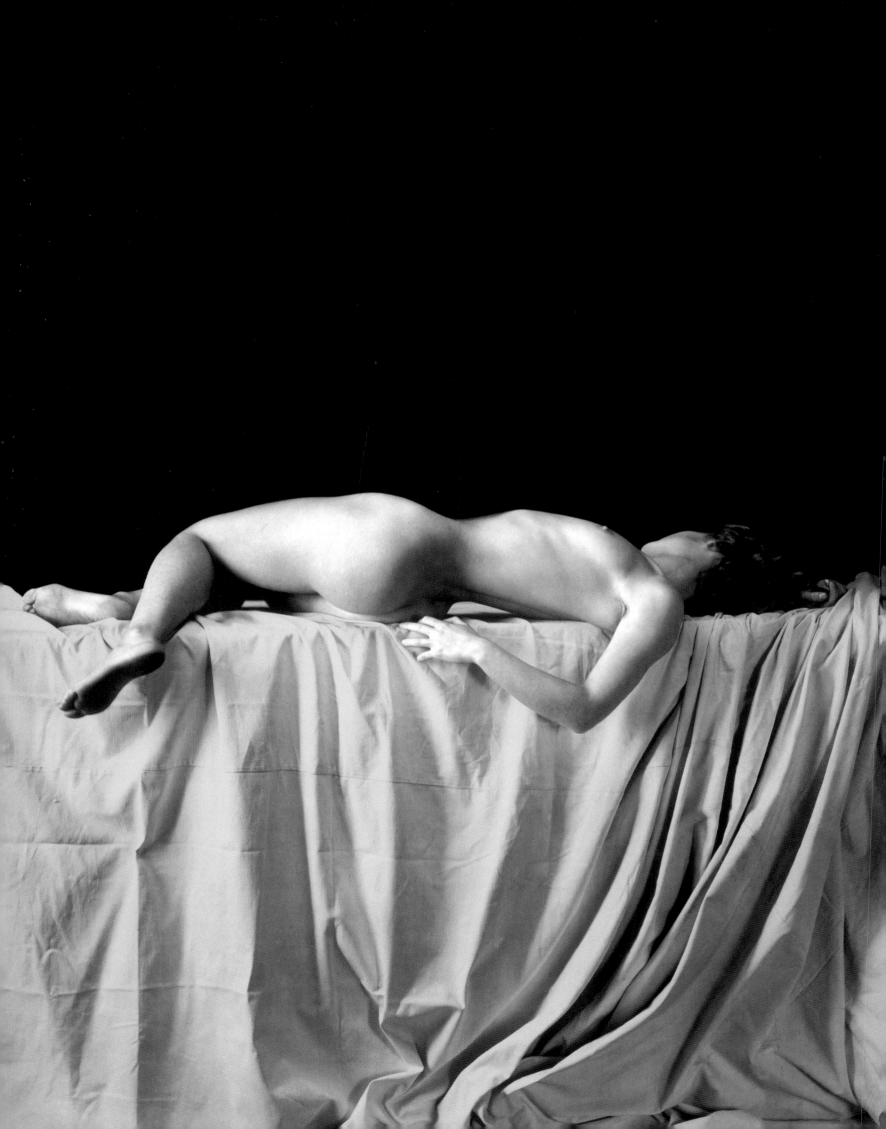

Assia
The nude of the 1930s

During the creative ferment of the interwar period one photographic model stands out from all the others: Assia Granatouroff. Born in 1911 into a Russian-Jewish family in Bogopol in the Ukraine, when aged ten she and her mother went to Paris to join her father, who had already been living there for a few years.

Quickly finding her feet, Assia earned her living as a seamstress, drawing patterns for textile manufacturers. In 1932, but hiding the fact from her family, she began posing for photographs in the studio of the then celebrated Roger Schall. He loved the resulting pictures, and from 1933–35 published many in *Paris Magazine* to considerable acclaim. Assia was soon in front of the lenses of many of the great names of photography, such as Dora Maar and Roger Parry, and enchanting Emmanuel Sougez, in whose finest nude works she features. Germaine Krull employed her for both advertising work and art studies. Each in their own way capture the sculptural beauty of her vigorous body and her natural sensuality, a combination of raw power and erotic charge that, for all the grace of her female curves, occasionally verged on the androgynous.

These sittings helped Assia fund drama courses at Charles Dullin's Atelier and she was soon acting on the stage and embarking on a career in the movies. From 1935–40 she starred in nearly ten feature films, under the name Nine Assia or Assia Granay, sometimes taking roles opposite leading actors of the day, such as Pierre Brasseur in *Jeunesse d'abord*, Harry Baur and Jean-Pierre Aumont in *Black Eyes*, and Danielle Darrieux and Charles Boyer in *Mayerling*. In addition to collaborating with masters of the lens, she worked with some of important painters of the century, such as Waroquier, Kisling, Van Dongen, and Derain, as well as with sculptors like Maillol and Despiau. In 1937, the last of these produced the work for which he is probably best remembered today: it bears the first name of the young muse. All these artists were captivated by her robust physicality, which blended classical qualities with quintessentially modern vitality.

Assia in *Nude, Rest* by the photographer Emmanuel Sougez, 1937. Her face was very rarely shown when she posed in the nude.

Kiki

Queen of Montparnasse

The illegitimate Alice Ernestine Prin was born on October 2, 1901, at Châtillon-sur-Seine, Côte-d'Or, Burgundy, to a mother aged just eighteen. Raised by her grandmother, she left her home to go to Paris in 1913, joining her mother, a typographer, and living in modest lodgings in the fifteenth arrondissement.

Working at a bookbinder's, one day Alice found herself stitching an edition of the *Kama Sutra*: "With the fire I already had between my legs, that was all I needed!" she later confessed. She later found menial employment with a baker who mistreated her. She left shortly after, finding herself on the street. Breaking with her mother, Alice took refuge with an elderly sculptor, for whom she worked as a nude model. The artist worried, however, that her extreme youth might cause a scandal, so once again Kiki moved on, embarking on a wretched hand-to-mouth existence, posing for artists or doing odd jobs.

Photo portrait of Kiki, published in *Tempo* in 1932. Jean Rhys, in her 1929 novel *Quartet*, created a character based very closely on Kiki (known as Cri-Cri, in the novel): "She was a small, plump girl with astonishingly accurate make-up, a make-up which never varied, day in and day out, week in and week out. Her round cheeks were painted orange-red, her lips vermilion, her green eyes shaded with kohl, her pointed nose dead white. There was never too much or too little, or a lock of hair out of place. A wonderful performance. She was the famous model of a Japanese painter, and also a cabaret singer and a character."

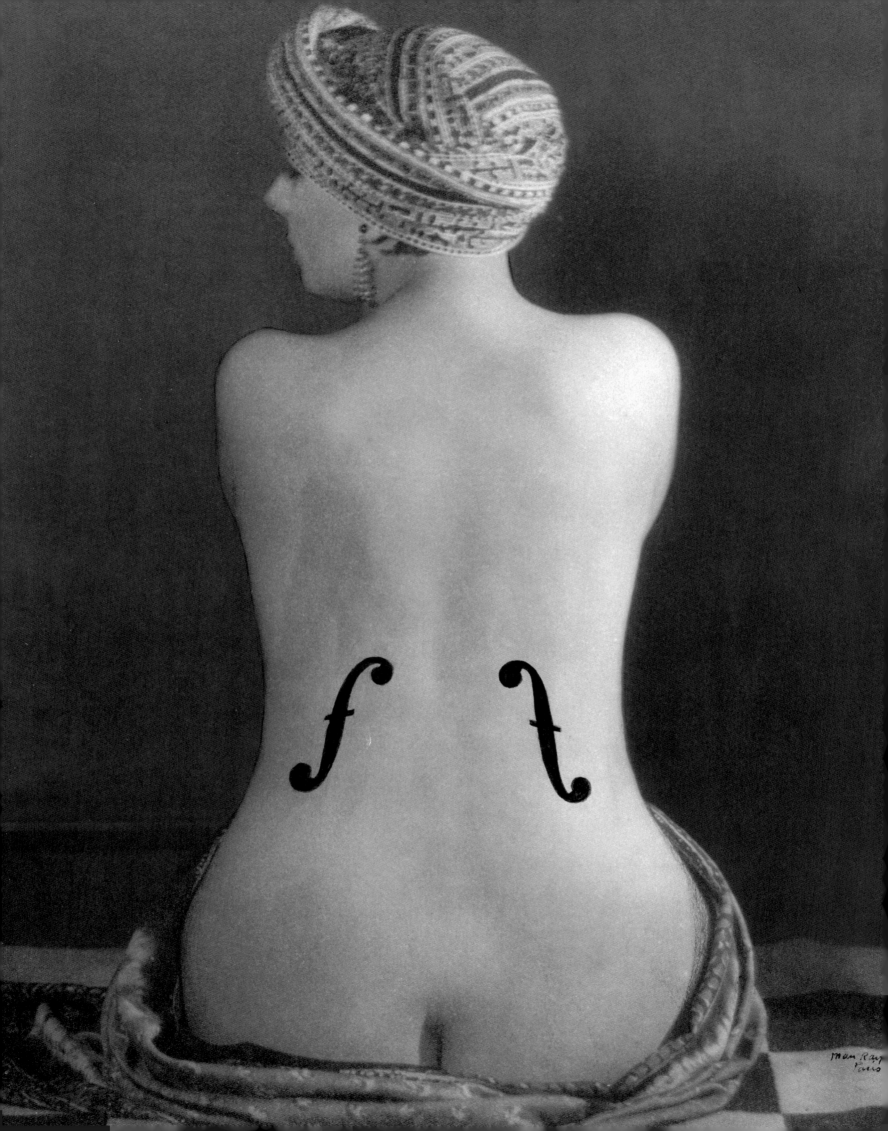

Kiki: Queen of Montparnasse

Alice, Aliki, Kiki

One winter when it became too cold under the Pont Edgar-Quinet, the artist Soutine put her in touch with a girlfriend, who offered her a bed, burning the furniture to keep warm. After a relationship with a certain Robert, who mistreated her, in 1918 she embarked on her first great love with a painter of Polish extraction, Maurice Mendjisky, who knew Soutine as well as Picasso and a whole host of down-at-heel artists whose model she would become. It was Mendjisky who dreamt up her moniker, a diminutive of the Greek translation of her first name: Alice—Aliki—Kiki. "I'm shacked up with a painter. There's not much cash, but, sometimes, we eat," she wrote. During World War I, she worked in an armament factory before ending up in a general store as a bottle washer. Shortly after the end of the conflict, she started going to a famous brasserie, La Rotonde in Montparnasse, then an artists' haunt. Independent, energetic, cheeky, and fearless, Alice forged some significant contacts in the quarter. Soon her many talents were being sought after: at once model, singer, actress, painter, and author, she possessed a ready wit and an explosive temperament, though on occasion she could be gripped by a sudden timidity. As Jean Dutourd noted, this girl from an underprivileged background was at this time already rubbing shoulders with some extraordinary men—though it took time for the history of art to acknowledge their worth: "In her way, Kiki is a kind of muse for the penniless budding artists surrounding her. . . . Then the years pass and one learns the names of these painters: they are called, quite simply, Modigliani, Pascin, Soutine, Kisling."

A model for Foujita, Kisling, and others

Tsuguharu Foujita—the son of a general with the Joint Chiefs of Staff in the Japanese Imperial Army—known as Léonard Foujita, or by some as Fou-Fou owing to his antics, had a studio in a disused stable on rue Delambre, where Kiki posed for him for hours, sometimes in the courtyard. Like many of his compatriots, he worked with his canvas flat on the ground, dispensing with an easel. Quickly becoming friends, Alice and Foujita enjoyed going out on the town together. One day, turning up stark naked under her coat, she decided it was time they swapped roles and she drew his portrait. "By the time the work was finished," the painter remarked, "she had sucked and bitten all my pencils and lost my little eraser and was *dancing, singing, and shouting* in delight." The sketch was immediately sold at the Dôme, a famous café a stone's throw away. By way of revenge, Foujita painted a nude picture of her in what was for him an unusual format: this is the famous *Reclining Nude with Toile de Jouy*,

Kiki did not like posing for Man Ray, because, as she said, "a photographer only records reality." She appeared nevertheless in *Le violon d'Ingres* (gelatin silver print, mounted on paper) of 1924. At the crossroads of painting and photography, the sound holes were drawn in lead pencil and India ink directly onto the print.

which brought its creator unprecedented success and a certain notoriety for Kiki. The canvas created a stir at the 1922 Salon d'Automne, where the press went into raptures. Foujita received official congratulations from the French government and sold the painting for eight thousand francs—a considerable sum—generously handing some of the money over to his muse, who frittered it away on dazzling outfits.

Following this success, Kiki posed for several other artists, including the well-heeled, steely Moise Kisling, of Polish origin, and the Norwegian painter Per Krohg, a pupil of Matisse's then living in Paris. Initially a three-month contract, their collaboration lasted throughout the 1920s. In these works Kiki resembles many of his female portraits of the time—thoughtful and abandoned, with sad expressions. The 1927 nude bearing the name of his muse emphasizes her voluptuous form, while a reclining Kiki from the same era offers beholders an expanse of her milk-white skin. There is no lack of anecdotes concerning her career as a model: for his splendid gilt-bronze mask of 1928 representing her face, the Spanish sculptor Pablo Gargallo never even made her pose. A still more absurd story concerns Utrillo, a painter who liked a drink. One day he sat down next to Kiki at La Rotonde and started a thumbnail portrait of her sipping a glass. The sitter described the result: "There I was, stock-still like I was stuffed. After ten minutes, he puts down his pencil and paper. I take a look. Flabbergasted, I see a country house with a little garden!"

"Play me like a violin"

In 1921, Kiki met the avant-garde photographer Man Ray. Initially refusing to pose for him, because she felt, "a photographer only records reality," she eventually found herself in front of his lens and then in his bed. Moving in with him and posing in the manner of an odalisque, she gradually assumed a major role in the Man Ray's oeuvre. Their personal relationship, however, was one of arguments and repeated breakups. Though fond of her and remaining fascinated as much by her buoyant and natural personality as by her perfect body (worthy, he felt, of an academic painting), Man Ray did not really reciprocate her love, rejecting the bourgeois code of relationships that Kiki, in spite of her free-spirited approach to relationships (which was probably due to a lack of self-respect, in any case), still cherished. In July 1922, they moved into a studio on rue Campagne-Première, on the understanding that Kiki would not be present when important clients came to visit. The following year, Ray offered her a part in his first short film, *Return to Reason*, where, after a sequence of nocturnal illuminations and iterative abstract forms, bands of light flicker over her naked torso. There

Man Ray in his studio in 1950, in front of a huge enlargement of a photo of Kiki de Montparnasse. She occupies a central place in his oeuvre, together with the American artist's other muse, Lee Miller.

144

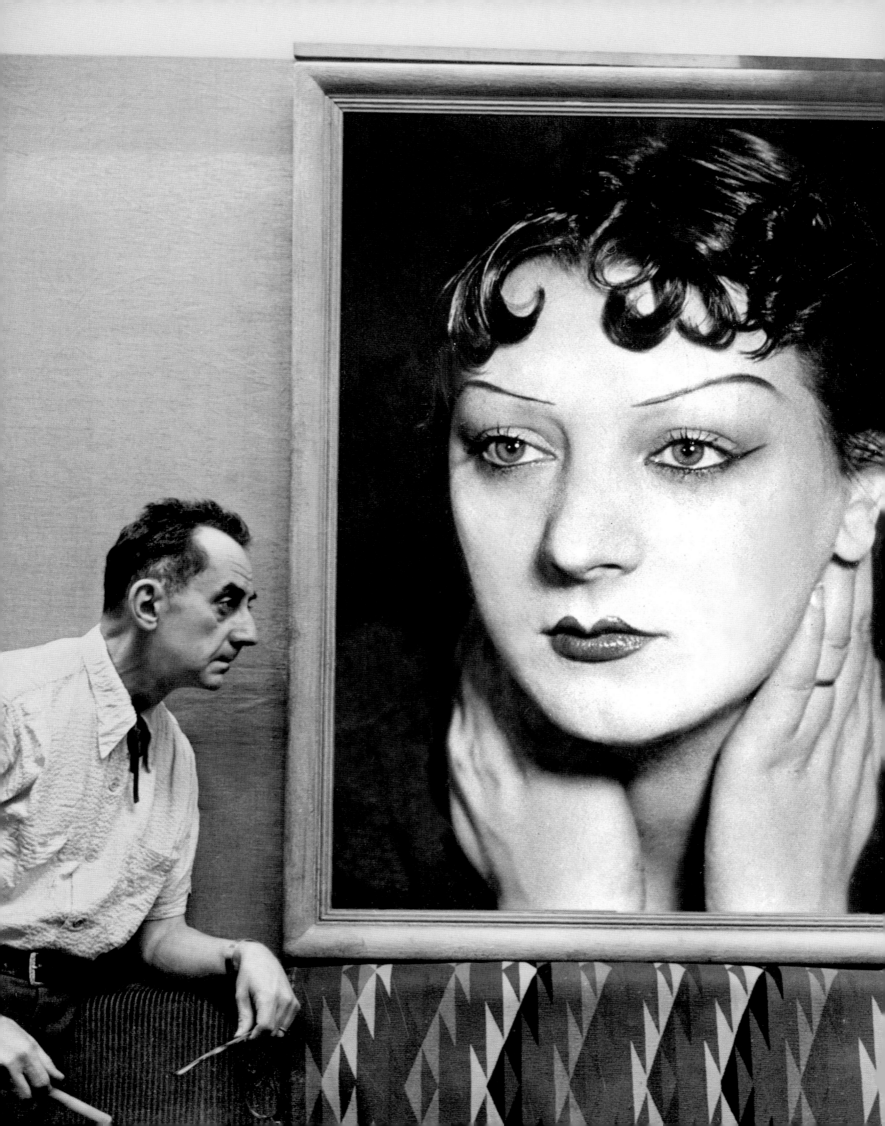

followed the experimental films, *Emak Bakia* in 1926, and *The Starfish* two years later, in which their friend the poet Robert Desnos also appeared.

After an unsuccessful attempt at breaking into the movies in the United States, in 1923 (the year of a further love affair), Kiki decided to devote herself to singing cabaret. The following year, in a room in the Hotel Istria where they were living, she made a huge scene with Man Ray, accusing him of regarding her as a *violon d'Ingres*—as nothing but a hobby with which he liked to toy every now and again (the French expression derives from Ingres' habit of playing the fiddle in his free time). Struck by the metaphor, he had her pose with her back to the camera, her arms clasped in front, and a piece of cloth round her hips. Around her head, in three-quarter profile, she wore an Oriental turban reminiscent of one of Ingres' famous *Bathers*. On the photograph's negative, Man Ray drew, symmetrically on either side of her spine, two sound holes in the shape of "*f*'s"—just as on a violin. As one of Kiki's biographers, Lou Mollgaard, explained: "In the place of a sacred *Bather*, he immortalized Kiki as a scandalous double. Once reproduced and retouched with the two sound holes, Ingres's image was transformed from a pun or a metaphor into a Dadaist artwork. Above and beyond its pecuniary interest, Man [Ray] had finally discovered the unsuspected treasures of photography, winning it the right to be considered as one of the fine arts."

While remaining a couple, their ties were gradually loosening. In 1925, he did not come with Kiki to Villefranche-sur-Mer—a favorite haunt of his friend Cocteau—when she moved there for a time to do some singing. But Man Ray did come to her rescue when, at the end of her stay, she was

Four versions of this photograph by Man Ray, showing Kiki holding a Baule mask from the Ivory Coast, exist (including one positive). Initially published under the title *Mother-of-Pearl Face and Ebony Mask* in the French edition of *Vogue* in 1926, it subsequently became known as *Black and White*.

unjustly arrested for prostitution. For, if Kiki had many lovers and liked to sing in skimpy outfits, she certainly never sold her charms for cash. As she insisted: "If I'd just been a little slut, I could have had it all! . . . Yuck! Doing it for money! . . . I have always been the sentimental girl overflowing with the affection I had to keep suppressed during my youth." The couple finally separated towards the end of 1927. Kiki met Henri Broca, author and publisher, while Man Ray sought solace in the arms of the young Lee Miller. In 1965, nearly forty years after their separation and twelve years after Kiki's death, Man Ray produced another version of *Le Violon d'Ingres*.

A nose for Calder, a Grace for Brassaï
Kiki inspired artists in many different ways. Quite apart from her "bather's" physique, they sometimes portrayed her as a melancholy soul, at others as a diva of the avant-garde, and at others again as the symbol of the Roaring Twenties. Few models made such an impact in so many disparate styles with so many creative artists from so many disciplines. The first portrait of Kiki on celluloid was made in 1929 by Pathé Studios and shot in the workshop of the American artist, Alexander Calder. A specialist in figurative sculptures made of wire, Calder was a major player in the Parisian avant-garde. He carried out three versions of "masks" of Kiki, the muse noting in her journal at the time: "To make a portrait of his model, instead of smearing canvas with paint from tubes or mutilating marble, he twists bits of iron wire, with consummate skill." Bordering on caricature, Calder's portrait focuses chiefly on her nose, which was admittedly appreciably long and pointed (Kiki herself described how it caused her to

Reclining Nude with Toile de Jouy (1922). It was this picture that earned fame for Foujita Tsuguharu, known as Léonard Foujita, and a certain fortune for Kiki, which she spent on outfits.

KIKI MODÈLE POUR PEINTRES CUBISTES

OU LA FEMME QUI VA ÊTRE COUPÉE EN MORCEAUX

Dessin de ZALIOUK.

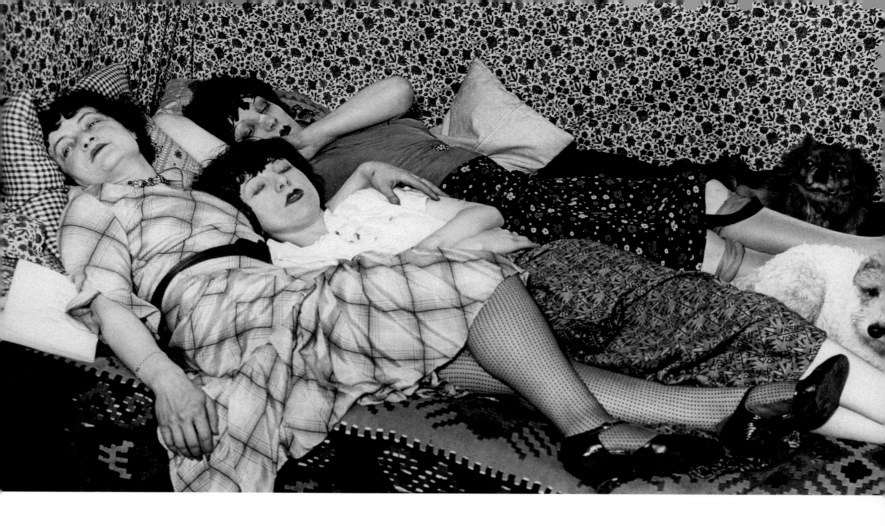

be called the "quarter of Brie" in her youth). The photographer Brassaï—
so adept at capturing the atmosphere of the Paris night and its seedy
underbelly in the 1930s—produced a splendid series of photographs of
Kiki when she was performing at the Cabaret des Fleurs in 1932. One of
these images finds her in the company of André Laroque, her accordionist
and lover, who gazes at her, a cigarette stuck between his lips with an
adoring expression. Kiki is holding the score of "Wonderful You," which
she often sang at this time. Luminous stars shine out from the walls,
bathing the couple in a nocturnal glow. In another photo of the same year,
the *Graces of Montparnasse*, she reappears flat out on a couch, quite
possibly the worse for wear, in the company of two other prone women
and as many lapdogs.

The Venus of modern mythology is clearly a very different animal
from her mythical ancestor.

Above:
After a wine-soaked dinner in 1932, Kiki
and two of her friends, Thérèse Trieze and
Lily, dozing in each other's arms on a divan
with a few of their puppies. Much amused,
Brassaï called this photograph *The Graces
of Montparnasse*.

Facing page:
*Kiki as a Model for Cubist Painters, or
Woman about to be Cut into Pieces*:
drawing by Sacha Zaliouk, published in the
satirical illustrated magazine *Fantasio*,
in 1925. Kiki one day confessed, "Poet,
painter, or thespian. I had no eyes for any
mortal outside those three professions."

Cabaret singer, naïf painter, actress, and author

Kiki had more than one string to her bow, as a glance at her biography
shows. Prepared to try anything, in every area she turned her hand to
she always embodied the character she had forged for herself and which
had made her a Parisian legend in her own lifetime. If the muse was now
playing her own role, others were not above playing it, too: at the end of
1930, the Théâtre Daunou reprised *Kiki*, a comedy by André Picard first
performed in 1921.

Following in the *chansonnier* tradition, in 1924 Kiki became a star
attraction at the cabaret, Le Jockey. The audience was a mixture of society

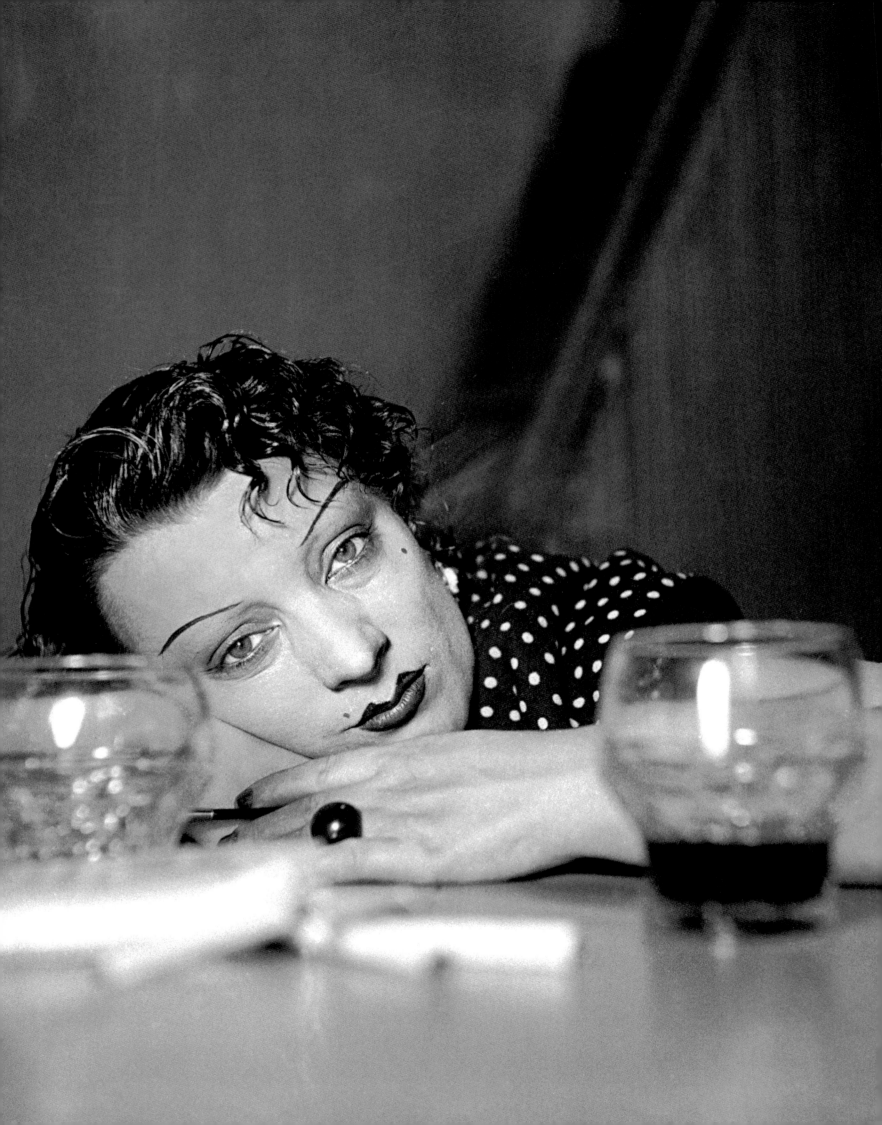

Kiki at a table with friends in the Dôme Brasserie, Montparnasse, in 1929. Artists and night owls would do the rounds of the cafés. As their pockets were often empty, they would get up to all sorts of tricks to get a drink.

Facing page:
Kiki in the 1940s. Alcohol and drugs, cocaine in particular, wrecked her health and she spent the end of her life in poverty and oblivion.

people out to see how the other half lived, art and showbiz professionals, and more unsavory characters. Kiki received no fee for her appearances, and had to rely on tips. Sometimes she obstinately refused to sing, while the punters howled their disapproval. Perhaps it is against this background that her dependence on alcohol and cocaine gained ground, with devastating effects. She moved on to the Quat'Femmes cabaret, then to La Jungle, and the Boeuf sur le Toit in 1929. In May, she received an emotional ovation at the Bobino during an official reception organized by her lover Broca in aid of an artists' relief fund. She was elected "Queen of Montparnasse" and everyone met up in La Coupole for the "crowning." Man Ray photographed the event, with three hundred thousand copies of the image printed. In 1930, she was back in the Jungle—literally and figuratively—and then in variety at the Concert Mayol, in the, at the time, far-off 10th arrondissement. During this period, Broca sunk definitively into madness and Kiki continued her career with her new friend, André Laroque, at the Cabaret des Fleurs. In May 1939, she signed a contract to cut four records.

While continuing to sing for her supper, Kiki also painted pictures of a naïf and popular genre—colorful images rather than the smoke-filled speakeasies where she performed. By the late 1920s she was exhibiting frequently. As for the movies, in addition to her appearances for Man Ray, until 1946 she would crop up in films by Marcel L'Herbier, in avant-garde pieces like Fernand Léger's *Mechanical Ballet*, or directed by René Clair or Jean Epstein. In 1928, she collaborated with Pierre Prévert and Marcel Duhamel on *Paris Express* (aka, *Souvenirs de Paris*). Shortly before her death in 1953, Michel Georges-Michel asked her to play herself in a film with a decent budget to be shot in Rome with the renowned Gérard Philipe. Her cinematographic career, however, remained a sideline, and her roles were never better than serviceable.

At an earlier date, after encouragement from Broca (who was also her publisher), Kiki wrote her *Souvenirs*. First published in 1929, in 1930 an English edition with a foreword by Hemingway fell afoul of the censor in the United States for obscenity. Kiki added to and altered these memoirs until 1938. Then, for sixty-five years, the manuscript vaporized: her *Souvenirs retrouvés* were only published by José Corti in 2005—fifty-two years after her death on March 23, 1953, destroyed by drugs and alcohol. Her final years of dependency and misery revolved around the artificial resuscitation of long-lost glories. Even the hearse that bore her through Montparnasse seemed to try to rekindle her heyday, as it halted respectfully before La Rotonde, Le Dôme, La Coupole, and Le Jockey.

Marlene Dietrich

Josef von Sternberg's alchemical muse

Marlene Dietrich photographed
by Don English in 1932.

Born in 1901, Marlene Dietrich was educated in a boarding school in Weimar before embarking on her acting career in Berlin. She had initially hoped to be a concert violinist, but in the 1920s she took courses at the famous school of Max Reinhardt, playing various minor—often non-speaking and unpaid—roles. In 1923 she married casting director Rudolf Sieber, with whom she had her only child, Maria, who was to say later of her father, "he played the role of the mandatory husband, impresario to his starry spouse, and confidant." In 1928, still little known, Marlene landed a part in a revue *It's in the Air*, in which she sang a duet with the then-star Margo Lion, a parody of the vaudeville act the Dolly Sisters that was described in the press as "androgynous." The following year she had a very minor role (with a solitary line) as an American girl in the play *Two Ties*. Despite this less-than-stellar beginning, her presence attracted the attention of Hollywood director Josef von Sternberg, who seemed to have been bewitched by the unremarked actress. As she wrote later, from that point he "had only one thing in his head; to take me away from the stage, and make me into a movie actress, to 'Pygmalionize' me."

"A creature destined to charm the world"

No one could have envisaged Marlene's glittering international future without the intervention of Sternberg, who, against all the odds, insisted on her for the lead role in his film *The Blue Angel*. From then until 1935, as he molded an image that the whole world would soon adore, he found Marlene a malleable and flexible muse, and she, in return, was eternally grateful to him. As he wrote with characteristic icy, almost disdainful, detachment, "No puppet in the history of the world has been submitted to as much manipulation as a leading lady of mine who, in seven films, not only had hinges and voice under control other than her own, but the expression of her eyes and the nature of her thoughts."

In autumn 1929, Sternberg had disembarked in Berlin in the hope of finding an actress for the role of the singer, Lola-Lola in *The Blue Angel*. For days, a procession of wonderful actresses filed through his office, but none seemed quite right for his heroine. Glimpsing Marlene, he called her in for a screen test. Her indifference during the shoot contrasted markedly with the attitude of her competitors: "And there he was, the stranger, the man who I would be seeing mostly behind the camera, the inimitable, the unforgettable Josef von Sternberg. Someone was sitting at the piano. I was asked to climb on top of the piano, to roll down one of my stockings to the ankle, and sing a song I was supposed to have with me." With unerring aim, the filmmaker crafted the little-known actress into the embodiment of this imaginary character, one of a type that relied on pictorial references ranging from the electrifying creatures of the painter Félicien Rops to the semi-clad women of Toulouse-Lautrec: that is, a particular aesthetic image of libertinism and high-class titillation. Sternberg, meanwhile, continued to model his modern icon, this goddess of the silver screen, donning the cloak of alchemist to carry out his subtle metamorphosis: "I then put her into the crucible of my conception, blended her image to correspond with mine and, pouring lights on her until the alchemy was complete, proceeded with the test. She came to life and responded to my instructions with an ease that I had never before encountered." Sternberg's original fascination for Marlene seems to have centered not on her intrinsic qualities as an actress, but on the aesthetics—the eroticism—of her face and body. To the rest of the production team Marlene's screen tests were unsatisfactory and the director was alone in backing her, convinced he had found the look he wanted. Certain of Marlene's unique attractiveness, of the phenomenal success they could have together, Sternberg dedicated himself to proving it to the world. He had already decided upon the attitudes, the walk, the style of dress, and the voice of Lola-Lola, as well as her dialogue.

Along with the image on page 152, this photograph of Marlene Dietrich was taken by Don English for the movie *Shanghai Express*, directed in 1932 by Josef von Sternberg. The first was used as the poster for the Forty-Fifth International Cannes Film Festival in 1992.

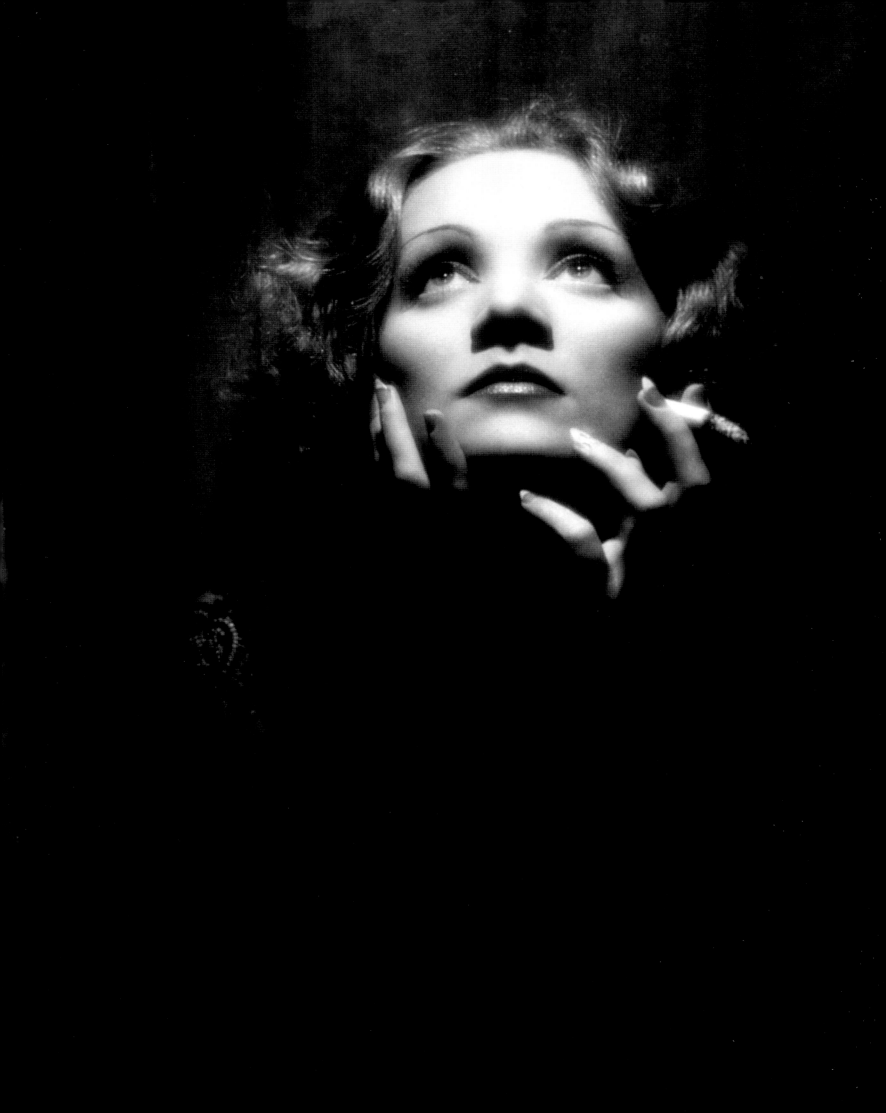

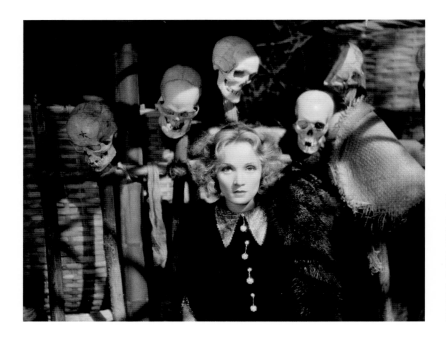

British drama critic and writer Kenneth Tynan wrote of Marlene Dietrich, "She is advice to the lovelorn, influence in high places, a word to the wise, the territorial imperative. She is also . . . the smoke in your eyes , how to live alone and like it, the survival of the fittest, the age of anxiety, the liberal imagination, nobody's fool and every dead soldier's widow." Marlene Dietrich here in the role of Shanghai Lily/Madeline, in *Shanghai Express*. Photograph by Don English.

As Marlene later protested, Sternberg seemed to use her as a sounding board, a "walking encyclopedia," and as what he thought was an authority on Berlin slang. As they shot this complex character, whose personality was so different from her own, Marlene gained in self-assurance, to the point that, as she said herself, her transformation seemed to have something miraculous, magical about it. But the metamorphosis had yet to be accepted by the rest of the world. Blind to Marlene's uniqueness, the heads of production pass up an option in the contract that would have given them exclusivity over Marlene's work. *The Blue Angel* was shown for the first time to a Berlin audience on April 1, 1930. The evening of the premiere, having just signed for Paramount, the actress was to leave Berlin to join Sternberg in Hollywood. Though departing late at night, she still found time to attend the preview where she was met, in the words of Sternberg, "by an ovation that would bring the house down."

A submissive, beguiled, and indebted muse

From the very outset of their collaboration, Sternberg was encouraged by Marlene's wholehearted commitment on set. Focused and eager to follow the filmmaker's directives to the letter, her dedication was, as he noted, almost servile. Anticipating his every desire, she never complained, her acting complying diligently with the will of her mentor, who only rarely had

Facing page:
Portrait of Marlene Dietrich in the extravagant ensemble designed in 1934 by the famous Hollywood costumier Travis Banton for Empress Catherine II of Russia in the *Scarlet Empress*, directed by Josef von Sternberg. She wears a short jacket and a fur hat and muff over a broad velvet skirt.

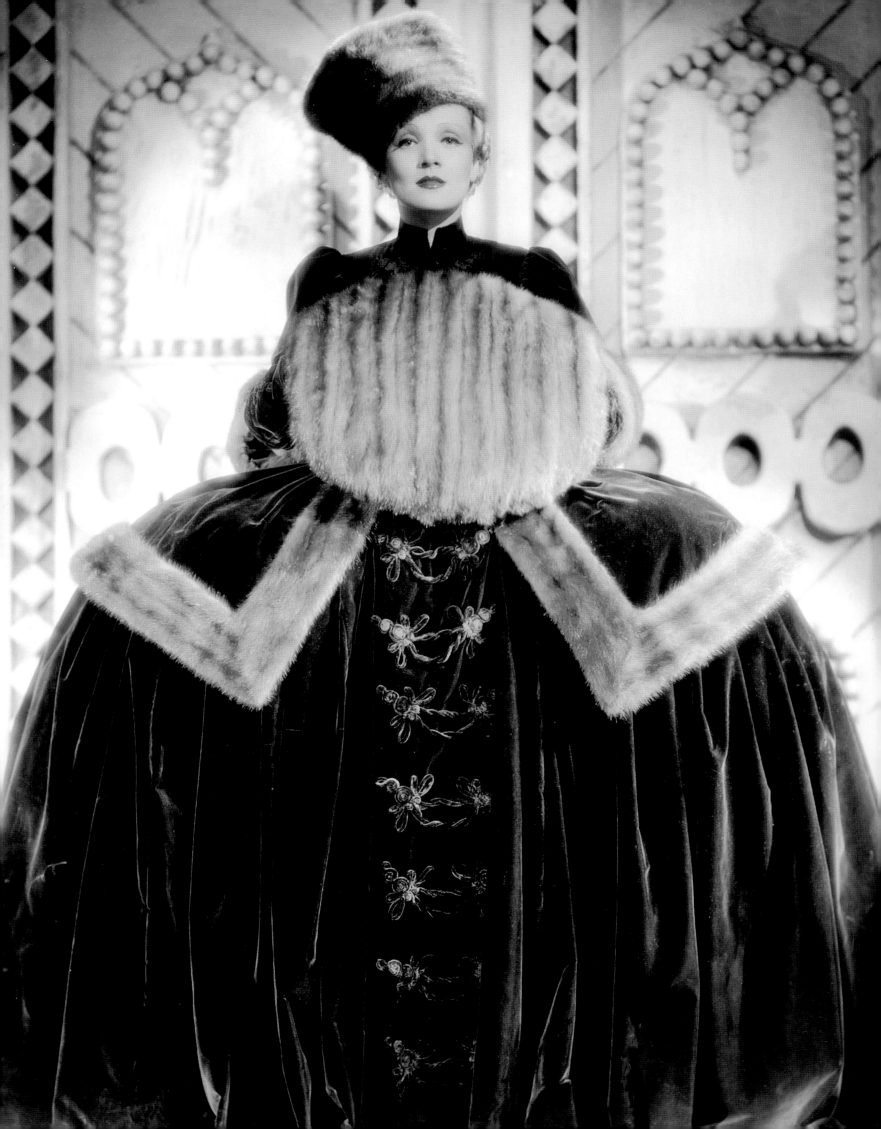

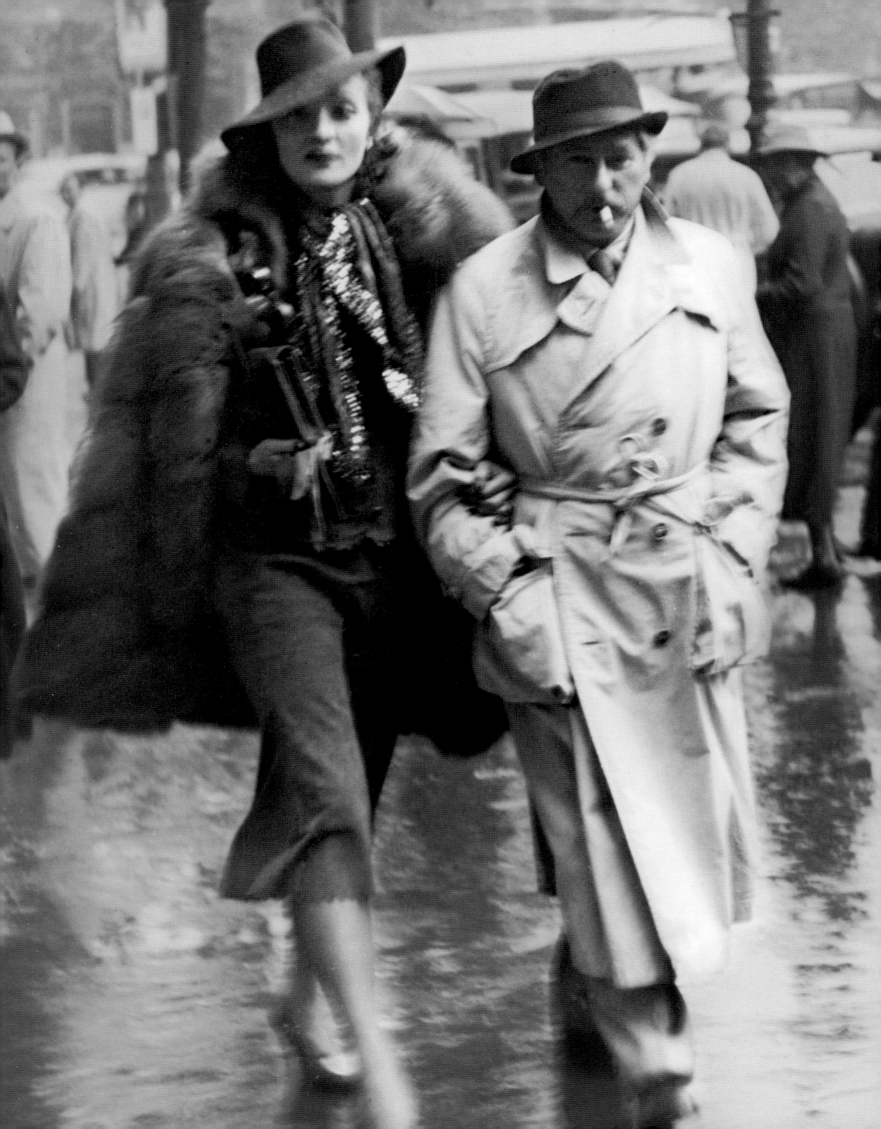

Marlene Dietrich at the Auteuil race course, besieged by autograph hunters. Photograph for the magazine *Voir* dated June 21, 1939.

Facing page:
Marlene Dietrich snapped in 1937 in Paris while out walking on place de l'Opéra on the arm of Josef von Sternberg. The director had it that, "I had excavated an ocean and from it emerged a woman designed to enchant the world."

to do a second take. Disciplined, punctual, aware of the problems caused by the conditions of the shoot, her overriding aim was not to disappoint: "In other words," she later joked, "I was simply too perfect to be true." In Sternberg, her patience and pliability—for which Fritz Lang subsequently reproached her—encountered a domineering personality. Sternberg was of the opinion that it is a woman's nature to be passive, receptive, submissive to male aggression and able to endure suffering. Marlene's attitude could only consolidate this notion. Yet, if she derived pleasure from being objectified and manipulated, on occasion she would put her foot down, although years later she could not speak highly enough of her mentor. As Sternberg liked to point out, he was the man she most wanted to please: "Not only was she more resistant and less sensitive than the others, but she would go to extremes, full of praise for the director while he kept her very much under the critical microscope." Marlene was painfully aware that, before he took control of her career, she had been nothing, and believed it was only through his creative genius that life was breathed into her.

There is a puzzling contrast between the unstinting pressure and subjugation—almost a kind of slavery—she underwent every day on set under the iron fist of her director and the adulation the star enjoyed from the press and her fans. This situation was exacerbated after their second movie of 1930, *Morocco*, a colonial adventure that saw her play opposite Gary Cooper, and which completely won over transatlantic audiences. Sternberg recalls how, now at the zenith of her fame, "she bent to the inevitable. With unerring instinct, she ceased complaining about her 'torment', and transformed herself in a martyr, grateful to the divinity who was so graciously pleased to cover her with wounds." But Marlene was not quite as passive as it seems: some of her ideas on set were taken up and she even had a hand in editing some of the films, with Sternberg initiating her into the techniques personally. Bound to him by her meteoric success (and by clauses in her contracts), Marlene stood by her Pygmalion through thick and thin. During these years she refused to act under another director, because she understood that only Sternberg was able to perpetuate the idolized figure she had become almost in spite of herself. When Nazi Germany offered her a golden handshake, if only she would return to her homeland ("One word from the Führer and all your desires will be realized, *if* you agree to return," the German ambassador whispered to her in Paris), she reminded him of her unfailing attachment to a filmmaker who was, after all, of Jewish origin. They certainly formed a strange, nefarious couple—she still fascinated by the magic of his talent and he protecting her like a china doll, forever at her beck and call. "The

responsibilities he assumed with regard to the actress he desired and the woman whom he escorted were overwhelming," she wrote. And she was to express her gratitude until the end of her life, despite the fact that theirs was a suffocating, overpowering collaboration—a mixture of contempt and wounding criticism, punctuated by arguments and tears. Sternberg did not deny his sadistic streak, but for him the individual was nothing compared to the creative mission he had been assigned and he justified his cruelty in the name of art: Does anyone accuse a sculptor cutting his stone or modeling his clay of sadism? And, whatever Marlene's sufferings, nothing diminished her passion for the remorseless master, a guardian who also served as her shield through the Hollywood jungle, and whose authority, skill, and tutelage were irreplaceable.

An ambiguous figure

Marlene's daughter, Maria Riva, contends that her mother was a master at plotting, lying, willfully forgetting, and at many other dastardly tricks—though sometimes she was hoist on her own petard. To Sternberg, on the other hand, Marlene's personality appeared honest and straightforward, comprising equal doses of extreme sophistication and almost childlike simplicity: a paradoxical being, prone to serious depression followed by outpourings of breathtaking energy. If the filmmaker certainly changed her—altering her hair color, having her eyebrows plucked, using makeup to make her face look thinner—he did not try to endow her with a personality *entirely* at odds with her own. Rather, he selected, accentuated, and dramatized her charms, in order to make them more visible.

If there was one aspect of her personality that Sternberg did exacerbate and emphasize, it was her androgyny. Even before they met, on stage the ever-provocative Marlene had already sported a monocle (a telling detail: it was her father's). If the full-bodied woman Sternberg modeled for *The Blue Angel* was unsophisticated, brash, and regarded as a "new incarnation of sex," the mysterious and aloof figure in *Morocco* and in later films was a different animal entirely. In one scene, dressed as a man, she kisses another woman on the mouth. Sternberg wrote, "I had seen the decorous little German housewife dressed as a man in a Berlin beer hall and came up with the idea of having her put on men's clothes for a sequence in a café during which she would sing in French, walk among the audience, and give another woman a kiss. A tuxedo endowed her with considerable charm, and I did not want just to bestow a light lesbian touch to her look . . . but to also prove that her sensual attraction was not solely due to the classic shape of her legs."

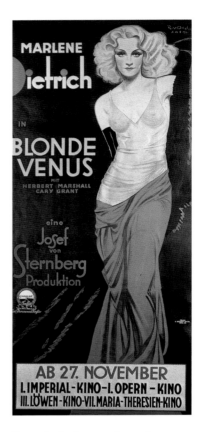

Poster for the German release of *Blonde Venus*, shot in 1932 by Josef von Sternberg. Resembling a contemporary version of the Venus de Milo, Marlene is presented wearing an extremely revealing negligee.

Facing page:
Still of Marlene Dietrich from *The Devil is a Woman*, made in 1935 by Josef von Sternberg. The screenplay by John Dos Passos was adapted from Pierre Louÿs's novel *La Femme et le Pantin*. This was the last film they were to shoot together, and Marlene's favorite.

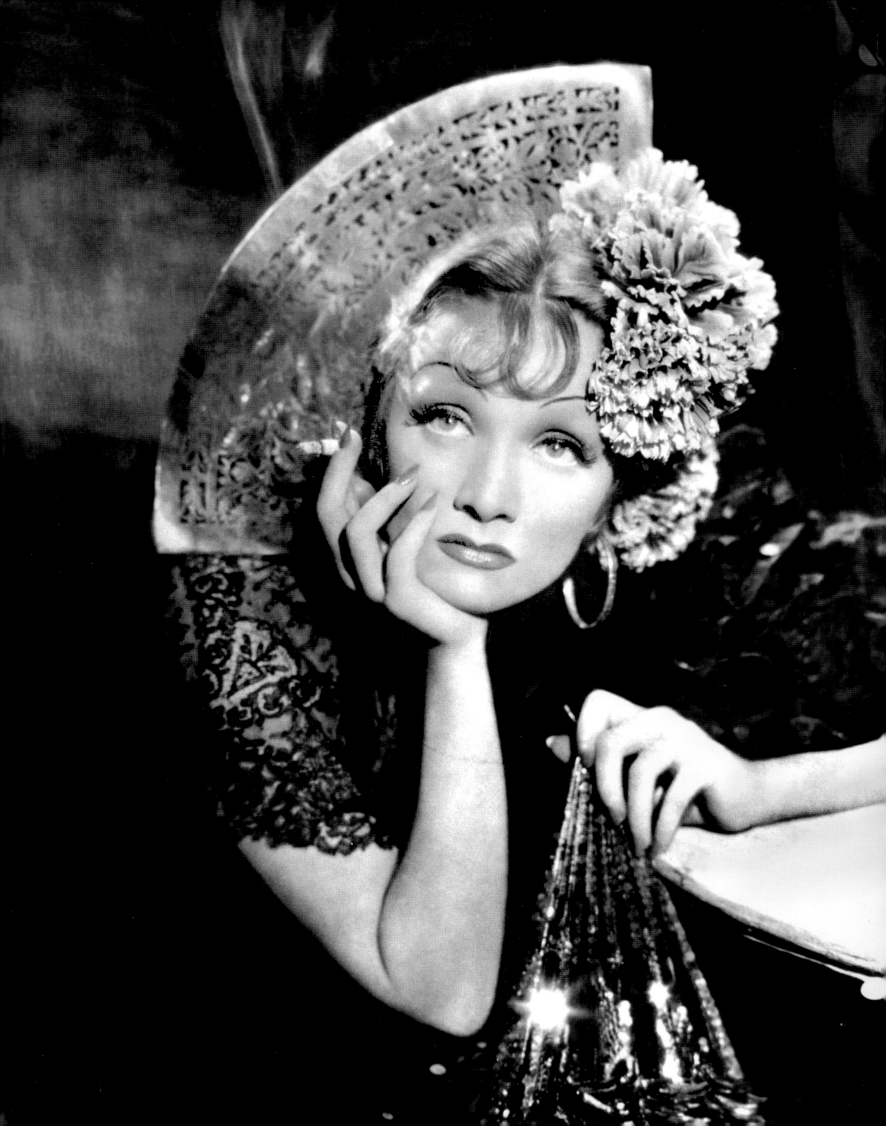

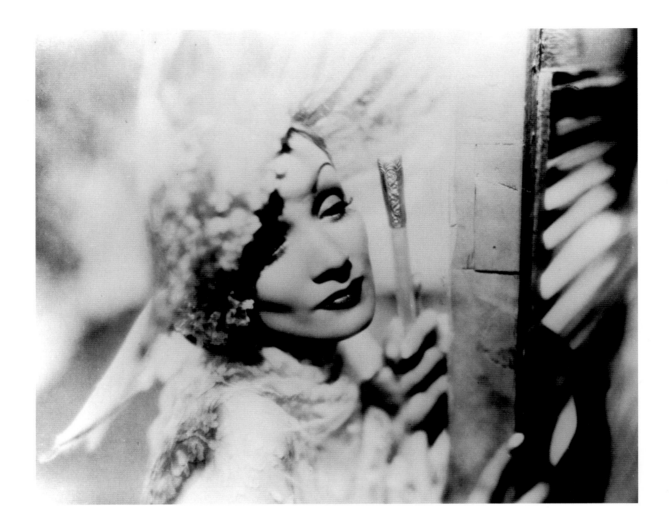

Marlene's real-life bisexuality is beyond question and her relationships with men could be strained (her daughter mentions frigidity). A passionate affair with the Spanish-American poet and artist Mercedes de Acosta (Greta Garbo's celebrated love interest) is well documented. A number of biographers, waving a photograph of them enjoying a French kiss, credit her with an affair with Edith Piaf. Sternberg continued concocting his fantasies, exploiting her ambivalences and replaying the fetishistic scenes of cross-dressing. Setting aside the men's formal wear, he bedecked her in feathers for *Shanghai Express* (1932), while in *Blonde Venus* (1932) she wore a gorilla outfit, and in *The Scarlet Empress* (1934) played the role of a domineering princess in uniform. "An androgynous creature, she entertains sadomasochistic relationships with older men, willing victims, who strangely, like Adolphe Menjou (*Morocco*) and Lionel Atwill (*The Devil is a Woman*), sometimes recall the director in physical appearance," noted film critic Michel Ciment. Valid or not, his observation reveals something crucial: the game of smoke and mirrors that had always characterized relations between the filmmaker and his muse.

Above:
Another portrait of Marlene from *The Devil is a Woman*. In an exotic and baroque Spain, Antonio Galvan falls in love with cabaret singer Concha Perez, a devious and heartless femme fatale played by Marlene.

Facing page:
Portrait of Marlene Dietrich by Eugene Robert Richee taken on the set of *Shanghai Express*. This was her fourth collaboration with Josef von Sternberg and met with international success, Marlene's masterly interpretation being acclaimed by all. The magnificent concoction of black feathers was once again designed by the costumer Travis Banton.

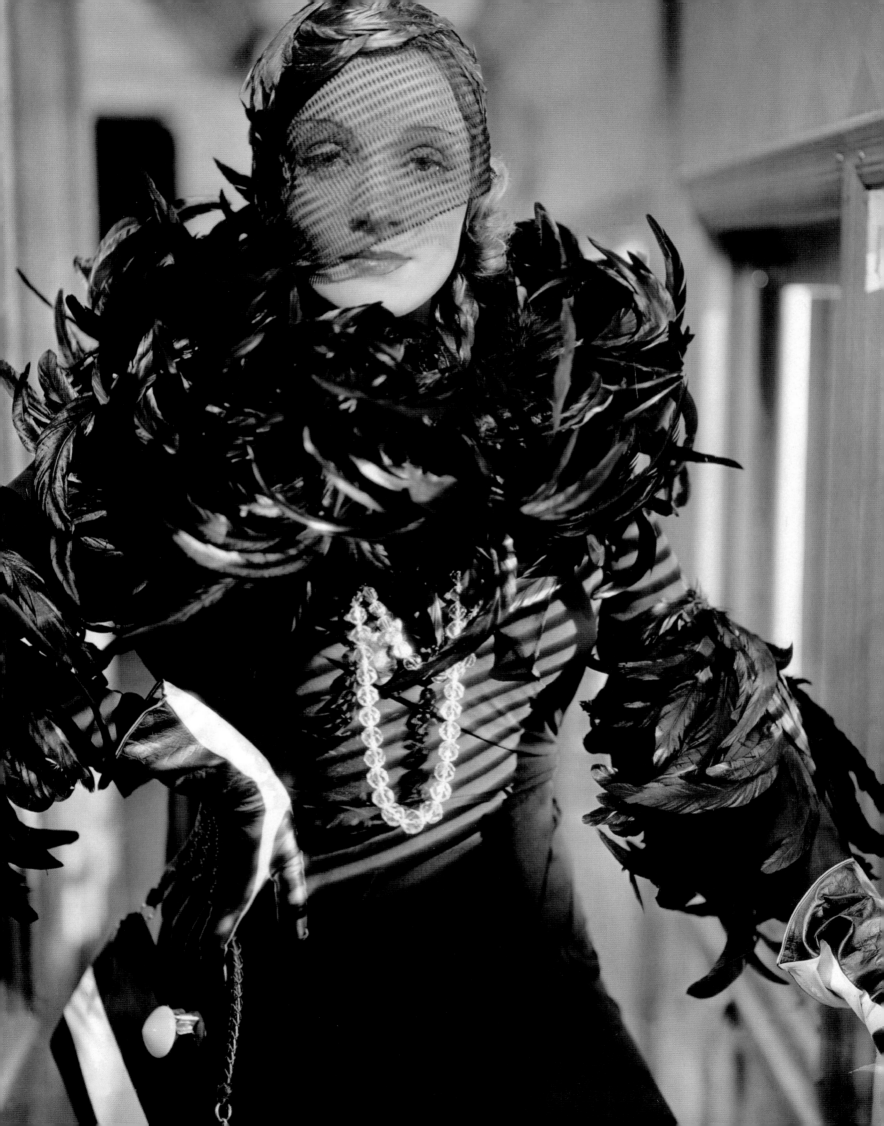

Nancy Cunard

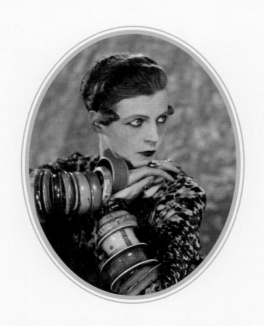

Aragon's temptress

The name Cunard is synonymous with the transatlantic liner. It was Nancy's great-grandfather, an English engineer and businessman, who set up the steamship company, soon finding himself at the head of a vast industrial empire. Born in 1896, Nancy, like all aristocrats of the time, was brought up by a succession of governesses. Nancy's mother, Maud, an American heiress and golf widow, provided Nancy with the model she was to keep to throughout her life: that of a seductress with a penchant for brief affairs. Maud had friends among the most famous artists, politicians, and adventurers of her time, and Nancy grew up in an environment where ostentation vied only with cleverness. As a teenager, she embarked on a lengthy affair with a onetime lover of her mother's, the novelist George Moore, to whom she devoted a book in the 1950s. Living a gilded, if slightly scandalous, bohemian existence, after a series of lovers and a failed marriage she became smitten with the young surrealist poet Louis Aragon, probably due to her attraction to things avant-garde. This great and, in the end, unhappy love affair marked Aragon's work to such an extent that his wife Elsa Triolet confessed, "People always talk about the poems Louis wrote for me. But the most beautiful were for Nancy."

Nancy Cunard photographed by Man Ray in 1926.

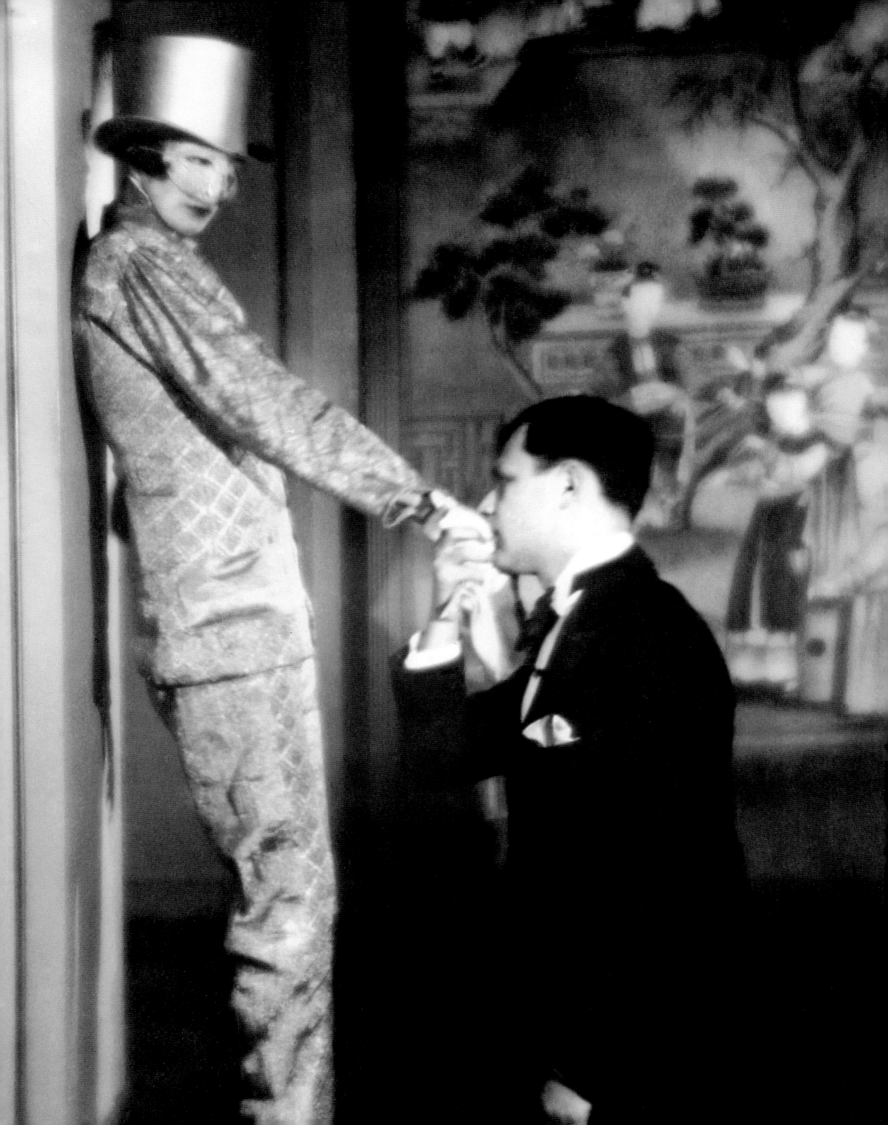

"Miss Nancy Cunard" makes the cover of *The Sketch* magazine on September 25, 1929, photographed by Cecil Beaton, who was fascinated by her somewhat androgynous appearance.

Facing page:
Nancy Cunard with Tristan Tzara at a ball thrown by Count Beaumont, 1924.

A virile, independent muse

Nancy's short-lived marriage to British aristocrat Sydney Fairbairn had dominated the society pages in 1916, but they separated only twenty months later, although they would not be legally divorced until 1925. After the couple began living apart in 1918, she devoted her time to poetry. The following year, contracting—like so many others—Spanish flu, she made her way to the French Riviera to convalesce. France then became a second home to her, and she immersed herself in the works of French writers such as Maupassant and the then much-vaunted Anatole France. In 1920 she took as her lover a young Armenian author of a singularly successful collection of stories entitled *The London Venture*. Dikran Kouyoumdjian—who changed his name to Michael Arlen—placed Nancy at the center of his second novel *The Green Hat*, which became an international bestseller. Appearing in the shape of the free-spirited and unconventional Iris, the portrait Arlen paints of Nancy underscores her unusual and individualistic character: a princess of the night who lives for parties, music, and alcohol. As the work's narrator recounts, "You had a conviction, a rather despairing one, that she didn't fit in anywhere, to any class, nay, to any nationality. She wasn't that ghastly thing called Bohemian; she wasn't any of the ghastly things called society, county, upper, middle, and lower class. She was, you can see, some invention, ghastly or not, of her own."

Although her unconventionality made her in some respects a proto-feminist trailblazer, Nancy's independence manifested itself in outright promiscuity. In 1920, gynecological complications forced her to have a hysterectomy, and the figure of the femme fatale was thus complete. After Arlen, it was the turn of Aldous Huxley to fall for the chilly and detached Nancy. His second novel, *Antic Hay* (1923), describes his fascination with the beautiful, cruel, and maliciously manipulative Myra. Another of Huxley's novels, *Point Counter Point*, again tackles the theme of female cruelty. Depicted as incapable of feeling, and quite unlike any other member of the fair sex, the protagonist is a relentless predator who takes possession of a man's soul. Huxley's masochistic efforts—he never managed to breech the wall of her indifference and infidelity—are not without echoes of Aragon's subsequent and equally fruitless endeavors.

In 1921, Nancy, now living in Paris, became a friend of Ezra Pound and published her own collection of poetry, *Outlaws*: "[I] am the perfect stranger, / Outcast and outlaw from the rules of life." After a fling with British modernist painter and novelist Wyndham Lewis, the driving force behind the vorticist movement and creator of two portraits of her—one in a novel and the other a drawing—Nancy frequented that madcap zoo

of the Jazz Age, the cabaret Le Boeuf sur le Toit. She also found time to smoke opium with Jean Cocteau, at smoke-filled soirées organized by aesthete and hedonist Jean Guérin. The unimpeachably Dada Tristan Tzara, meanwhile, also became close to her, encouraging her inclination to eccentricity still further. After a passionate affair with writer Norman Douglas, with whom she was to remain on friendly terms, she was painted by the expressionist Oskar Kokoschka in 1924. In 1925, she met the Fitzgeralds, leaving a lingering impression on Scott when, nine years later, he came to write *Tender is the Night*, where the boyish character she inspired is qualified as "frightening." At the end of that year, she spotted Louis Aragon, well known for his legendary good looks, sitting in a taxi. Sidling up to him, she sparked what he would call the "first great affair" of his heart.

A murderous love

Born in Neuilly-sur-Seine in 1897, Aragon was the illegitimate son of Louis Andrieux, the commissioner of police and onetime senator, and Marguerite Toucas. The founder of the avant-garde journal *Littérature*, with André Breton and Philippe Soupault in 1919, Aragon was a member of the Dada movement, before becoming one of the founders of surrealism, joining the Éluard circle. By the time he met Nancy, he had already published two collections of poetry and four novels. He was toiling away on the La Défense de l'infini ("Defense of the Infinite"), a plethoric work over which he had already spent several years, and which he would later burn in 1927, in Madrid, after yet another argument with Nancy. An underground production (it would surely have been censored if it had ever been printed), the erotic fragment *Le Con d'Irène* (*Irene's Cunt*) is an extract, with the character of Nancy occupying a central place. Over the decades, other sections of the book that were snatched from the flames have emerged. (Nancy, for her part, rescued 248 sheets now preserved at the University of Texas.) Certain passages bear witness to the wealthy heiress's incredible powers of attraction: "Positively intoxicated, she feels she could seduce the whole world. Nobody must be allowed to escape. She snaps up even the most redoubtable lover with a yawn, the mistress trailing him briefly in her wake. A hunter of locks of hair, she likes to clothe her body in sobs."

Nancy and Aragon spent most of their first year together traveling, in Holland, Spain, and Italy. England, too, was a frequent destination, where they combed junk shops in search of "Negro" art. They also both worked for the Hours Press, the publisher and art printers set up by Nancy. Wherever they were, they stayed up until all hours in nightclubs, brothels, and cabarets.

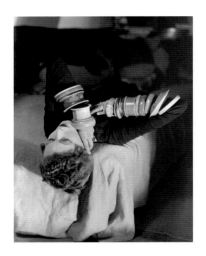

Nancy Cunard had been living in Paris for five years, hobnobbing with avant-garde artists. Among her coterie were Ezra Pound and Wyndham Lewis, as well as the eccentrics of Dada and the surrealist movement, like her friend Tristan Tzara, and Man Ray, who took the 1926 portrait shown here.

Facing page:
The English aristocrat had a passion for traditional African ebony and ivory body ornaments, often wearing them for photo shoots or when out on the town. This photo was taken in Harlem, New York, on May 2, 1932, while she was researching her anthology *Negro*.

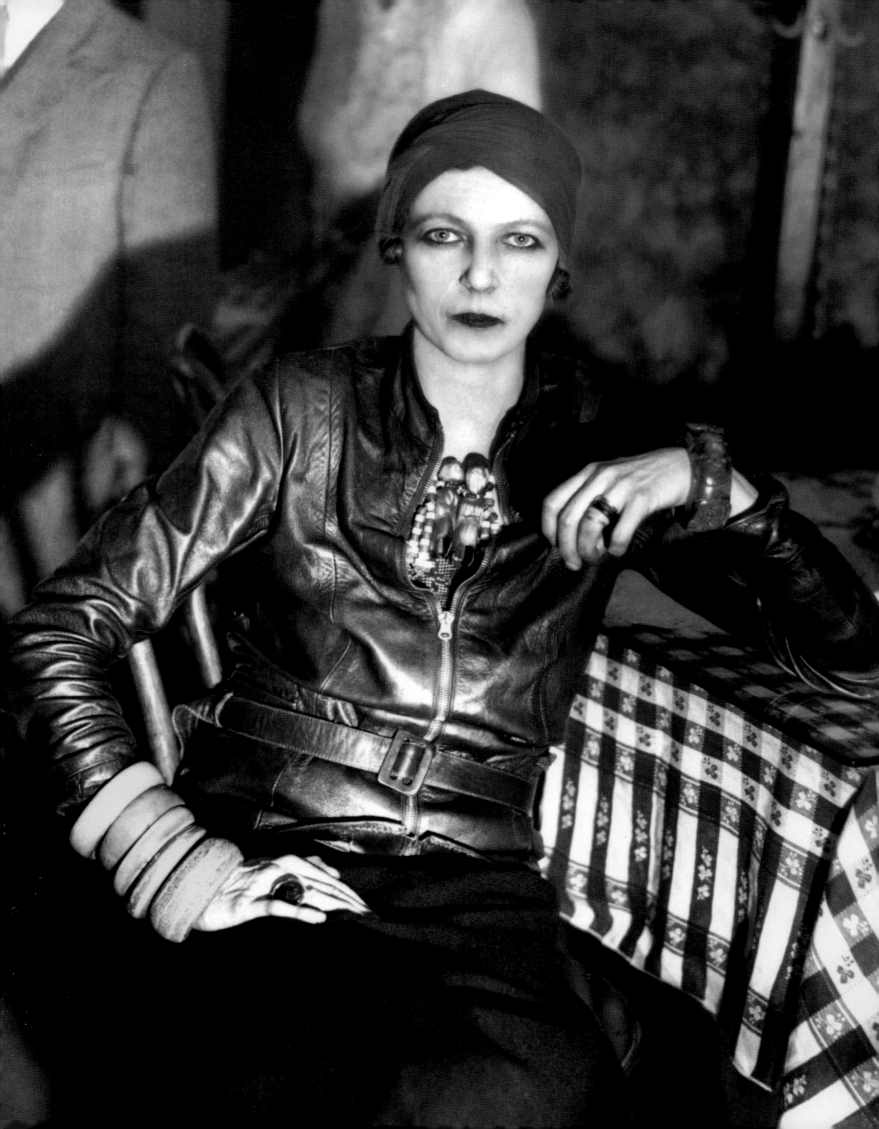

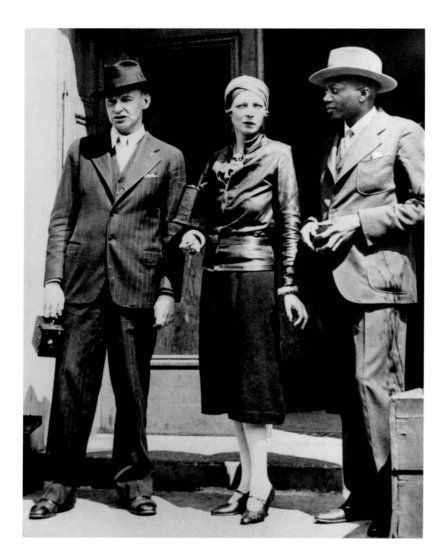

Nancy Cunard standing outside the entrance to the Grampion Hotel in Harlem on May 2, 1932, flanked by John Bantry (on the left) and her lover Henry Crowder, a musician and pianist in the jazz band Eddie South and his Alabamians. Their love affair was particularly intense.

When in Dieppe, Monte-Carlo, or Biarritiz, they frequented casinos or other pleasure spots for coke-fueled insomniacs and fans of the Charleston. Alcohol had already begun to take its toll on Nancy's volcanic nature and she increasingly exploded into violence. In addition to the disparity in wealth, which gnawed away at their relationship, Aragon suffered from the lack of affection on her part and from her combination of infidelity and possessive jealousy. In 1927, while staying not far from Dieppe in Normandy, he was deeply upset to discover that Nancy was having a fling with his longtime friend André Breton. In 1928, as was her habit, Nancy rented a palazzo in Venice; Aragon accompanied her, in spite of a relationship now at boiling point. The couple argued incessantly and Aragon became increasingly febrile, narrowly escaping death after a deliberate overdose of sleeping pills, which rang the death knell for their affair. Although Nancy blithely continued her life unscathed, Aragon's wounds took longer to heal. Despite this, he continued to visit Nancy from time to time, but she, with her self-destructive character, was just not made for a stable relationship based on

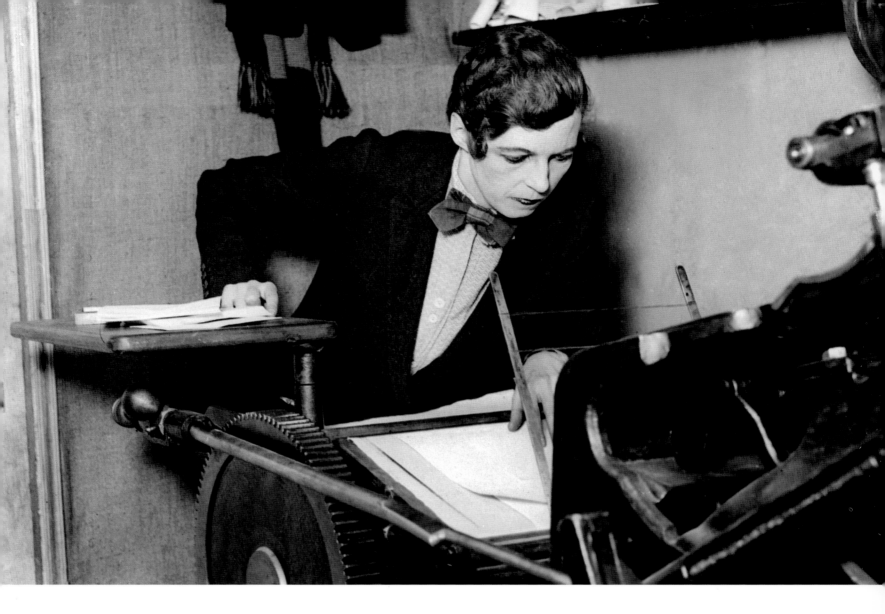

Nancy Cunard in her studio, which published art lithographs, c. 1930. Her passion for literature saw her publish many works, including the first published work by the young Samuel Beckett, *Whoroscope*, in 1930, with a print run of three hundred.

trust. She was motivated by the desire for change and by ephemeral thrills. As the surrealist André Thirion noted, "When she wanted someone, her desire had to be satisfied immediately, without further ado; she attacked; it is difficult to imagine the torture that such unpredictable inconstancy and her yearnings inflicted on her lovers." In a remaining fragment from *La Défense de l'infini*, Aragon himself wrote, "She was devoted to risk, she plays an impossible game, she'll not lose it without grandeur." Nancy's last years, however, contradicted this prediction.

Militancy and a wretched end

In Venice, Nancy met the African-American musician Henry Crowder, a pianist in a jazz band called Eddie South and his Alabamians, and embarked on a great love affair. Back in Paris, she pursued her adventures as an author and publisher, while in London she posed for Cecil Beaton, the society chronicler for *Vogue*, who portrayed her as a stylish eccentric. It was Nancy who inspired the boyish, surrealist image for women typical of the Jazz Age. Author Roger Vailland, in an article entitled "The Great English Lady," explained how she had to leave her homeland because she could not "give free rein to her sensuality without scandal." She then fell under the literary charm of a young Samuel

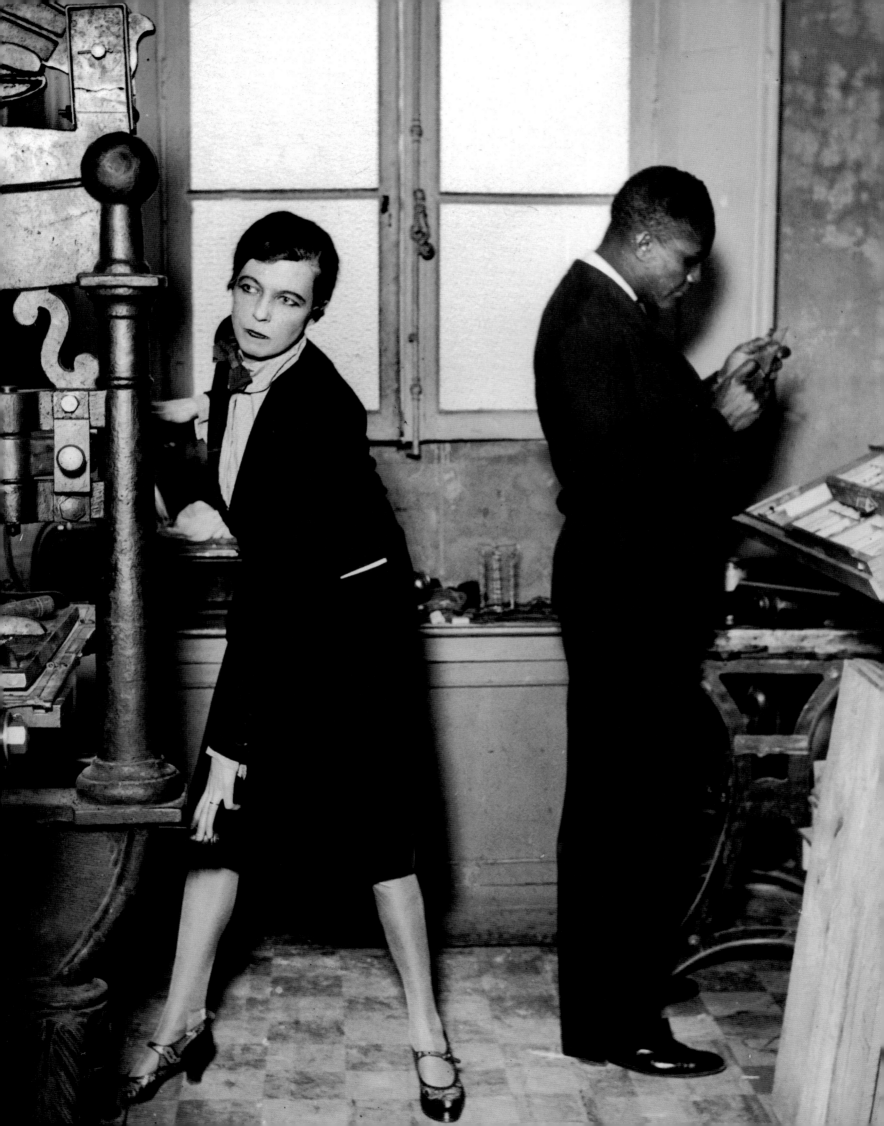

Portrait of Nancy Cunard from about 1925 by the photographer Curtis Moffat, another friend and lover. One in a series of highly theatrical poses, here she sports an extravagant feather headdress.

Facing page:
Nancy Cunard in her lithography studio in about 1930 with Henry Crowder, whom she met in Paris. It was probably her affair with Crowder that sparked her militant stance against racial segregation. In 1931, she published an antiracist book, *Black Man and White Ladyship*, which scandalized members of her social milieu, especially her mother.

Beckett, with the Hours Press publishing his first book, *Whoroscope*, in a print run of three hundred in 1930.

Around this time Nancy severed old ties, distancing herself from her mother in particular, who could not tolerate Nancy's relationship with a black man. Taking up the fight against racism, she visited Harlem, denounced segregation in the United States and, from 1931–34, embarked on the ambitious anthology designed to advance black culture, *Negro*. Her commitment and activism in the United States earned condemnation and death threats from the Ku Klux Klan. In 1935, now definitively separated from Crowder, she visited Cuba and Jamaica, and then traveled alone to Moscow. The four following years were dominated by the Spanish Civil War. By 1936, she was living in Madrid where she struck up a relationship with Pablo Neruda, who recalled, in his *Memoirs* a "Quixotic" woman "inalterable, fearless, and pathetic, Nancy was one of the strangest people I have ever known." In 1939, in a report for the English newspaper the *Manchester Guardian*, she testified to the plight of Republican refugees at the Pyrenean border; her subsequent articles on the subject were revealing. After traveling to Chile, where she joined Neruda, and to Mexico and Cuba, she arrived back in London in 1941, before becoming a translator for the French Resistance during the summer 1943. After World War II drew to a close, she returned to La Chapelle-Réanville in the Eure, France. In spite of her age, she continued her conquests of young men bedazzled by her antics.

In 1956, on the publication of Aragon's *Roman inachevé* ("The Unfinished Novel"), which recalled the time they spent together on the Île Saint-Louis in Paris, she wrote to him, "There are thousands of 'OK' people, more or less similar, more or less different. BUT THERE IS ONLY ONE YOU." Alcohol, to which she remained faithful throughout her life, irremediably damaged her health. The Queen of the Night, muse of the Jazz Age, was turning into a ghost from another age. After spending a few days in jail for trying to organize a solidarity network for political prisoners, Nancy was expelled from Spain in 1960, and arrived in London in a psychotic state. She was even arrested for being drunk and disorderly, and for soliciting on the King's Road in Chelsea. In a letter she addressed that same year to one of her friends, the American writer Janet Flanner, she alleged she had been loved by only one man, Aragon, and it was him she carried in her heart. In 1965, and as thin as a rake, she descended into mental illness, terrorizing the few friends she still had and turning up uninvited at their homes. Later, in Paris, she found herself out on the street after having tried to set fire to the hotel room where she was staying. Admitted to the Hôpital Cochin, this woman of strong ideals and a great promoter of literary talent died in the solitude of a communal ward a few days later, on March 16, 1965.

Tina Modotti

The bittersweet muse of Edward Weston

Portrait of Tina Modotti (detail), dated 1921, most likely taken during the beginning of her short-lived movie career in Hollywood. She had just become acquainted with Edward Weston, and their relationship was to change her life.

At the end of 1925, Tina Modotti wrote a letter to Edward Weston, now considered one of the greatest American photographers of the twentieth century. Blessing the day they met in 1920, and realizing they could learn from one another, she wrote, "The little prints of the portraits you took of me are so beautiful! Just the fact you have made such immortal photos of me shows your ability to bring out the best in me." They had met in Los Angeles when Tina was then playing minor roles in Hollywood, and Weston was slowly making a name for himself, obtaining an award in 1915 for his participation at the Panama-Pacific exhibition. By sheer coincidence, Tina had met her future husband at that exhibition, the painter and poet Roubaix de l'Abrie Richey (known as Robo), whose wife she became two years later. By the end of 1920, when Tina's relationship was on the rocks, she and Weston met again through bohemian artistic circles. Though now married and the father of four boys, the photographer remained a tireless seducer and the pair soon fell in love.

An Italian in Hollywood

Assunta Adelaide Luigia Modotti Mondini was born in August 1896, in Udine, in the province of Friuli-Venezia-Giulia. Her family's nickname, Assuntina, was soon abbreviated to Tina. The daughter of a mechanic, she lived with her family in Klagenfurt, Austria, until 1905, before returning to her birthplace. The following year her father decided to leave alone for the United States, hoping to improve his finances sufficiently to be able to send for his family later. By the time she was twelve, Tina had had to take a job to help her family make ends meet, and she was already lending a hand in the studio of her uncle, a photographer and portraitist. In 1913, she joined her father in San Francisco. He, too, set up a studio, but it closed within a year. While he returned to the mechanics workshop, Tina's sister joined a clothing company, soon followed by Tina, who went on to model its new lines part-time. In 1914, Tina began acting with a local theater troupe, meeting her husband-to-be the following year. Tina was often noticed at auditions and in performances, and the leading newspaper in the district was gave her a glowing review. After joining the Moderna troupe, a critically acclaimed repertory company on Washington Square, she and Robo married and left for Los Angeles, where Tina hoped to carve out a niche for herself in the emergent movie industry. In 1920, Tina landed her debut role in a melodrama, *The Tiger's Coat*, and then took part in two other films. But then her career stagnated, probably because, as Weston noted with irony, "the brains and imaginations of movie directors cannot picture an Italian girl except with a knife in her teeth and blood in her eye."

Lover, model, assistant

If Tina had already posed a few years previously for the sculptor Portanova, the photographers Jane Reece and Arnold Schröder, and stills' specialists whose images were intended to promote her screen image, never had she offered up her body to an artist's inspiration as freely as she did to Weston in 1921. She seemed determined from the outset to give rise to truly exceptional photographs. Weston, from a well-off background, had first used a camera—a gift from his father—when just sixteen in 1902. Four years later, he settled in California and tried to make his way in the profession. Marrying Flora May Chandler in 1909, he then opened a studio at Tropico and published various articles on the art of the darkroom. In 1921, his creative style was still dominated by pictorialism, but little by little he was abandoning its aestheticizing effects. Choosing increasingly geometrical subjects and then slices of everyday life, he nonetheless still accepted commissions for conventional portraits and nudes. As

Portrait by Wallace Frederick Seeley of Tina Modotti wearing a kimono that she had decorated herself, Los Angeles, 1921. The Cuban writer and art critic Loló de la Torriente described Tina as follows: "Not very tall, her body supple and well put together, soft and curvy, a very expressive face, eyes of an ardent black, a sensual mouth, auburn hair, a broad face, delicate, fine hands. The slow, steady stride, the soft voice, her look, gentle but spry. In her, everything was natural."

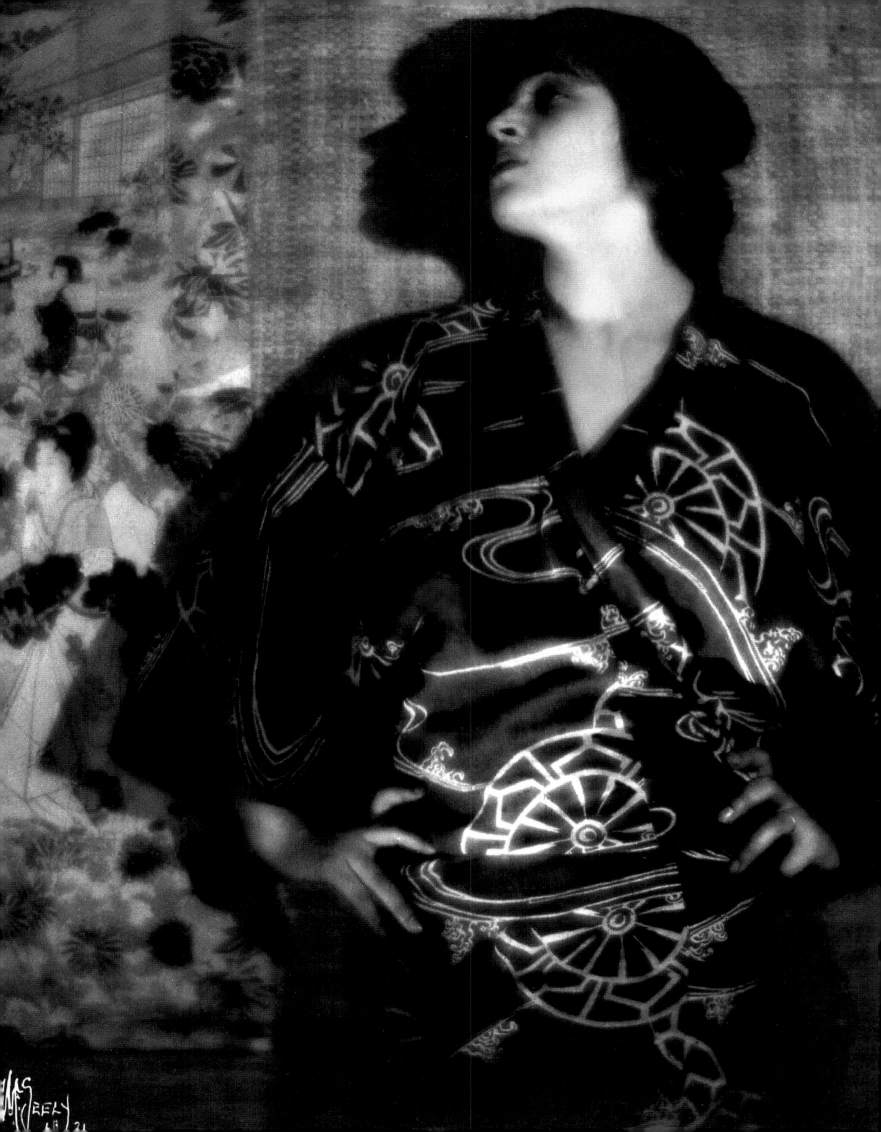

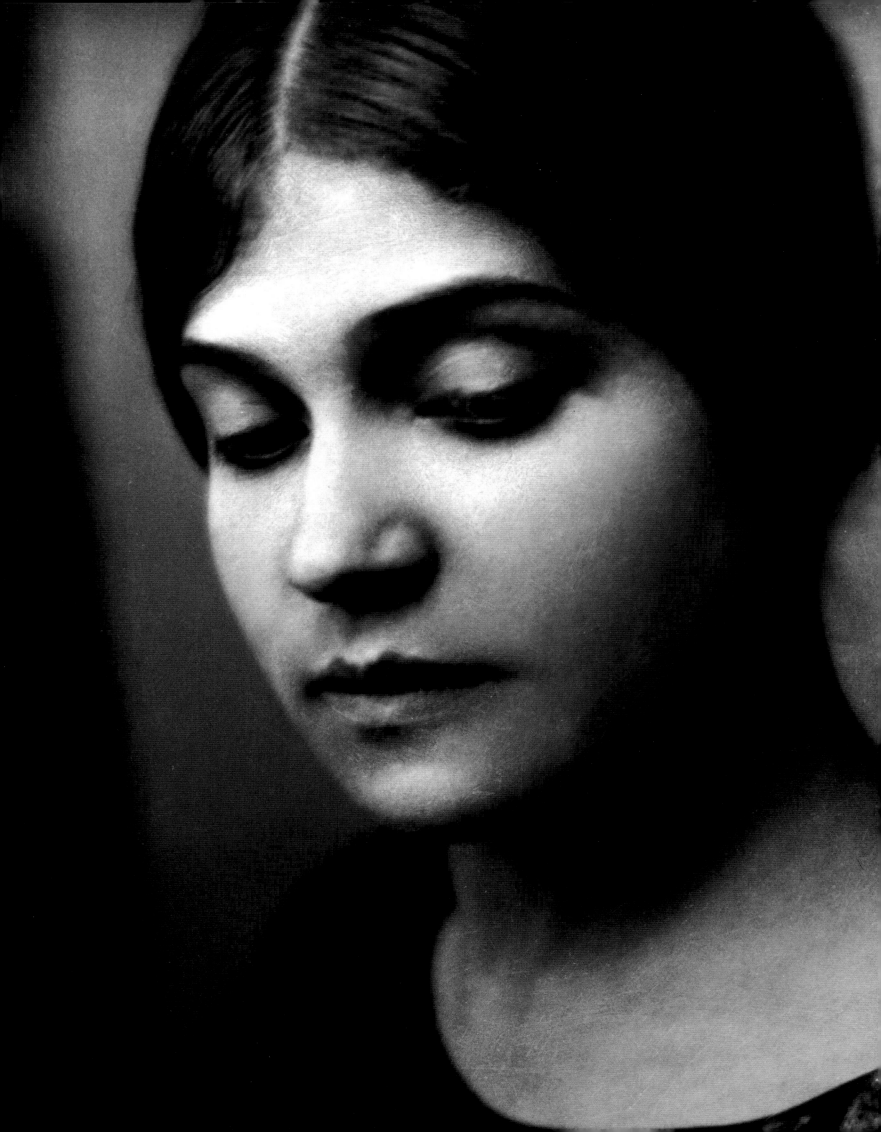

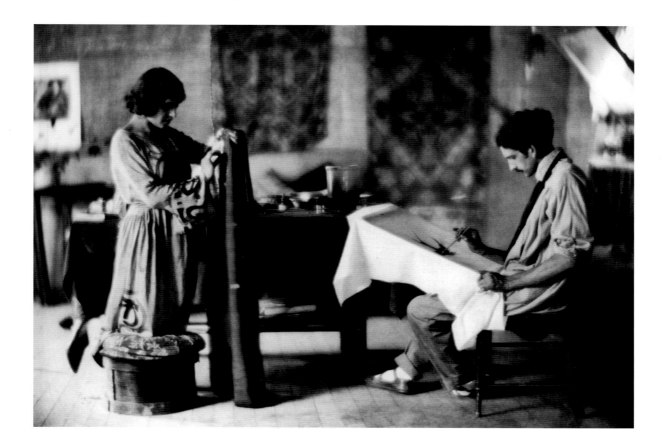

Facing page:
A 1921 portrait of Tina Modotti by Johan Hagemeyer, a friend of Edward Weston's, who confessed some time before this picture was taken that her assistance had been invaluable in some of his finest photographs.

Above:
Tina Modotti with her husband, the poet and painter Roubaix de L'Abrie Richey, known as Robo, in about 1920, in their studio-house in Los Angeles. They eked out a living painting on cloth in the manner of batik. They had met in 1915 and married two years later, but she left him for Edward Weston in 1921. Struck down by smallpox, Robo died on February 9, 1922.

Weston and Tina's relationship grew, Tina was reluctant to accompany her husband to Mexico, who went by himself to Mexico City, presenting work by his artist friends—including some of the pictures Weston had taken with his wife. Not long afterwards he fell unexpectedly and gravely ill and Tina rushed off to join him. The disease turned out to be smallpox, and he died before she arrived at the hospital on February 9, 1922. Tina was deeply affected by his death, and suffered a further shock the following month with the death of her father. She paid tribute to her late husband in the form of an exhibition and a publication.

In nearly 1923, Weston encouraged her to take up photography, perfecting her knowledge of its techniques; in time, she became his apprentice. In July of that year, with Weston now separated from his wife, they embarked together on the *SS Colima*, which set sail for Mexico. To avoid becoming a burden to one another, they granted each other considerable latitude in their emotional lives, but this false "freedom," in which Tina's room for maneuver was in fact sorely limited, already bore the germ of the end of their great love.

1924

"The new head of Tina is printed. Along with Lupe's head it is the best I have done in Mexico, and perhaps even the best I have done at all. But while the face of Lupe is heroic, the head of Tina is noble, majestic, exalted;

they contain at once the innocence of natural things and the morbidity of a sophisticated, distorted mind." The following year, it is Weston's turn to make the following confession: "Tina dear, if I have been an important factor in your life, you have certainly been in mine. What you have given me in beauty and fineness is a permanent part of me, and goes with me no matter where life leads."

> *"The slow, steady stride, the soft voice, her look, gentle but spry. In her, everything was natural."*
> *Loló de la Torriente*

After a relationship with the communist painter Xavier Guerrero, Tina fell for a young Cuban revolutionary, Julio Antonio Mella, who was assassinated in January 1929, while returning home with her one evening. Mexican justice, after first suspecting the young woman of complicity, later exculpated her. Soon she was again in trouble, however, this time accused of involvement in an assassination plot against the Mexican president. Deported to Europe, she entered an enforced exile under the tyranny of a new companion, Vittorio Vidali, a militant working for Comintern. Having begun to use photography to testify to the often cruel reality of Mexican life and so denounce the political system—while Weston had always been more of a formalist—Tina now gave up the medium entirely. By 1931, she was in Moscow joining the Communist Party, dedicating her efforts to International Red Aid, an organization assisting persecuted militants. Setting up a branch in Paris two years later, she enlisted on the side of the Spanish Republicans in 1936. Nursing casualties in hospital, she also played a role in liaison. When Barcelona fell into the hands of pro-Franco forces in 1939, she retreated to France, still flanked by Vidali, who was suspected of overseeing a large number of summary executions. Refused asylum in the United States, the couple returned to Mexico, where they lived hand to mouth. In 1941, in the night of January 5–6, while returning from a dinner, Tina died of a heart attack in a taxi.

Pablo Neruda penned a long poem by way of epitaph: "Tina Modotti, my sister, you do not sleep, no, you do not sleep: / perhaps your heart still hears yesterday's rose / blossom, the last rose of yesterday, the new rose / Rest easy, my sister."

The White Iris, by Edward Weston, 1921. A true masterpiece of Weston's art, in this photograph Tina Modotti appears ethereal, surrounded by the expressive subtlety of the flower's fragrance. At this time Weston had not yet freed himself from the poetic aesthetics of pictorialism, a current in photography that specialized in vaporous settings and intimate atmospheres.

Lee Miller

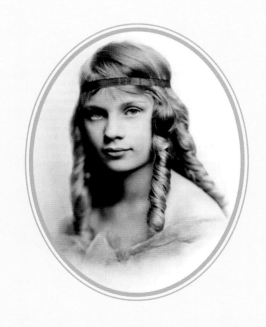

Man Ray's demon angel

Portrait of Lee Miller aged eleven. This photograph was perhaps taken by her father, who was an amateur photographer.

One rainy October day in 1932, a man tramped down a street in the Paris district of Montparnasse, a revolver in his pocket. Passionately in love with Lee Miller, with whom he had shared years of creativity and intense passion, Man Ray took their separation hard. Against his will, she had just booked a crossing on the transatlantic liner *Île-de-France*, scheduled to depart for New York in just a few days.

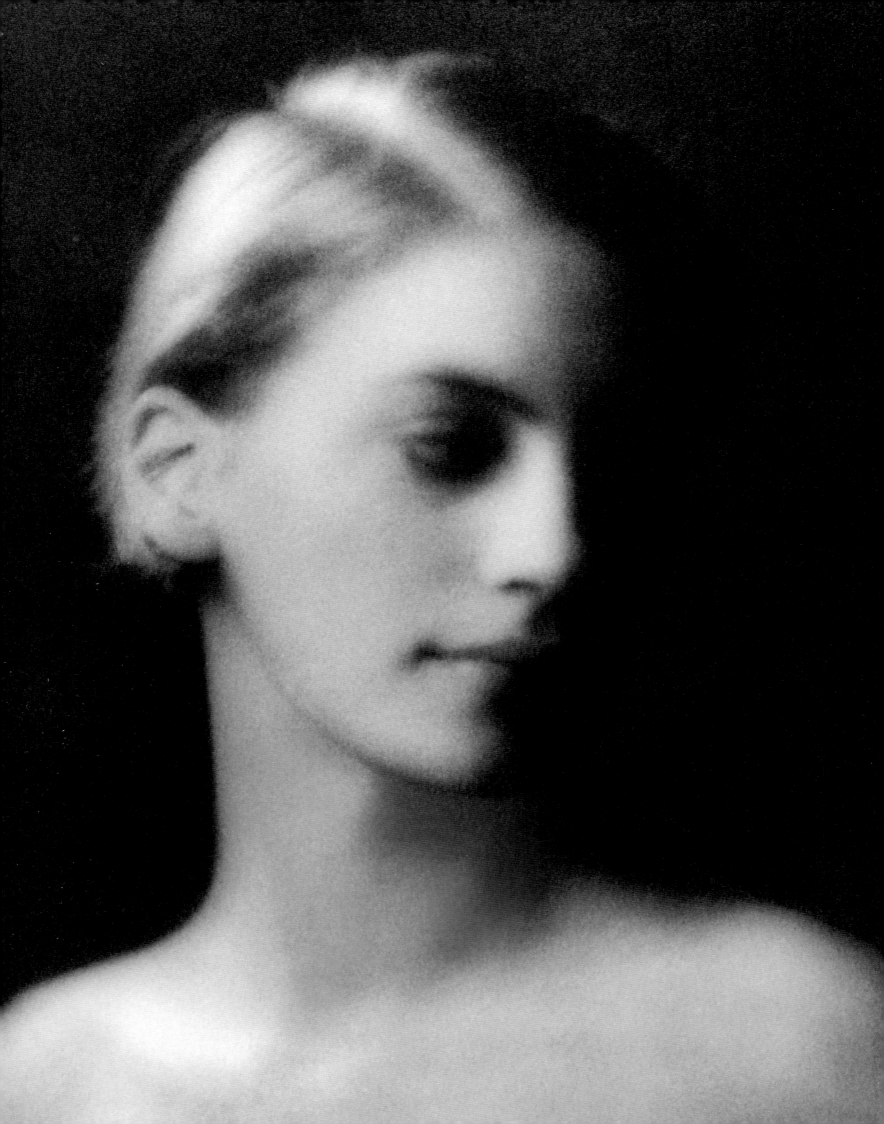

"I am always in reserve"

Moments before, he had sent her a letter containing a leaf torn from his notebook, on which he had sketched her classically perfect features, with her name scribbled over it in black: *"Elizabeth Elizabeth Elizabeth Elizabeth Lee Elizabeth."* Adding: "Accounts never balance, one never pays enough. . . . I love you, Man." In guise of a postscript, the envelope also contained the picture of his eye cut out of a photo, on the back of which he had written some lines that ended, "I am always in reserve." The miserable lover still hoped to win back the woman who had been simultaneously his muse, his assistant, his collaborator, and his life partner. Even in these very last instants, the seeing eye remained at the center of their relationship. Yet, nonetheless, it was during this depressing autumn day that a love story that had started in spring of 1929 came to its brutal end. The soaked Man Ray washed up in the Café du Dôme, where he bumped into Jacqueline Barsotti. Brandishing his weapon, his intentions left little room for doubt. Later, Jacqueline recalled his infinitely melancholy air and her fear he might take his life. Together, they walked around the Montparnasse cemetery, then on to his studio nearby where, faithful to his principle of creating art from life as well as from fantasy, he pleaded with her to help him channel his sense of nullity and destructiveness into some sort of image. Thus is born a photograph of Man Ray in despair: bare-chested, seated at a table on which stand an alarm clock and a stemmed glass, he stares at a pistol with a sinister expression. From the ceiling hangs a rope that passes around his neck. The photo could have been entitled *The Muse Takes Flight*.

Meanwhile, Lee Miller's artistic initiation was complete. Climbing through the looking glass, from now on she would take charge on the other side of the lens.

Raised in the darkroom

Lee (given name Elizabeth) was born on April 23, 1907, to a cultured family with an interest in technology, conformist and progressive, puritan and liberated. Her father, Theodore, a company director, was a genuine self-made man who had started from nothing to become a great art lover, while her mother, a less down-to-earth figure and prone to nervous disorders, was one of the first to undergo psychoanalysis in America. Lee was a tomboy, with delicate features and an angelic expression, who grew up in the countryside not far from Poughkeepsie, New York. Keen on photography, her father set up a laboratory in the house and taught Lee how to use his box camera. Accustomed to having his wife pose in

Lee Miller in about 1927, by the famous American portraitist of German extraction Arnold Genthe, whose studio was located in New York. Genthe's image portrays Lee as virginal, imbued with gentleness. She would go on to embody a new female type of modernity and inspire some of the greatest names in American photography.

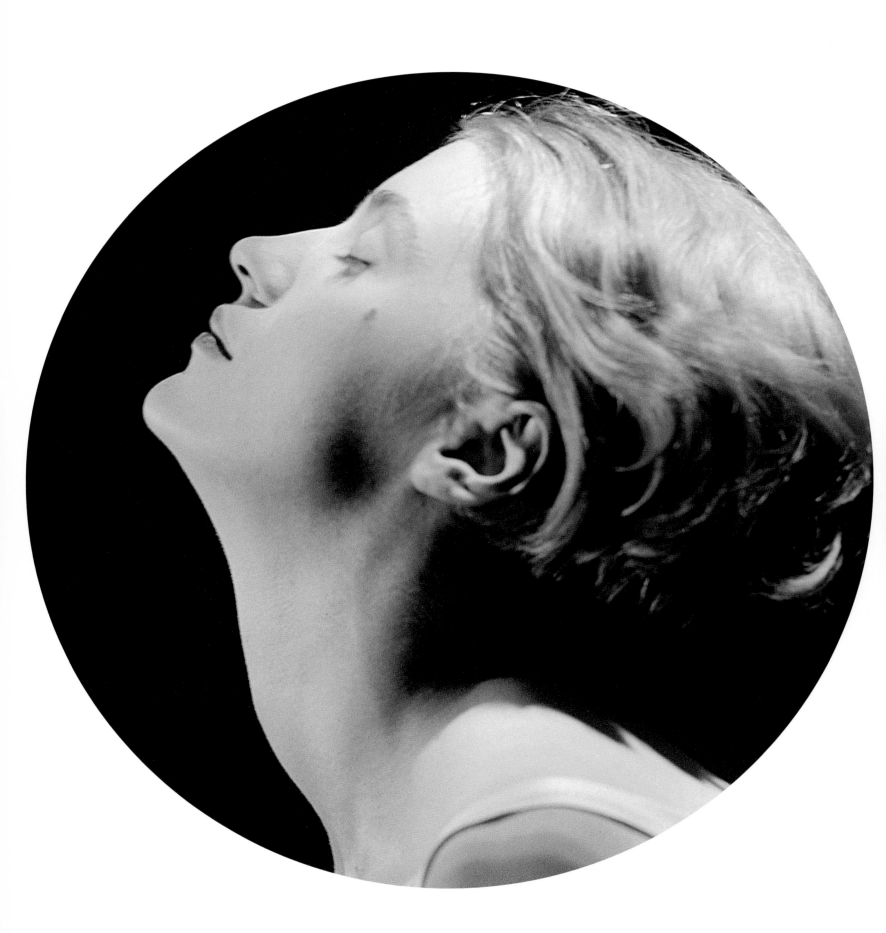

the nude, it was a practice he continued, with disconcerting nonchalance, with his daughter. Persisting for many years, this disturbing "visual incest" later became a problem for Lee with regards to her relationship to her body and her identity. Equally terribly, when she was seven, and under circumstances that remain obscure, she was raped while staying with a friend of her parents. This terrible crime left a permanent scar on her psyche and explained why she would later describe herself as "a water-soaked jigsaw puzzle, drunken bits that don't match in shape or design." Adding to the damage, the child contracted a venereal disease from which she never recovered.

Perhaps, in forging an image of her body—a process she pursued well into the 1930s— Lee was trying to perform a kind of exorcism, in the hope of expunging the trauma through idealization and multiplication. By exhibiting her beauty, she tried to wash away the suspicion surrounding the crime and the (presumed) sin, allowing her double to absorb, as it were, the ontological stain of her one—and only—stigmatized body. In 1915, no more than a year after the crime, her father had her pose naked in the snow for *December Morn*, a portrait with echoes of the painting *September Morn* by Paul-Émile Chabas. Some time later, Theodore, who exhaustively recorded his daughter's life as she grew up, started using a stereoscope. These sittings continued into Lee's adulthood: in 1926, they went to the woods of Oak Ridge where she played the role of a naked wood nymph. Theodore even invited girl friends of his daughter to take part in group portraits while his wife looked on—an extraordinary and sinister family practice in which "artistic study" seems to have served as a pretext for something else. Some time later, meeting up at the end of 1930 in Stockholm after some time apart, father and daughter almost immediately started staging erotic photos in the hotel bathtub. A few days later, in Paris, Man Ray took a series of portraits of the two in which their attachment is palpable. As Carolyn Burke, Miller's biographer, has written, "Since Lee's childhood, the photographic apparatus, the experience of posing, and the darkroom itself were all charged for her with sexual meaning."

Co-ed and fashion model

On her first trip to France in 1925, Lee spent a few months in Paris, where she registered at a school for costume design and lighting, before her parents insisted on her return to the United States. By 1926, she was training to be a dancer in New York, and was soon hired as a chorus girl for the revue *Scandals*, but her private life was clouded with tragedy: her

Portrait of Lee Miller by Man Ray, 1930. One of Lee's biographers, Carolyn Burke, declared, "Man's many portraits of Lee celebrate her body as an instrument of pleasure, but do so . . . in the vocabulary of modernism. Perhaps because they hold the muted awareness of his new muse as a *garçonne* with a style and a mind all of her own."

boyfriend at the time, a young man named Harold, drowned on a boating trip and the accident was witnessed by Miller.

At this time, Lee—independent, promiscuous, cultivated, and already attracted to the avant-garde—represented the very antithesis of traditional middle-class womanhood. It was an era in which a handful of privileged women were striving for liberation—wearing trousers, cutting their hair short, acting provocatively, and taking lovers when they wanted. Lee, with her combination of extraordinary beauty and strong-mindedness, was the embodiment of this new species of modern female, and professionals of the image could hardly fail to notice her. Scarcely had she left the parental home and settled in New York than she was working as a model for a lingerie company. By pure chance, while crossing the road she literally bumped into press baron Condé Nast, who offered her work in *Vogue*. She appeared on the March 1927 cover of the fashion magazine in a drawing by the French artist and poster designer Georges Lepape. Consequently, the foremost portrait photographers in New York began lining up to work with her. Thus began her glittering career: with the Hungarian Nickolas Muray, who immortalized many of the stars of the period; with Arnold Genthe, a pillar of the pictorialist Photo-Secession group; and with Edward Steichen. That Secession group had long been a haunt of one Emmanuel Radnitsky, alias Man Ray, an artist misunderstood in his homeland, who had set out for Paris to join the surrealist firebrands in 1921. Steichen—a truly great photographer of the time and instrumental in introducing the European avant-garde into the United States through the exhibitions he organized at the 291 Gallery—played a significant role in Lee's career. Choosing her as "1925's ideal model," he carefully nurtured her vocation for photography; it was Steichen, too, who advised her to meet Man Ray.

On May 10, 1929, Miller embarked for Europe with a friend. When the steamer was scarcely out of New York harbor, a shower of rose petals fell onto the deck, thrown from an airplane by one of Lee's lovers. A few hours later, while she sat dreaming of her new Parisian existence, the besotted pilot crash-landed his plane and perished.

Lover and collaborator

The scene took place in Paris, in a bistro in Montparnasse. Lee went up to Man Ray. "'Hello, I am Lee Miller and I am your new student,'" she recollected. "He said that he didn't take pupils [and] that he was leaving for Biarritz the next day. I said 'So am I.' I never looked back." Thus started their three-year love affair, during which Lee became known as Madame

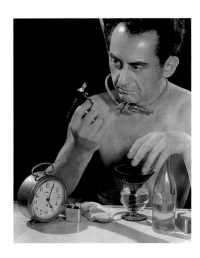

Self-Portrait—Suicide, by Man Ray, early October 1932. The artist has just been jilted by Lee Miller. To lose a woman who was his muse, assistant, collaborator, and partner has made him think seriously of ending his life. Meeting a friend, he decides to act out his despair for the lens: with a noose around his neck, seated bare-chested at a table next to an alarm clock among other items, he stares at a pistol.

Facing page:
Lee Miller as a model, photographed by George Hoyningen-Huene, c. 1931. At this time, the celebrated fashion photographer was director of photography for the French edition of *Vogue*. Lee Miller, whose physique and features corresponded perfectly with the zeitgeist, often posed for the magazine that already led the way in fashion matters.

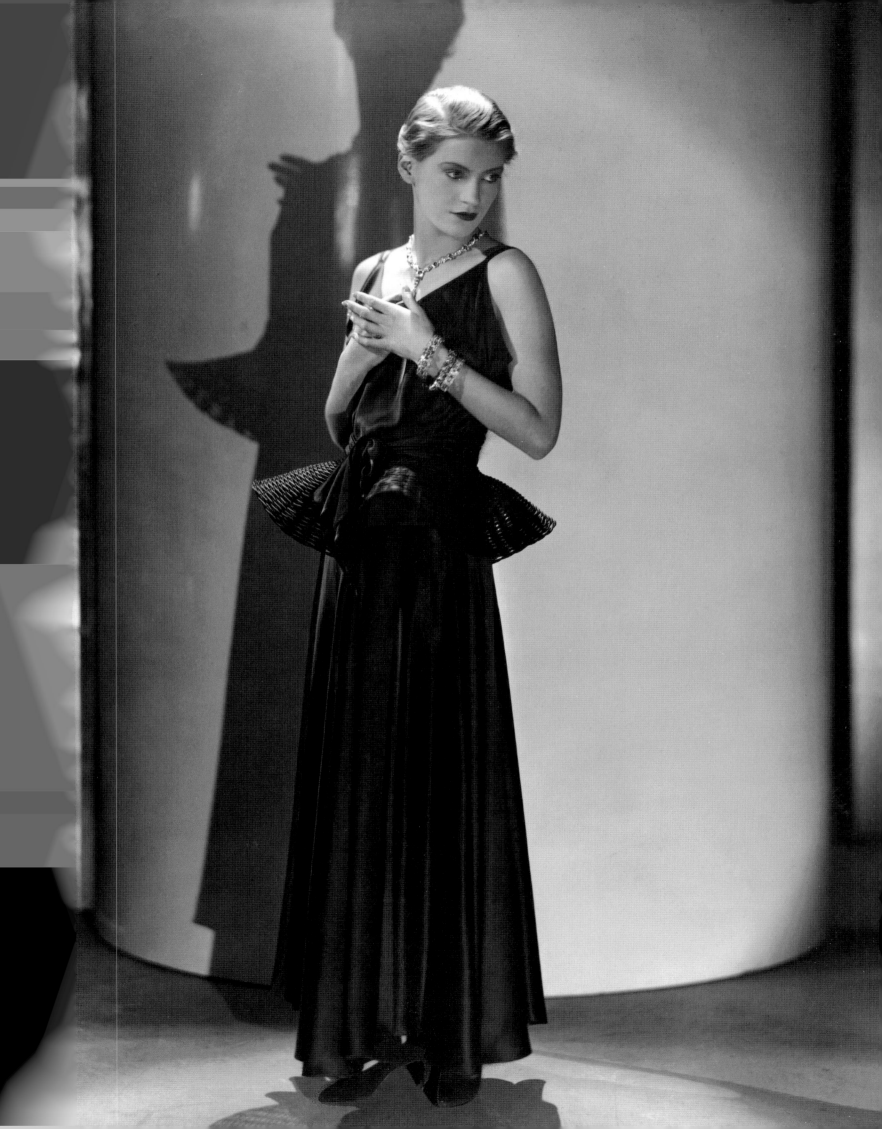

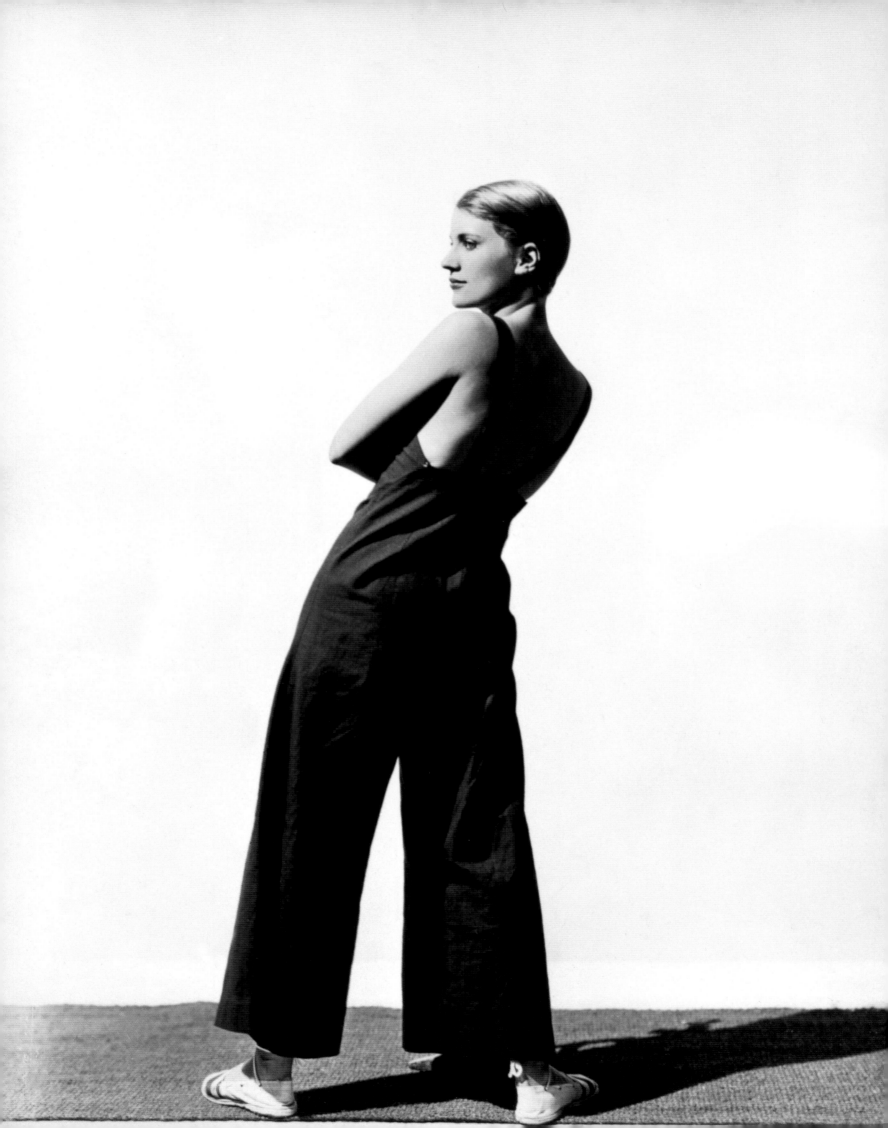

Man Ray shooting a rifle at a fairground, next to Lee Miller, in 1930.
Initiating a trend, along with his surrealist friends, that was to meet with huge success in the twentieth century, Man Ray often portrayed his private life in his photographic oeuvre.

Facing page:
Another picture of Lee Miller by George Hoyningen-Huene, taken for *Vogue* in 1930. The smooth, elegant lines of this pair of overalls cut from sailcloth are as modern-looking today as when they were first photographed.

Man Ray. New student? Or new Eve? On the road to Biarritz there began the long series of portraits recording a relationship that soon became all-consuming. Witnesses recalled glimpsing the couple walking down the road chained together.

Lee became Man Ray's favorite model, his lover, his muse, and his collaborator, to the point that the authorship of some works is unclear. As she would say later, "While we were working, we became practically the same person." Taking an active part in his artistic research, she dealt with development and printing, learning much from her teacher-cum-lover, who was an expert with glass plates and at enlarging, cropping, and laboratory manipulations of all kinds. In 1929, she redeployed the process Man Ray had called solarization, which involved switching the laboratory light during development and so revealing unexposed zones of the negative, producing a halo round the subject. This haphazard sort of double exposure technique reverses the values of light and shade, creating an electric aura around the objects. Lee also took care of the delicate process of touching up the prints, organized client visits, and prepared for the sittings of the many celebrities who filed through the studio in those years: James Joyce, Dalí, and Cocteau, to mention only a few. By the end of the year, she had acquired a broad palette of photographic expertise in various domains: handling prints and negatives, arranging lighting, as well as portraiture and still-life.

Man Ray—who was no Adonis and whose modest size and origins contrasted with the natural elegance of his tall, slender girlfriend—fell

utterly under her spell. But, although his love was exclusive, she would often depart from the straight and narrow. For some, their relationship was an enigma, whereas others just thought "the ray man" was besotted with Lee's dazzling solar beauty. During a crisis following one of the young woman's misdemeanors, Man Ray wrote to her: "I have loved you terrifically, jealously; it has reduced every other passion in me and, to compensate, I tried to justify this love by giving you every chance in my power to bring out what was interesting in you. . . . I have tried to make you a complement of myself, but these distractions have made you waver, lose confidence in yourself, and so you want to go by yourself to reassure yourself. But you are merely getting yourself under someone else's control." His words speak volumes about the nature of their relationship: her role as muse; his paternalist sway over her—he was seventeen years her senior; his position as Pygmalion and mentor. But at this time it was still too early for Lee to spread her wings.

Opportunism leads to emancipation

Ambitious, egocentric, autonomous, opportunistic: Lee did not neglect her image for the benefit of Man Ray's photographic cravings. In 1930, she posed frequently for George Hoyningen-Huene, who produced a photo of her considered today a classic of fashion photography, *Lee Miller Wearing Yraide Sailcloth Overalls*. Viewed from the back, standing and twisting her head to three-quarters, she is wearing a haute couture version of one of the earliest styles of overalls, with nothing underneath. The glamour-orientated and commercial Huene exploited the whole range of feminine figures she was able to embody: romantic, modern, tomboy, seductress, ingénue. Over time, Lee gradually moved away from Man Ray and took an

"Only sculpture could approximate the beauty of her curling lips, her long languid pale eyes, and column neck," the photographer Cecil Beaton said of her. Here we have Lee Miller turned into a statue and without arms, in a still from the 1930 film *The Blood of a Poet* by Jean Cocteau. The inaccessible muse was soon to come to life.

apartment of her own, although it was only a stone's throw away from him, and he lent a hand with the move. Hurling herself into Paris society, she was the ornament of the chicest costume balls, becoming immensely and enduringly popular with men—and thereby rendering Man Ray insanely jealous. Now working independently and taking portraits, in the same year, 1930, Cocteau offered her the role of a muse in his film, *The Blood of a Poet*. Lee played a statue without arms that comes to life. Delighted with this novel experience, Lee found herself top of the bill. Regarding Cocteau as a plagiarist, the dour surrealists were unimpressed by the work, as was Man Ray, whose very own inspiration and muse was being purloined. Ray spent his time making an experimental and personal film, *Self Portrait*—a distorting but nonetheless faithful mirror of his relationship with Lee and of her role as his muse.

In 1931, Lee crossed to the other side of the camera, as assistant to the director of the commercial and exotic *Stamboul*, for whom she acted as cameraperson and took the on-set stills. At last she had become a *real* photographer, and a player on the Paris market. At this time, she was also becoming friendly with Charlie Chaplin, whose enthusiasm for pretty women was notorious. Joining up with him in Saint-Moritz, the most fashionable ski resort of the time, she came across the immensely wealthy and distinguished Egyptian Aziz Eloui Bey, with whom she started an initially clandestine affair.

The muse in pieces

Deploying his typical surrealist idiom, Man Ray composed an image of their relationship in hundreds of photographs. They detailed his fascination with her appearance and style, as well as his distress at her new-found independence. The question remains whether many of these portraits—whether "traditional," dream-like, or "sacrificial"—simply represent a desperate and ceaseless ploy to regain possession of her. Standing at the crossroads between the body, the glance, and the image, between love and desire, in these images fetishism and fantasy are never far off. One series dating to 1930, produced using an orthopedic mould and metal meshwork, ensnared parts of Lee's body, an arm and her head, as if throwing wire net over her. One of these images was reused by André Breton in his periodical *Le Surréalisme au service de la révolution* to illustrate a fantastical description of the youthful paragons of the future. For the surrealists, the mystery of woman no longer focused, as it did for earlier generations, on child-bearing, but on sexuality, and theirs was a particular approach that was not exempt from misogyny: woman was viewed as an object for male

appetites, sometimes with Sadean connotations. Still, they did broach topics that conventional culture considered taboo, like masturbation, orgasm, fetishism, and homosexuality. It is probable that Lee served as the model for the Man Ray's *The Prayer*, where, with rump exposed, her hands conceal and protect her intimacy. If this is indeed the case, the image would possess special significance, and on various levels.

Playing with light and fond of abstract backdrops, Man Ray was a past master of a photographic surrealism based on principles of division and fragmentation. In a number of works it is the body of Lee that is divided into pieces. In the series *Anatomy*, her head and neck, plunged into a shadowy half-light, verge on the abstract. For *Electricity* (an offshoot of a commission for an advertisement), she was transformed into a surrealist Venus de Milo. Man Ray often deployed the process of solarization in lighting portraits of Lee. At the Julien Levy Gallery (another of Lee's lovers, who described her as possessing an aura made of audacity and light), he exhibited a sculpture-object assemblage entitled *Boule sans Neige* ("Snowless Ball"): a glass paperweight in which, when shaken, the enlarged picture of Lee floated among artificial snow. The photographer had "stolen" the eye and glance of his muse and lover, at the very moment when, emerging, photographically speaking, from his shadow, she was being hailed by American critics as a fully fledged creative talent. There can be no doubt that Man Ray was conscious of the symbolic import of such fragmentation, and of its deliberate or unconscious implications. On the eve of their separation, in the summer of 1932, he made another sculpture-object, composed of a metronome similarly mounted with a photo of Lee's eye, this time furnished with the title *Object of Destruction* (aka *Object to be Destroyed*). The object originally came with a drawing representing the mechanism accompanied by the following instructions: "Cut out the eye from a photograph of one who has been loved but is seen no more. Attach the eye to the pendulum of a metronome and regulate the weight to suit the tempo desired. Keep going to the limit of endurance. With a hammer well-aimed, try to destroy the whole at a single blow." After their final split, Man Ray continued his artistic quest, the images of Lee's body becoming simply another component in his oeuvre. His painting entitled *Observatory Time—The Lovers*, for example, is based on a photograph of Lee's mouth.

Portrait by Man Ray of Lee Miller posing in front of a lace curtain before a window, in 1930. In his films and his still images alike, Man Ray often deployed light effects of this kind. Such geometrical shadows and reflections distort reality—or accentuate it, as here.

Renée Perle

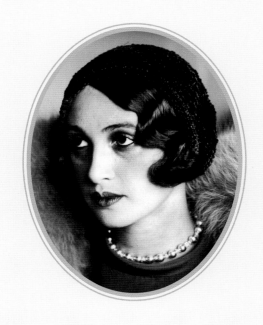

Lartigue's alter ego

Seated at the wheel of an impressive Talbot, Jacques-Henri Lartigue was driving slowly along the streets of the sixteenth arrondissement in Paris, in early March 1930. "Alone with his imaginings," he became intoxicated with the scents of spring, thinking of kissing his then-mistress, a certain Doriane, before returning to the marital home where his wife no longer waited up for him. He gazed at the passers-by, gliding down avenue Victor Hugo, before turning into rue de la Pompe. Just coming up to the Lycée Janson, he saw two women waiting for a taxi in the gloomy half-light of a streetlamp: "One is a midget, the other taller and slender. A parasol next to a flowerpot," is how he described the pair. The latter waved him down. He slowed, performed a U-turn, and drove back to them. He had never seen either of them before; they had mistaken him for the slender woman's brother. Nonetheless, conversation flowed easily, and they decided to take a stroll down one of the many paths of the nearby Bois de Boulogne, allowing them to get to know one another better. Lartigue examined "the parasol" out of the corner of his eye. "A long neck, a tiny nose, a shiny, wavy curl of hair that rubs against her mouth." This initial appraisal boded well, and shortly afterwards, the beautiful Renée Perle, a twenty-six-year-old model of Romanian origin, became the muse of the French photographer who would, much later, be recognized as one of the greatest of the century.

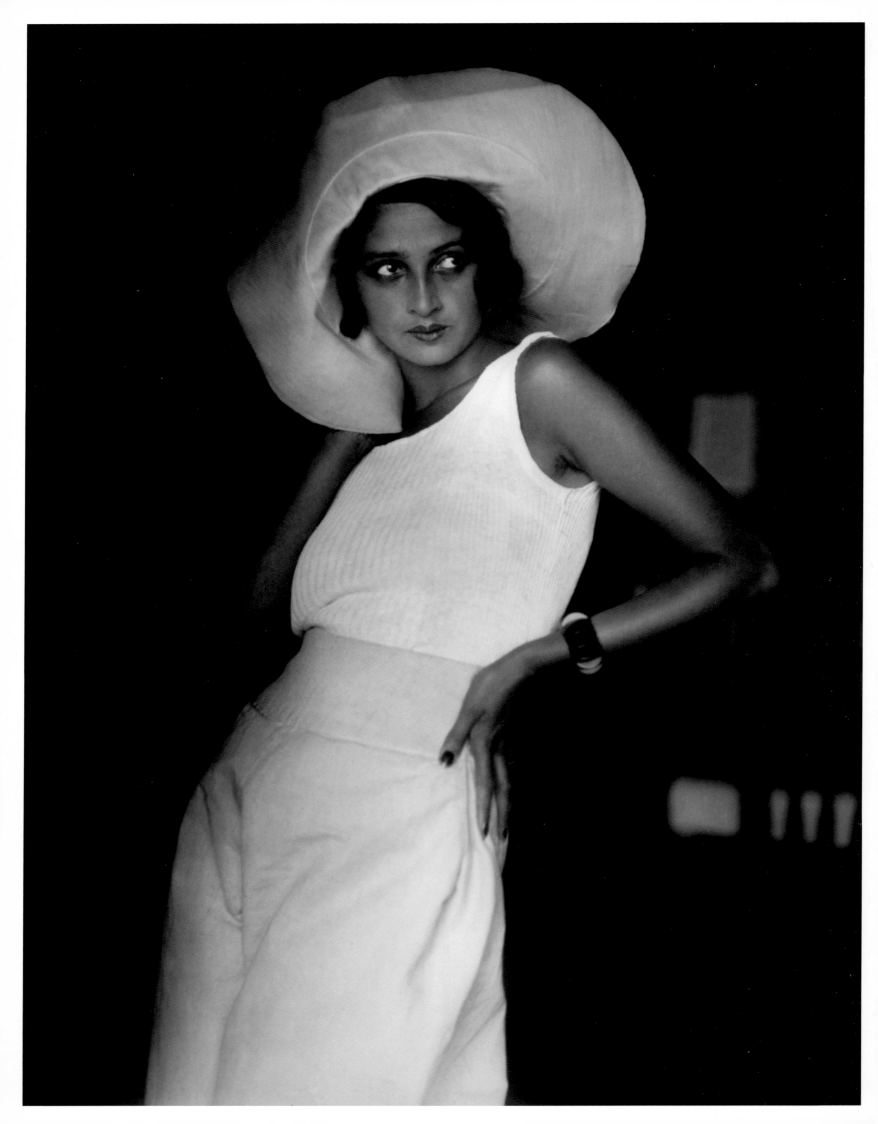

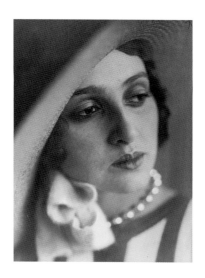

Renée at Juan-Les-Pins, May 1930. It was on the coast near Antibes on the Riviera, on the top floor of the Hôtel des Pins-Parasols, in spring 1930, that Renée Perle and Lartigue lived their ardently passionate love. Between two sittings, she enjoyed the pleasures of a *dolce far niente*, while he, bathing in the glow of love, would spend the morning at his easel.

Facing page:
Renée in Biarritz, August 1930. Renée Perle's dreamy feminine grace and elegance played an important role in the fascination she exerted over her photographer lover, who confessed, "Renée is always with me with her perfume and her disconcerting coquetry. Around her, the halo of all the magic spells that surround me."

Separations

Lartigue was at this time at a crossroads in his life. Eleven years after his wedding with Madeleine Messager, known as Bibi, the daughter of the famous composer André Messager, who had died a few months prior to Lartigue's encounter with Renée, the marriage was on its knees. If the couple were still living under the same roof, they shared nothing else— save for a mutual understanding, a sort of camaraderie based on respect for their former love and their son, Dani. Both conducted love affairs on the side, with Lartigue flitting from woman to woman. It cannot be said that he possessed an especially tender heart—something he was conscious of and for which he frequently reproached himself. Detached from his feelings, he rarely exhibited empathy for other people, whether intimates or nodding acquaintances. In any case, he found the spectacle of nature infinitely more engaging than the artificiality of the society circles he moved in. In the weeks preceding his encounter with Renée, he was feeling unusually fragile. Assailed by uncharacteristic doubt and having suffered a personal tragedy, he would come to wonder whether this newfound weakness was the cause of his "falling for the first girl to walk by."

Only three days before first encountering Renée, Lartigue had paid a last visit to a dying friend, the dashing, athletic Sala, a companion in his games and vacations for many years, struck down by tuberculosis tragically young. Lartigue had been to Sala's Paris home, listening to his dying friend's delirium, which overflowed with sun-kissed memories, recalling intense moments of happiness.

Birth of an idyll

Lartigue knew the Bois de Boulogne as well as his own backyard. Between 1910 and World War I, he photographed the most elegant women in Paris there, as they breezed down its avenues in their finery: furtive pictures of demimondaines in the latest styles (many of whom were fashion models), their graceful silhouettes in impossible gowns and unconscionable hats, whom he snapped unawares or surprised, alone or in groups. Half a century later, this series of photos would make his international reputation. It was also in this corner of urban rusticity that, in 1911, he had shot his first film, using a camera given him by his father. So it was to this fashionable park that Lartigue, little known at the time, took Renée and her friend. It was the first of many rendezvous for Renée and Lartigue, who would subsequently meet minus the friend.

Their passion grew, and for Lartigue the world began changing, gaining in depth. Something inexplicable transformed the tiniest detail, every

day a new light shone on his life, and, soon, this new reality, as well as his emotions, could not be put into words. So Lartigue—normally so adroit at literary introspection—felt compelled to conjure up its evocative power with images. Delving deep into the inexpressible reality of his nascent love, he wrote with astonishing foresight: "One would need a film, like the ones that will be made one day, in color, with depth, atmosphere, perhaps even smell. In my memory, there's only a vision: and that's blurred. Too near to be kept in focus, it's her mouth against mine, the long, bare legs, a lock of hair crushed against my cheek. It's a close-up. A close-up of smell too, of her mysterious and fleeting fragrance." Perhaps the hundreds of photographs he was to take during their relationship, with Renée as practically the sole and exclusive subject, was his way of attaining the *right distance*, of *focusing*—in the literal and figurative senses—on his discovery of femininity, on this intoxicating passion.

The wicked fairy and the "spirit" fairy

The star of Renée's femininity rose while that of Bibi, his partner of the last twelve last years, was on the wane (the breakup was made legal a year later, in March 1931). If the spouses' love had evaporated, their relationship conserved a certain charm, a friendship based on trust and laughter. Lartigue believed that Bibi complemented him, whereas Renée *resembled* him. Even as he came to terms with the powerful sexual desire that Renée aroused in him (she was flirtatious in a manner he found fascinating), it is Bibi's intelligence that shines through: "Well now, the wicked fairy is not all-powerful since the spell she has cast can be undone by the 'spirit fairy'. Never has Bibi seemed to me as witty, as jovial, understanding, honest, and straightforward [as now]," he recalled after first spending time with alone with Renée. Indisputably, there was a gulf in class and cultural level between the two women. However bewitching the Romanian immigrant might have been (she worked as a model for the House of Doeillet), she was no match for the daughter of a celebrated composer, well used to society ways. The cruel snobbery directed at the new couple exasperated Lartigue on several occasions. Yet he himself was not immune to social convention, initially, at least. Renée lodged near the Porte de Champerret, in a hotel room he found horribly nondescript; her conversation often appeared shallow and her manner twee. Even her irreproachable beauty seemed suspect to him: the girl was just *too* pretty (he often remarked), and always dressed in very luxurious and dubious-looking fur coats. At the onset of their affair, he placed her, with what seemed a conscious insensitivity, in what he described as "the gold-digging, 'two-faced tart' box." And so,

fearful of the contradictory feelings she aroused in him, he quickly broke off the affair, before, went his thinking, the attraction became impossible to resist. Believing himself in danger, he wondered whether he was truly ready to accept the unthinkable dream shimmering before him. But this hiatus proved to be of short duration.

The self in the other's image

Their passion now gained the upper hand and the more he flew in the face of convention, the more Lartigue's uncertainty was replaced by a new sensation of bliss—though one still threatened by doubts. Thus began a reflective process that he soon conveyed through photography. With clairvoyance and candor, he noted, "Renée is the female version of another myself." The confession is unambiguous: in a narcissistic identification, the image of the self is reflected in the aesthetic perfection of the opposite sex that completes it, both physically and aesthetically. Since earliest childhood—and not without that hint of vanity perhaps inevitable with the exceptionally gifted—Lartigue had valorized the self by magnifying and sanctifying the bodies of his alter (if not entirely *alter*) egos. As with his string of lovers, his male friends and sporting buddies (like the late-lamented Sala, a water sports champion whose superb build was so unlike his own skinny physique) attracted his lens like a magnet. Used to

Renée in J.-H. Lartigue's Car on the Paris–Aix-les-Bains road, July 1931. Renée Perle and Lartigue never tired of exploring France in the most up-to-date automobiles, driving to voguish seaside resorts or elite holiday venues, such as the thermal baths at Aix-les-Bains.

taking on the characteristics of others—often their physical qualities—he discovered in Renée a form of womanly perfection. It was as if the ultimate aim of all his artistic endeavors with her—in photography, but also in painting—was to forge an image equivalent to the one he would like as his own. A sheet in an album dated November 1930, entitled *Renée-Me* seems to be expressing exactly this. By sharing the limelight, he could become her equal in perfection. If she played the ingenue, her face leaning against the edge of a wall, he duplicated himself in a montage, both full-face and profile, his leading-man features emerging from a darkness that both emphasized and transcended the enigmatic side of his character. Hence photography is the mirror for the ideal.

A tryst in April 1930 saw the couple blessed by the Riviera sun, a bolder light that seemed to illuminate a new-found, carefree attitude to the world and the pleasure he derived from creating images of himself. If Lartigue appeared only occasionally, like a reminder, in the pages of these photobooks, he was omnipresent in the icon he constructs with such relish.

"She's a woman!"

The bedroom perched on the top floor of the Hôtel des Pins-Parasols at Juan-les-Pins was a little corner of paradise. Lartigue whiled away the mornings before the easel, his confidence in his work as a painter now consolidated thanks to a growing reputation. That indolent spring, he dreamed of his lover, who he knew was ready to satisfy his every desire. Overflowing with joy, he felt that this unofficial honeymoon had given him all he could wish for. He savored the prospect: "She's upstairs. She's waiting for me in her room. She's doing her hair, getting dressed, putting on her mascara, eating a candy? . . . Doing nothing? . . . No matter. All I know is that she's up there, waiting for me and I'll go up to her the second my love calls! And she? . . . Who is she? Renée. But first and foremost she's a woman! A WOMAN! The first perhaps I've ever encountered." Lovemaking occupied their days, punctuated by the occasional trip to Cap d'Antibes. Bewitched and intoxicated by sensual pleasure, Lartigue took photograph after photograph in what is an act of total fusion, a sign of union in which Renée offered herself up to the dark chamber of the apparatus in the brightness of day—a paragon of perfect love in all the freshness of her youth. To what extent did she contribute to the compositions of Lartigue's pictures? At the beginning of their affair, her hands, whose role was often significant in the images, were the object of acute examination, but it seemed that Renée was more than just the photographer's plaything. She appeared generally willful; a determined presence that adapted smoothly

Facing page:
Renée in Paris, November 1930.
Lartigue recalled in his diary the limits of his photographs in capturing Renée Perle: "And now it is over to you, modest photographs, to do what you can—rather little, I reckon—to tell all, to explain all, to hint at everything . . . everything, even—no, especially—what cannot be photographed."

Following pages:
November 1930–Paris (Renée–Me).
A phrase in Lartigue's journal offers the perfect caption for his double portrait, which underscores the narcissistic ambivalence of his relationship to his muse: "She does not complement me; she resembles me."

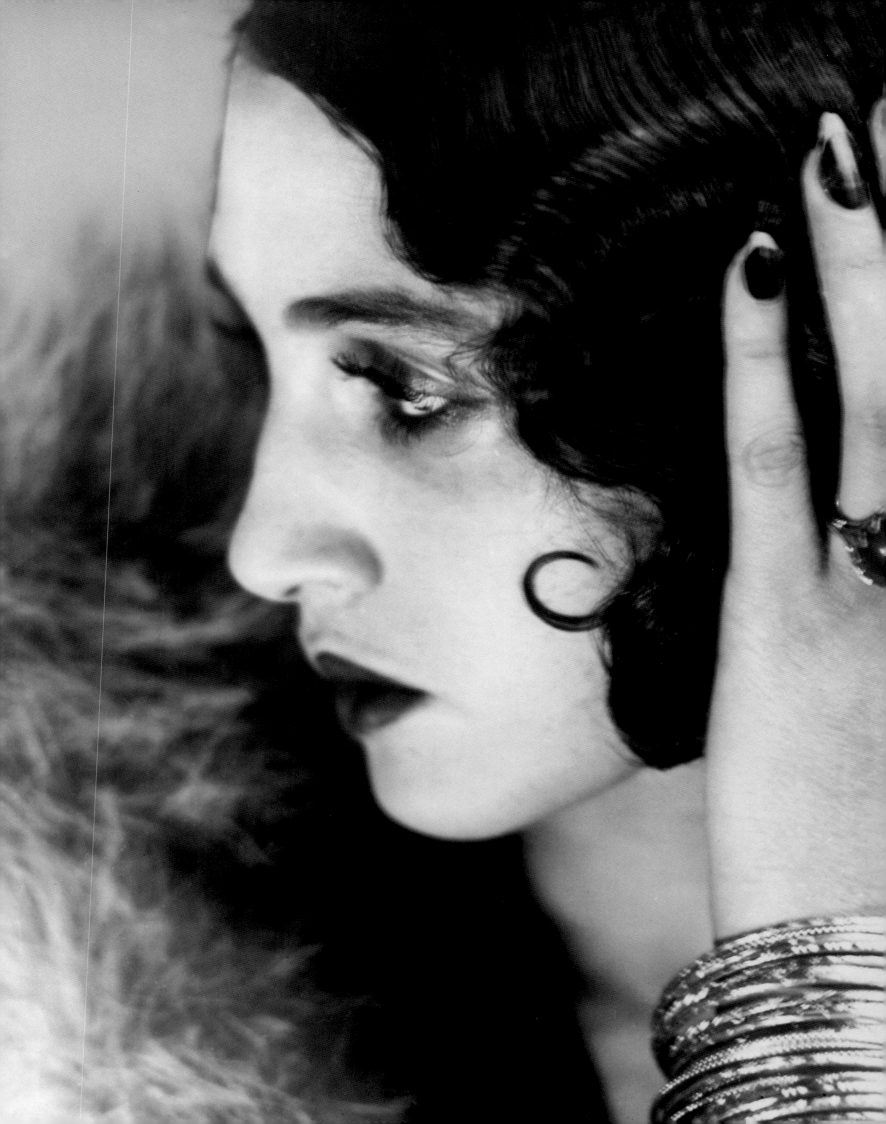

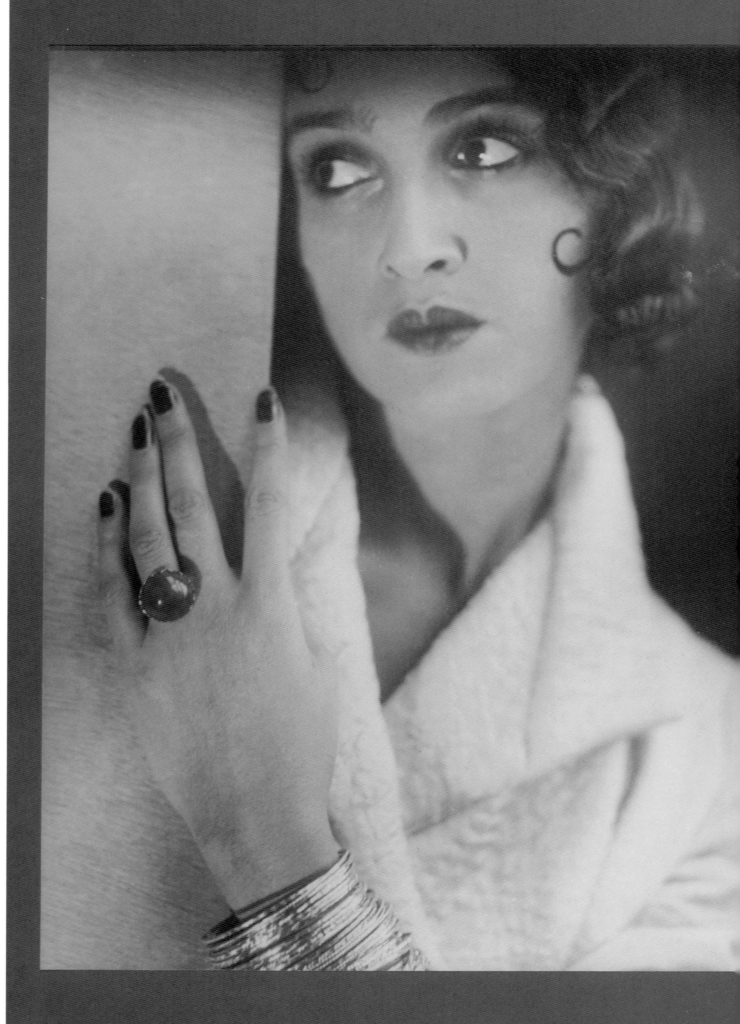

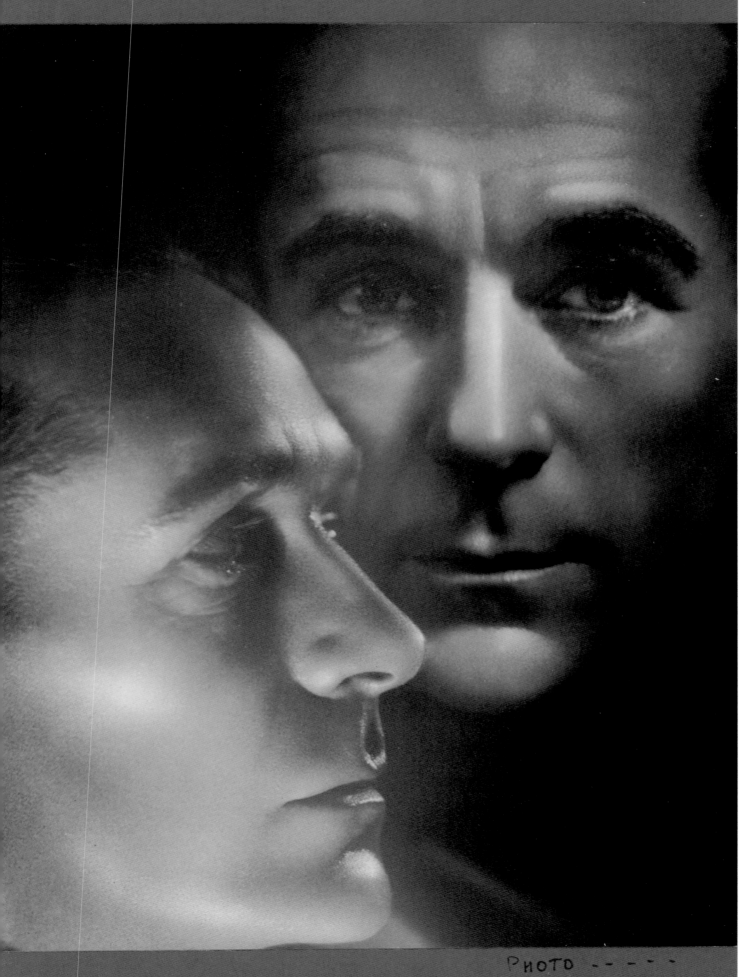

PHOTO - - - - -

to the demands of surrounding space, of a world reduced, it might almost be said, to a backdrop to her splendor. At Juan-les-Pins, precise posing was the order of the day; snapshots were almost nonexistent. There was little place left for chance and uncertainty. From the outset, the accent was on revelation, on tribute and dedication. What Lartigue gained in exactitude in this science of portraiture and the control over the frontality of his exclusive subject was counterbalanced by what he lost in spontaneity and facility. No spectacular lyricism or moments of wonder: here, the body, the absolute master, governed the composition, with Renée's face carefully positioned, her smile sometimes seeming to convey the mystery of their relationship, an enigma that further transpired, perhaps, in her often downcast demeanor.

Limits

"Renée is the flower garden of my dreams. I could walk through it forever. Forever without tiring. But it can be covered in three strides. So, when winter does its work and the ground lies bare, what will be left of it?" Lartigue frequently oscillated between his reason and his heart, between logic and impulse, between romanticism and pragmatism. Even at the height of their affair, both still experienced uncertainty and suspicion. Lartigue's critical mind alloyed with a tendency for self-analysis often marred what should have been an unshakeable sense of well-being. So receptive to the zeitgeist, Lartigue—even if he himself was unaware of it—often betrayed an eminently modernist individualism and self-centeredness, and was frequently hobbled by pessimistic introspection. Preempting obstacles and problems, and in spite of his best efforts, he shrank from the present, relying on photography to mitigate its shortcomings: but to no avail. By the beginning of the year 1931—probably due to their difference in social class—they had, he said, been turned into "two hearts laid bare and prepared to be trampled by the mob." Restless, with angst gnawing away at him, Lartigue circumscribed the limits—including those of photography, which could not say everything, explain, or suggest everything. The shoots now provided him scant relief: just tattered bandages over what he called his "little precipice." As Lartigue saw it, artists lived in a closed world, as powerless as "mice trying to bite through the hull of a steamer." After the couple's relationship fell apart in 1932, they never saw one another again. Until she died in 1977, however, Renée kept a collection of all the prints Lartigue gave her concerning their life together; the gift of an oeuvre in which the image of love attains the sublime.

Renée at Ciboure, August 1930.
"A chimera? Yes, she's my chimera, my dream for forever," wrote Lartigue in his private diary.

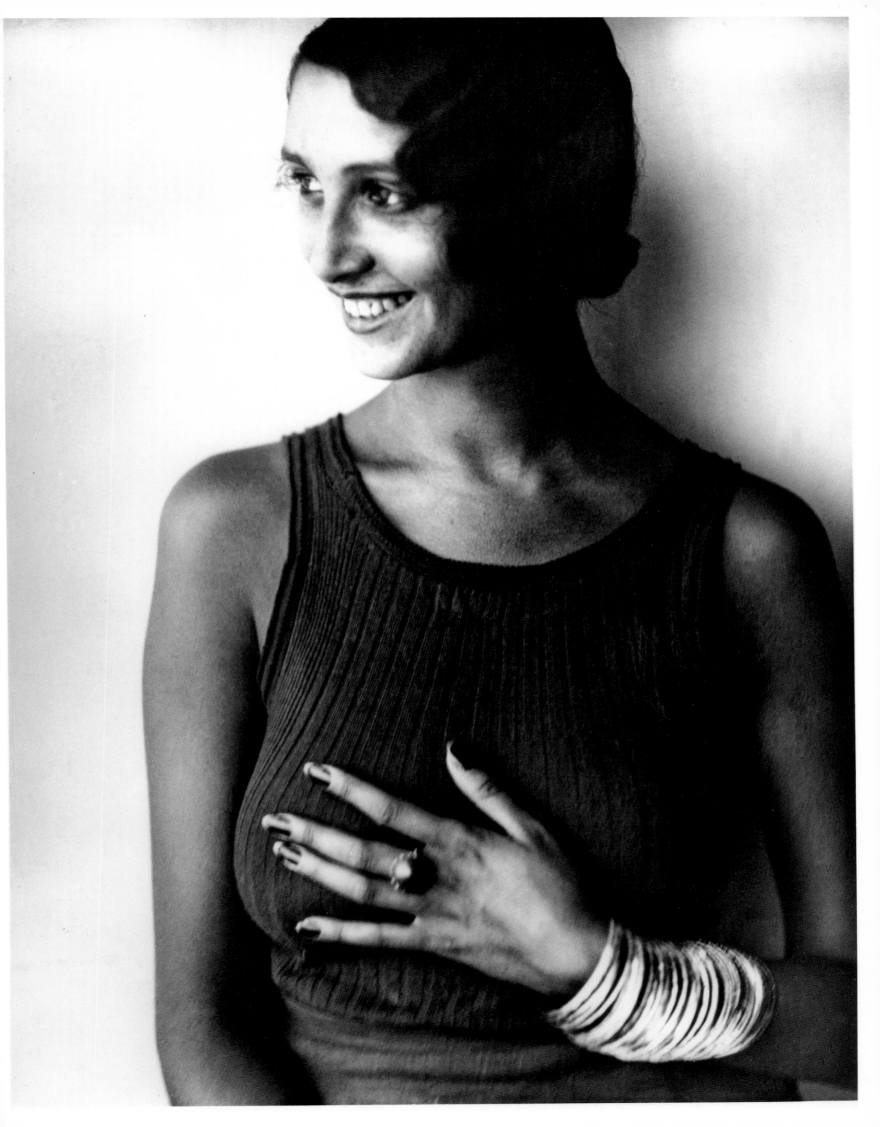

Dina Vierny

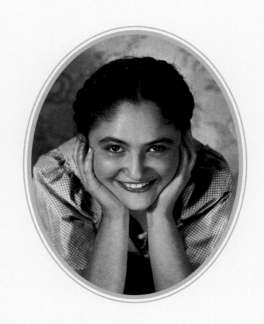

Maillol's archetypal beauty

Dina Aibinder was born into a cultured family of Jewish origin in Kishinev, Bessarabia, in 1919. She left the Soviet Union for Paris in 1926, along with the rest of her family, when her father, a pianist and committed social democrat, fled Stalin's repressive regime. Artists and intellectuals were invited to their home for private concerts, with Russian expatriates like Ivan Bunin (awarded the Nobel Prize for Literature in 1933), mixing with French writers, such as Antoine de Saint-Exupéry, author of *The Little Prince*. One day, the architect Jean-Claude Dondel was struck by the resemblance between Dina, then aged fifteen, and the type of female nude that featured in the work of the Catalan artist Aristide Maillol, considered one of France's foremost artists, the spiritual heir to Cézanne and Gauguin. Dondel later told Maillol of the resemblance, which prompted him to write to Dina: "Mademoiselle, I have been informed that you look like a Maillol or a Renoir. A Renoir would be good enough for me." Thus one Sunday morning, Dina, if not particularly enthusiastically, went to the sculptor's home to attend a reception he was throwing for some artist friends. It was a meeting that determined the course of her entire life.

Terra-cotta figurines photographed by Brassaï in Aristide Maillol's studio in Marly-le-Roi, 1937. It is not easy to distinguish with any certitude the ones modeled after poses by Dina, but there can be no doubt that the whole ensemble is influenced by her well-rounded physique.

The amorous eye of Pierre Jamet

Dina's first lover, Pierre Jamet, began to take photographs of her when she was no more than sixteen. A onetime member of the AEAR (an association of revolutionary writers and artists), in 1938 he established and led the Groupe 18 ans, a choir with a repertoire of popular songs. He sang in ensembles with Dina, subsequently enjoying a brilliant career as a tenor with Les Quatre Barbus. In the middle of the leftwing government of the Front Populaire, and at the introduction of paid leave, the young couple joined the recently established Youth Hostels of France. They loved camping and the life of the outdoors. They spent the night under the stars, went on treks, and Jamet even worked as a camp director on occasion. As she confessed later, Dina was a liberated woman, ahead of her time: "I wore shorts in 1936 when nobody did. I went dressed like that in the metro. People gave me a hard time because of it!" Taken with a Rolleiflex, Jamet's pictures of this period—quite apart from offering a heartwarming testimony to a time of shared joy and fraternity—are also a paean of love to the dazzling features of his beloved. Half naturist ode, half proletarian pastoral, they celebrate her healthy physique and happy spirit. The photographs reveal to the viewer a blossoming, insatiable lust for life, the epitome of youthful freedom. A substantial number of these portraits, both posed or spontaneously candid, were taken in the colony of the Grand Village at Belle-Île-en-Mer, which Jamet was managing in 1938. Jamet, whose humanist work has not been sufficiently acknowledged, was also a collaborator on *Regard*, a weekly with links to the Communist Party, which, like the magazine *Vu*, devoted much of its content to social

Facing page:
Dina Vierny at the "Friends of Nature" camp at Chalifert, Seine-et-Marne, June 1936. Pierre Jamet captures her as a kind of pastoral Venus.

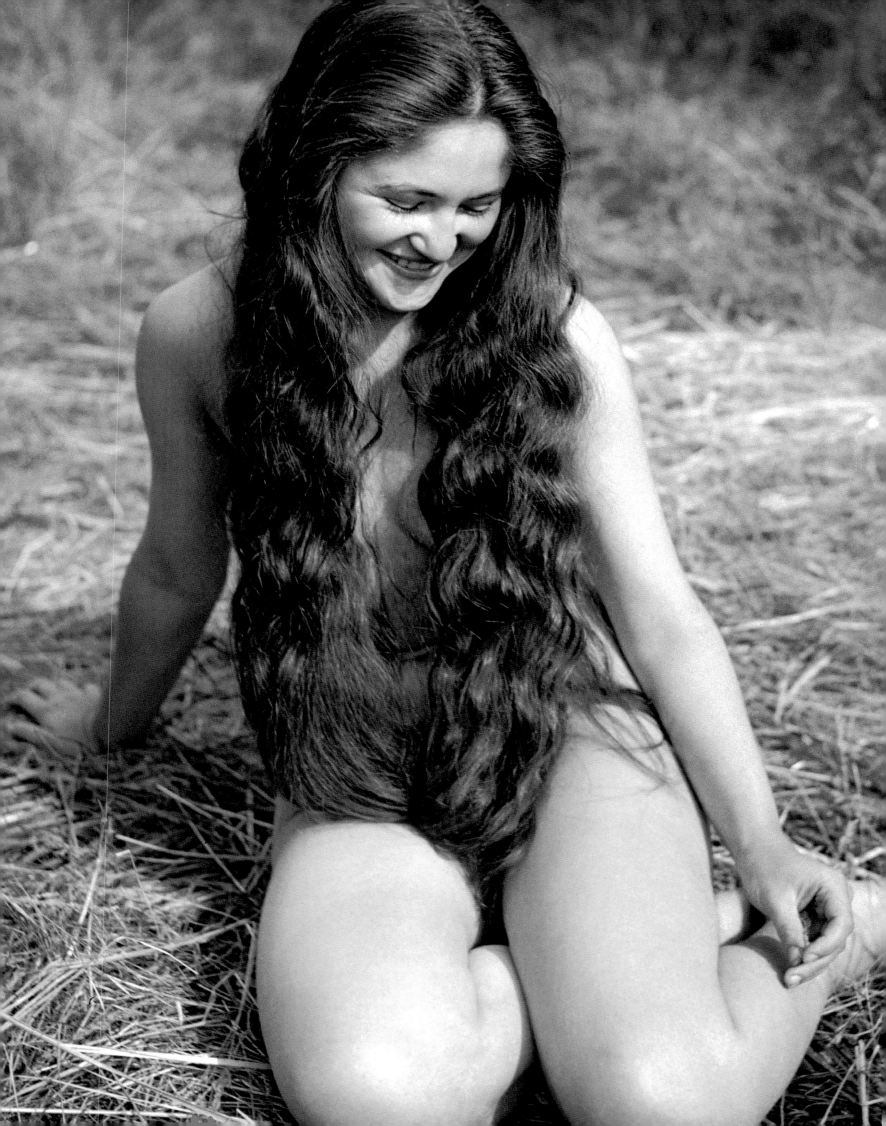

reportage. Its associates included major photographers such as Capa, Cartier-Bresson, Doisneau, and Ronis. At the dawn of the twenty-first century, however, Dina affirmed that the finest images of this joyful, militant youth were signed by Jamet. Showing the great store she placed in friendship, much later, when Jamet returned to photography following the dissolution of his group in the 1970s, she took on her former lover to work in the gallery she had founded in Paris after World War II.

Aristide Maillol at work in 1942. Behind him, a large drawing of a reclining nude representing Dina Vierny. Photograph by André Zucca.

With the Prévert brothers and Jean Renoir

Dina joined the agitprop theater troupe Le Groupe Octobre in 1936, the year of its final performance. An avant-garde, interdependent, and popular theater company, close to the Communist Party and to the CGTU trade union confederation, it was at that time run by Pierre and Jacques Prévert. The "anti-bourgeois" troupe played in striking factories and at political meetings, and was a veritable breeding ground of talent, with an impressive roster of members soon to become famous artists, such as the singer Marcel Mouloudji and movie director Claude Autant-Lara, as well as thespian luminaries like Jean-Louis Barrault and Jean Vilar. Dina was a gifted singer and she enjoyed singing throughout her life, if in sometimes unusual circumstances: in cabarets in Montparnasse with a gypsy band, in Fresnes during her internment by the Nazis, or later at a feast organized in her honor by a tribe of Amerindians in the Amazonian forest. In 1975, she was the main attraction on an LP record entitled *Songs of Siberian Prisoners*.

In the mid-1930s, she also worked as a film extra. She made a brief appearance in *Youth in Revolt*, a movie starring Jean-Louis Barrault, Odette Joyeux, and Bernard Blier, which tells a story that might easily have occurred to Dina in real life: six young Parisians decide to change their lifestyle and move into a chalet far up in the Alps. In 1936, in Jean Renoir's *La vie est à nous* ("Life is Ours," a movie actually produced by the Communist Party, in which Paul Valiant Couturier, Jacques Duclos, and Maurice Thorez play themselves), she sings the "Internationale" among a vast crowd. There was also mention of an appearance in *La Bête humaine*, but the part never got off the storyboard. Dina though seems to have preferred posing for artists rather than hanging around on set.

A growing friendship

"I might well not have done it. But it was fun, enjoyable. From the start, art intrigued me, it interested me. To take part in something creative, there's nothing finer. The first time I paid him a visit, I said to him, 'Monsieur Maillol, I'm going to spend half an hour with you.' I just wanted to see, I was

Facing page:
Dina Vierny in the courtyard at the youth hostel at Villeneuve-sur-Auvers, Essonne, in 1937. "The only worthwhile photographs of my youth are by him," she said of Pierre Jamet's pictures.

Dina in the Red Dress, oil on canvas, by Aristide Maillol, 1940. This is the dress she would wear at the railroad station at Banyuls-sur-Mer, to be recognized by the Jews, members of the Resistance, and antifascists she would take into the mountains at night in preparation for crossing the border into Spain. When she told Maillol of her involvement, he showed her shorter paths over the terrain and lent her a remote studio in the uplands to use as shelter.

Facing page:
Another photograph of Dina Vierny taken by Pierre Jamet in the yard of the youth hostel at Villeneuve-sur-Auvers.

inquisitive. And I stayed for ten years!" From 1934, Dina, unbeknownst to her parents, started going regularly to Maillol's studio in Marly-le-Roi. Maillol's cheerfulness and uncomplicated spontaneity, allied to Dina's joie de vivre, curiosity, and her taste for the creative arts, consolidated their growing friendship, despite the nearly sixty-year age difference. The sittings, during which they chatted endlessly, usually lasted three hours. Over the years, they evolved into moments of shared pleasure and complicity, although there was never anything untoward in their friendship. "He was completely unique, always in a good mood. We saw each other all the time and it was a daily source of amusement." Maillol's wife, Clotilde, did not take umbrage at this new female presence in the workshop. She had, in her day, sat as his only model for years, inspiring masterpieces such as *The Mediterranean* (first exhibited under the title *Woman* in 1907, later also called *Thought*) and *The Night*, a bronze sculpture of 1909, today on display in the Tuileries gardens.

For Dina, Maillol started with drawings and frescoes, before—inspired by the body of this emancipated nymph, who practiced nudism and who herself offered to pose naked—returning to large-scale sculpture. The freshness and spontaneity of this new muse was responsible for changing the course of his artistic practice. But the news spread quickly and one day Dina's father read in a newspaper that his daughter—still a minor— was posing naked for a major artist. The two men met, and, sharing a love of erudition and a passion for literature, soon became friends. Maillol built a desk to allow Dina to read and study during sittings and so continue her schoolwork. The position she thus adopted influenced the very form of certain works: in many sculptures, the female figure appears to be leaning forward slightly. Maillol initiated the girl, at the time better versed in the arcana of revolutionary socialism, into modern art, introducing her to his longtime friends who were painters and erstwhile companions in the Nabis group: Bonnard, Dufy, and Matisse. When the latter enquired about his new model, Maillol replied, "She's beautiful and talks like Gide!"

In 1934, she visited for the first time Maillol's birthplace at Banyuls-sur-Mer, near which he owned a smallholding. Having set aside painting in order to devote his time entirely to sculpture, it was in this remote location in the Roume valley that Maillol re-erected his easel. He painted Dina outside, bathed in sunlight amid the hills of Languedoc-Roussillon. In 1940, she returned to pose naked for the sculpture *Harmony*. The previous year, Dina had "betrayed" the Catalan artist by posing for the sculptor Charles Despiau, but only for drawings, as well as by marrying Sacha Vierny, a Frenchman of Russian origin, no less politically committed than

Female Nude, a drawing by Maillol from the end of the 1930s—now part of the Dina Vierny collection—in which the model is easily recognizable.

her. During World War II, however, the couple floated apart, separating over the following years, though Dina opted to keep the surname of the first of her three husbands.

"She's beautiful and talks like Gide!"
Aristide Maillol

The Woman in the Red Dress

The Woman in the Red Dress is the title of a picture painted by Maillol now preserved in the Paris gallery that bears Vierny's name—the Fondation Dina Vierny. It shows a bust of Dina in profile against a green ground, her eyes cast downwards. She is wearing a garment of a dark shade of red. The portrait was painted in Banyuls at the beginning of World War II, from where Maillol escaped at the very last moment, in September 1939. Five months later he was joined by Dina, who became his impromptu assistant. She had barely arrived than she started posing for the sculpture *Harmony*, to which the demanding artist would devote a further four years of intense work. In spite of more than twenty molds representing various stages of development, the piece remains unfinished and without arms.

Dina traveled regularly to Marseille, where she came into contact with the Resistance network run by Varian Fry. So began her activities in the underground, consisting mainly in helping antifascists and Jews out of the country over the mountains and into Spain under cover of darkness. The crossings took place in August–September 1940, and Dina

Aristide Maillol photographed by André
Zucca in 1941.

estimated that in all she must have guided a hundred or so people to
freedom (a number of witnesses resurfaced after the conflict attesting
to her help). When Maillol learned of her activities, he showed her some
safer and more practical paths used by goatherds, even lending her one
of his studios far up in the mountains where she and her fugitives could
spend the night in relative safety. On mission—in a station or in a café—
Dina wore a red dress as a sign to the refugees seeking her aid. History
with a small "h" intersecting with History with a capital "H," it is in this guise
that Maillol painted her: clothed in the color of blood. But the border was
routinely patrolled and one day Dina was arrested at home by the French
police. At her trial, Maillol engaged a high-flying attorney who pleaded her
innocence with the creative defense that she crossed the border to Spain
on a regular basis in search of cooking oil. Granted the benefit of the doubt,
she was released. To protect her from herself, as well as from the forces
of collaboration, Maillol insisted she leave the region and go to live with
Matisse and Bonnard. Spending a month in turn with one or other of her
"marvelous uncles," Dina thus became first their model, then their friend.
Visiting Matisse in Cimiez on the heights over Nice, she brought a letter
in which Maillol noted, "Matisse, I send you the object of my work, you will
reduce her to a line." After making India ink drawings of the young woman,
the painter entertained the idea of using her for a figure of Olympia, but
this ambitious project risked taking too much of Dina's time away from
Maillol, who was prepared to lend his muse on a temporary basis only. On

the Riviera with Bonnard, Dina posed for *Dark Nude*, for which the painter stipulated that she had to keep constantly on the move. Her love of sunbathing, however, disturbed an artist whose dreams were of creatures with diaphanous complexions. Afterwards, she returned to Maillol and to her appointed role of model-in-chief. This time, the artist encouraged her to visit Dufy in Perpignan, to perfect her artistic education. A regular visitor, she found that "[o]ne cannot stop laughing with him. I posed very little, a few drawings only. But I talked a lot with him. And I learned many things." Ever since her very first appearance in Maillol's studio, as with all the artists she encountered, Dina was always much more than a mere model. Her beauty and inquisitive mind, her desire to learn and her love of the creative arts, and her intellectual acumen soon set up a complicity that blossomed into friendship.

In May 1943, while staying in a Montparnasse hotel frequented by members of the Resistance, Dina was caught up in a raid just before going to an appointment with her friend Picasso. She was questioned and checks were made; thanks to the zealous Vichy police, her past on the Pyrenean border resurfaced. She was imprisoned at Fresnes and underwent interrogation by the counter-espionage branch and the Gestapo, who beat her. After an internment lasting six months, Maillol managed to get her released thanks to the intervention of Arno Breker, a former pupil who had since become the official sculptor of Hitler's party, and whom Dina, in gratitude, would help to have "de-Nazified" after the war. The day of her liberation on November 13, 1943, she went to the cinema with Maillol before posing for him that evening in the studio belonging to Robert Couturier. Together with Maillol, Dina returned to the Pyrenees until the Liberation, which saw her on the barricades of Paris. Maillol, however, had trouble with some opportunistic members of the Resistance, who criticised him for his friendships with German artists. On his way to visit his friend Dufy, who had moved to Amélie-les-Bains, Maillol suffered a serious car accident, dying of his injuries on September 27, 1944. Dina, in spite of the promise she had made to herself to stay by his side until the end, could not be with him at his deathbed. Later she confessed, "He had become my father, my creator. He was everything to me. It was he who showed me the way."

Collector, gallery owner, heiress

Dina started out as a collector of archaeological pieces, her driving passion when an adolescent, and then later of horsedrawn vehicles, period furniture, dolls, and autographs. She was a lifelong treasure hunter, from

Dina playing the harmonica, photographed by Pierre Jamet in the youth hostel in Dammartin-sur-Tigeaux, Seine-et-Marne. Photograph c. 1937.

African weights to Amazon artifacts. Just after the war, Matisse urged her to open a gallery on boulevard Saint-Germain. There she presented abstract painting, in particular Kandinsky and Poliakoff, as well as other Russian artists despised by the Communist Party apparatchiks. In the 1950s, she briefly ran a bookshop in the same quarter. The executor and rights holder for Maillol's work, in 1963 she donated to the French government the monumental sculptures, which, thanks to the support of André Malraux, were erected in the Tuileries gardens the following year. In 1995, the Musée Maillol-Fondation Dina Vierny opened its doors in a grand townhouse on rue Grenelle in Paris. Presenting works from her personal collection, it also stages temporary exhibitions of contemporary art. The town of Banyuls hosts another museum dedicated to Maillol, which occupies the smallholding where the artist's body rests. The public can even visit the studio where worked—in the company of his Dina—the sculptor who carved the "impalpable."

Dina died on January 20, 2009, at the age of eighty-nine.

Giulietta Masina

Fellini's childlike clown

Giulietta Masina in Federico Fellini's *La Strada*, which had its theatrical release in 1954. The Italian filmmaker once said, "I seek faces which, as soon as they appear on the screen, say all there is to say about themselves. I am even inclined to accentuate their character, to make it more obvious with make-up or clothing, just as with masks, where everything is already evident—acts, destiny, psychology."

One day, when the young actress Giulia Anna Masina was deep in conversation with Cesare Cavallotti, producer of the radio program in which she was acting, a tall, slender young man with brown hair and a broad smile barged into the office. This was in Rome, in autumn 1942. Carrying a fedora, looking elegant in a long raincoat worn over a dark suit, hair tumbling over his collar, was Federico Fellini. If the filmmaker was struck at once by the angelic appearance of the woman soon to be known as "Giulietta," she did not immediately succumb to Fellini's charms, whom, in any case, she knew by sight ever since she had acted in some of his humorous sketches. A few days later, he phoned to ask for a photograph, ostensibly to help her obtain a role in a movie for which he had written the script, *Ogni giorno è domenica* ("Every Day is Sunday"), a story of two young newlyweds. The theme of the young couple was a recurrent one at the beginning of his career. An appointment was fixed for via delle Botteghe, in the center of town. Arriving late, Fellini, who had emerged from his penniless bohemian period and now had money to burn, invited her for lunch in a sumptuous restaurant.

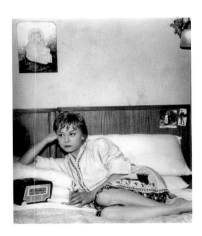

Giulietta Masina in *Nights of Cabiria*, which was released in 1957.

Facing page:
Valentina Cortese, Federico Fellini, and Giulietta Masina on the Lido in Venice, in 1955—the year that saw her play the role of a straitlaced wife in *Il Bidone*, directed by her husband.

The innocent and the magician

Giulietta was born in San Giorgio di Piano, not far from Bologna on February 22, 1921. Her father was a musician, but was unable to make ends meet in his chosen vocation and was forced to work as a cashier. Her mother, originally from Venice, was a teacher. The family was steeped in the arts—especially when Giulietta stayed in Rome with her Aunt Giulia and Uncle Eugenio, an upper middle-class couple who rubbed shoulders with many famous artists and who introduced Giulietta to the capital's cultural life. Upon her uncle's death, her parents allowed her to move to Rome and live with her aunt, who lived not far from the Villa Borghese. There she attended a high school run by nuns, where she showed a talent for singing, piano, and dance, and, especially, for acting, beginning by playing parts in Goldoni comedies in the school theater. At university, Giulietta took courses in various arts subjects (in 1945, she presented a thesis on Christian archaeology), before going for an audition at the theater of the GUF—the Fascist University Group that provided free courses—and quickly appearing at various venues. After a brief foray into teaching, she played a part in *The Eustachian Tubes*, written by her friend Vitaliano Brancati. Invited to become a member of the Academy of the Dramatic Arts, in 1942 Giulietta opted to join the Compagnia del Teatro Comico-Musicale, which produced variety programs for radio broadcast.

When they met, Giulietta was probably attracted to Fellini for his combination of a love of the popular theater and coruscating writing style. The son of a sales agent, born and brought up in Rimini, Fellini studied in a denominational college before leaving the province, settling first for a short time in Florence, before moving to Rome in 1939. Initially he made a living selling cartoons to newspapers and writing sketches for the radio. A few short months after this first encounter, in January 1943, Giulietta and Federico became engaged. Due to the privations of World War II, the wedding was celebrated in the absence of their families. As a director, Fellini was attracted to women with ample physiques, but chose for his wife a small, slightly built woman, with childlike, almost virginal looks. Could it have been that Federico, who viewed himself as a kind of ringmaster, almost a magician, found in the innocence and purity of Giulietta—an otherworldly figure who might have stepped out of a fairytale—an essential component in the construction of his oeuvre? In an interview many years later, he discussed the symbol that such a female figure represented in his creative alchemy: "In myth, the magician and the virgin go hand in hand. The wizard demands an untainted female figure to attain his goal of knowledge. The same applies, in a far more modest

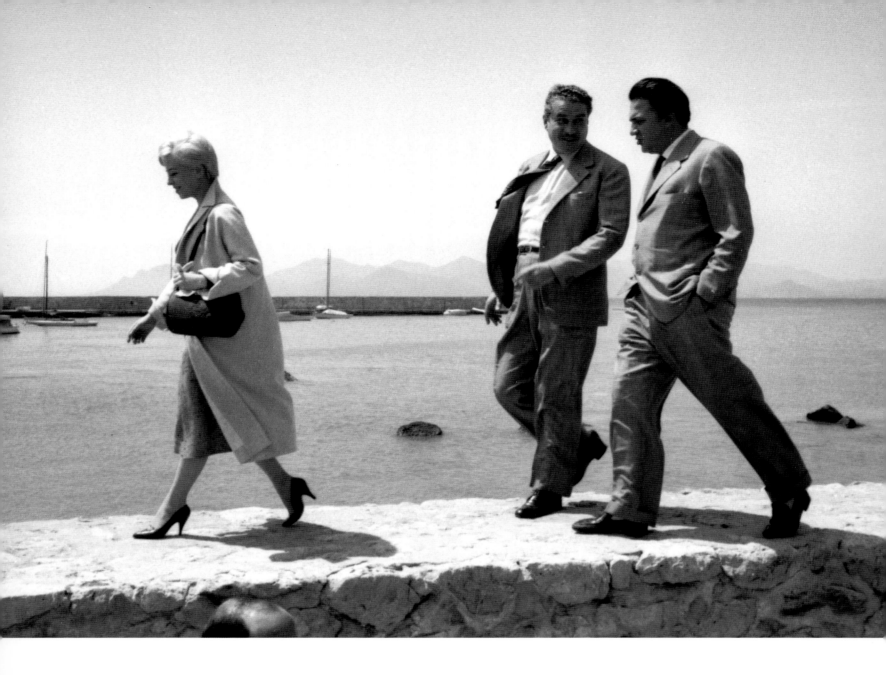

fashion, to the artist, who, for one of his inventions to come into being, must blend expression and embrace."

Typecasting

The years that followed cast a dark shadow over the happiness augured by their early days. Fellini kept himself hidden from the authorities to avoid being enlisted into the Fascist army, while Giulietta suffered first a miscarriage and then the death of their son at only a month old. They did not have any more children. Involved in Fellini's early efforts as a scriptwriter, Giulietta's first, short appearance on the screen dates to 1946, in *Paisan*, by Roberto Rossellini, and Fellini was one of its scriptwriters. Giulietta worked in radio, performing pieces written by her husband, before in 1948 gaining her first screen credit as an impish prostitute in *Senza Pietà* ("Without Pity"), directed by Alberto Lattuada and partly written by Fellini. The film had considerable success and Giulietta was awarded a Silver Ribbon at the Venice Mostra for best supporting actress. In 1950, the Fellini-Lattuada pairing founded an independent movie production

Federico Fellini chatting to actor Amedeo Nazzari as they follow in Giulietta Masina's wake, at the Cannes Film Festival in 1957. Fellini freely admitted that his wife played a crucial role in the material aspects of their life together.

Belgian poster for the movie *La Strada*, with Anthony Quinn. Giulietta Masina once again took the part of a simpleminded and naive woman, a victim of the maliciousness and boorishness of men.

cooperative. The co-op's debut feature, *Variety Lights*, marked Fellini's debut as scriptwriter-director. Giulietta played Melina Amour, a member of a troupe of actors led by her unfaithful husband, who, late in life, falls for the charms of a girl with dreams of making it in variety. Then in 1951 Giulietta played a series of more or less significant roles: in *Sette ore di guai* by Marcello Marchesi and Vittorio Metz; *Behind Closed Shutters* directed by Luigi Comencini; *Cameriera bella presenza offresi* ("Housemaid") by Giorgio Pastina. The following year, she made an appearance in *Wanda the Sinner* by Duilio Coletti and *The Greatest Love*—a movie directed by Rossellini, with Fellini as uncredited scriptwriter—in which she starred opposite Ingrid Bergman in the first of her many incarnations of the kind-hearted prostitute. When her husband tried to secure her a minor role as a lady of the night in *The White Sheik*, he sent one of the team off to announce the good news. The eminently respectable Giulietta, who had had her eye on the lead, burst out, "I've had enough of playing the whore; it'll stick to me like mud!" She finally accepted, however, and let Brunella Bovo play the bride, while she took the character of Cabiria, a kind woman of the streets who offers bed and board to a straying young husband. She played the role to perfection, and thus continued to be typecast.

Sideshow acrobat and lady of the night

"To me she seemed especially suited to expressing the sudden astonishment, distress, madcap joy, and comic gravity of the clown. Giulietta is an actress-clown, an authentic 'clowness,'" Fellini declared in the 1990s. Back in 1952, he decided to write her a movie vehicle: *La Strada*, in which she was to play the fragile and simple-minded Gelsomina, a pathetic little traveling acrobat sold by her mother to a brutish fairground strongman, Zampano, who makes her his mistress and his slave. It was through Giulietta's good offices, moreover, that, in 1953, Fellini unearthed his two other principal actors, Anthony Quinn and Richard Basehart, bumping into them when he came to pick his wife up on the set of *Angels of Darkness*. He fought tirelessly for her to be given this made-to-measure role, but it proved a considerable challenge for Giulietta, since she found it hard to identify with the character's plight. Worse still, Giulietta hurt her ankle in the studio and then suffered an ophthalmic lesion caused by the intensely bright lights used on set. Despite this, *La Strada* was hailed as a masterpiece on its release, and received a shower of awards (around fifty) from all over the world, the most prestigious being the 1956 Oscar for Best Foreign Language Film. It was thanks to their close collaboration and to Fellini's determination to mold his wife's talents into whatever he

wanted—without ever rendering her unrecognizable—that the couple earned their international success. It set the standard for her next role, however, which had to at least match, if not surpass, the part of Gelsomina in emotional power and empathy. Fellini first considered the idea of a nun performing miracles in a backward village, but her next role was, in fact, the model wife in *Il Bidone*, a supporting role that did not allow her talent to shine and which flopped upon release in 1955. In her next film, *Nights of Cabiria*, released in 1957, she was once again saddled with the role of an idealistic, unhappy prostitute in love. As in *La Strada*, and later in *Juliet of the Spirits*, the filmmaker and actress did not always agree on the conception of the role and its interpretation, but their divergent—occasionally antagonistic—viewpoints complemented each other.

Fellini was a director who did his fieldwork, absorbed the facts, and then tried to exacerbate their comic and bizarre side, while Giulietta was of more literary bent, of melodramatic and perhaps starry-eyed temperament, conveying a model of womanhood as faithful, patient, and forgiving homebody. The character in *Nights of Cabiria* was influenced by a real-life prostitute Fellini met while shooting *Il Bidone*, a romantically minded, impoverished woman who nonetheless displayed admirable dignity. Giulietta would wait up for him until all hours while he busied himself on location with Pasolini in some of the roughest areas of the capital inhabited by diverse fauna of the night. And Fellini clearly had affairs and mistresses; throughout his life he never denied his adoration of women, who, as he said, seem "to fill the space with a different light." In order to underscore Giulietta's fragility in *Nights of Cabiria*, he set up a powerful counterweight, playing her opposite a kind of sensual harridan (another recurrent female type in Fellini's movies), played by Franca Marzi, well used to the role of Junoesque man-eater. With broad hips and ample bust, her femme fatale appearance is the polar opposite of the waif-like physique and disarmingly sweet expression adopted by Giulietta. According to Fellini (as recounted by Bertrand Levergeois in *Fellini, la Dolce Vita du Maestro*), Cabiria is a "sleepwalking little spider, with one eye on reality and the other on her dreams. Nocturnal myths pursue her in broad daylight and she lives in constant expectation of seeing the medieval knight or the plumed archangel she saw in her most recent dream emerge from between the trees on the 'Passeggiata Archeologica' [a soliciting hotspot]." And indeed Giulietta's round, expressive face does give the impression of moving through a waking dream, entertaining the boundless—yet impossible—hope of one day returning to the bright colors of paradise lost. *Nights of Cabiria* was acclaimed the world

As Fellini declared one day, "If the basic meaning of my existence was to tell stories through pictures, it seems to me that my private life organized itself so that my work became its most important aspect. My wife, my friends, my affections, or absence thereof: there has been no dissipation, no enforced responsibilities or awakenings that might have taken time away from my work."

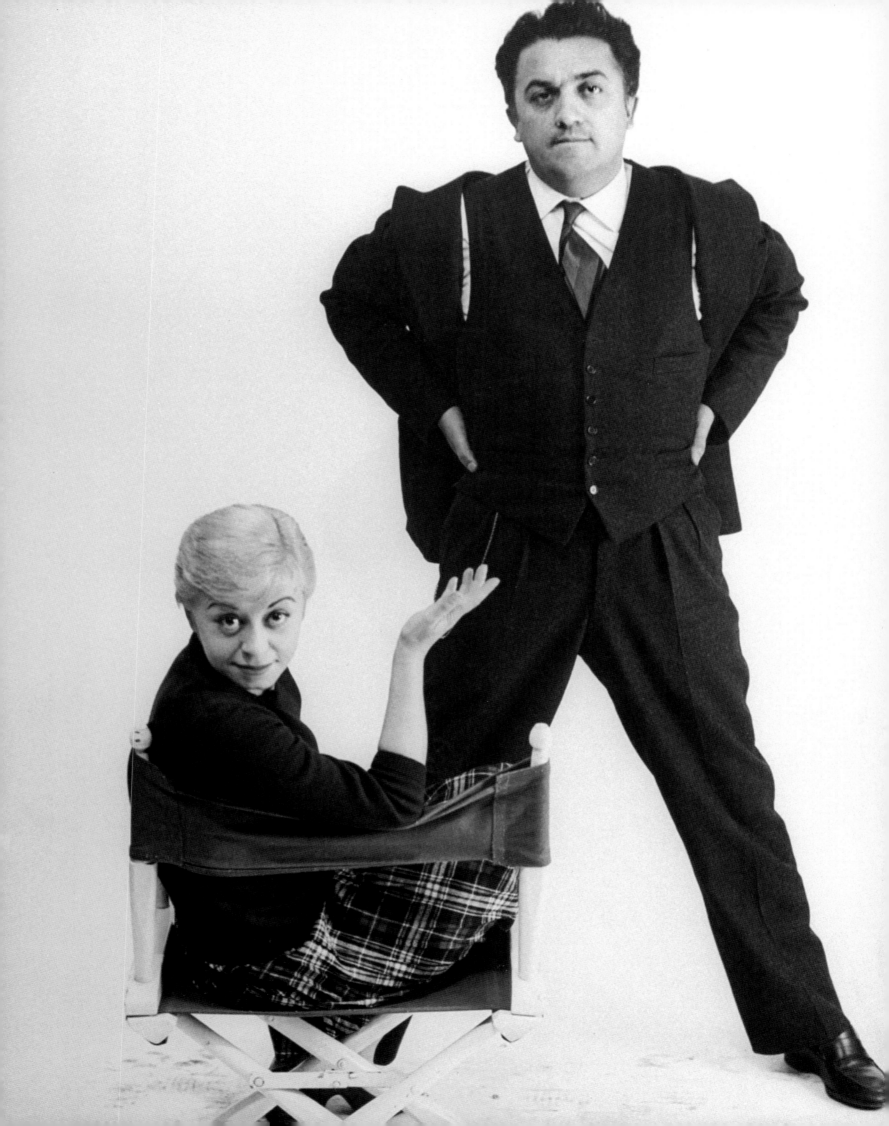

over and the talent of its star, who became very fond of the film, was recognized with a host of acting prizes, with Giulietta herself going to Hollywood to pick up the Oscar for Best Foreign Language Film in 1958.

Twenty years on

Interested in dreams and intrigued by the paranormal, Fellini in the 1970s began staging regular séances, an activity Giulietta regarded with suspicion. In *8 ½*, Fellini—in what for him was a new departure—adopted the idiom of imaginary autobiographical introspection. Following the film's release in 1963, he also began experimenting (under medical supervision) with hallucinogenic drugs, in the form of LSD 25. As his fascination with the occult began to wane, he planned a movie dealing with the subject, hoping to involve Giulietta, who, though at the time directed by some famous filmmakers (such as Julien Duvivier), had not had a significant role since *Nights of Cabiria*. In fact her career had hit something of a wall compared to Fellini's and it was now more than ever apparent that only her husband was able to shape roles worthy of her outstanding abilities. These years also saw the couple's relationship enter a rough patch. This fact is reflected in the magnificent and highly colored *Juliet of the Spirits* of 1965, the story of a middle-class Italian woman betrayed by her husband, who frees her mind through the power of the imagination and the subconscious. The main set in which Giulietta sinks into irrationality is an exact reproduction of the house the Fellinis owned on via Archimede in Rome. A movie misunderstood on its release by critics and audiences alike (even as to its feminist credentials), it represented for the Fellinis an unwarranted if incontrovertible failure. This cruel reversal seemed to ring the death knell on Giulietta's career.

> *"The fact is that Giulietta lives in me far more than other actors; to me, it seems she finds it impossible to make a slip."*
> Federico Fellini

Some twenty years later, however, in 1986, the ever-inventive maestro had the brilliant idea of recasting his two favorite actors for the title roles of *Ginger and Fred*: his wife played Amelia Bonetti, alias "Ginger," and Marcello Mastroianni portrayed Pippo Botticella, alias "Fred," onetime tap-dancers now eking out a living on a TV variety show (it is worth noting that photographer Jacques-Henri Lartigue takes the role of Brother Gerolamo). An acid, eccentric, but pitch-perfect lampoon of show business

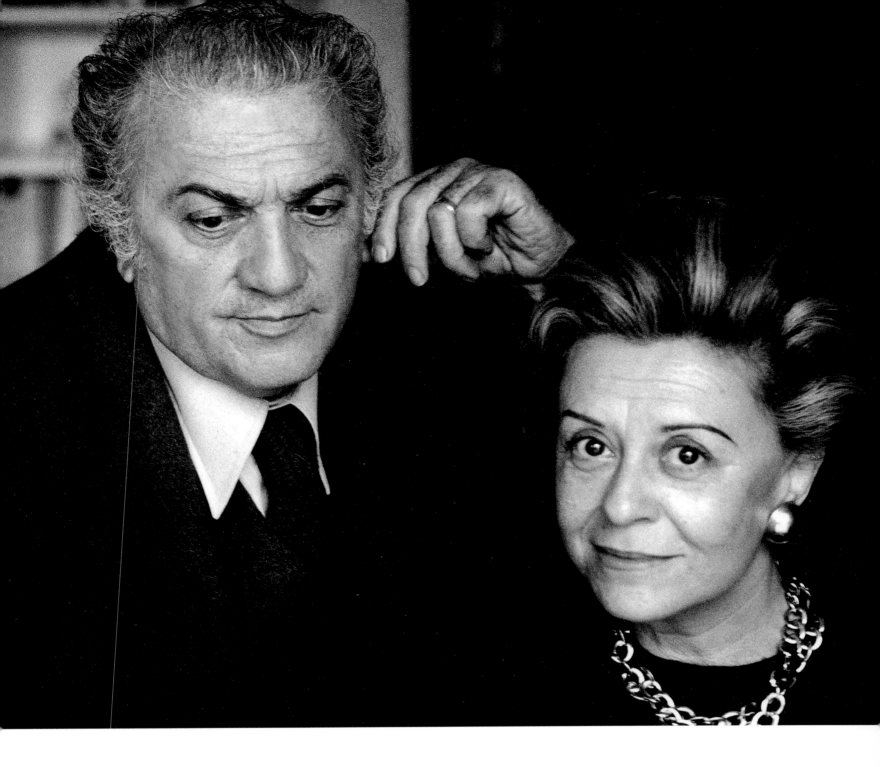

Admiring the expression of Giulietta Masina, we are reminded of Federico Fellini's remark, "And, of course, beauty moves me, the look of certain women, beautiful as enchantresses, who seem to fill space with a different light. Poignant apparitions!"

and the mediocrity of television, the film, through which waltzes a posse of star clones and fake commercials, is a masterly, nostalgic homage to the soul of true music hall and to its long-gone entertainers.

In 1993, Fellini, now in poor health, traveled with Giulietta to Hollywood for his fifth Oscar. On the rostrum, he brandished the statuette and, declaring that there were too many people to thank, looked over at his wife and said, "Let me [mention] only one name—of an actress who is also my wife. Thank you, dearest Giulietta." The following October, shortly before falling into the coma that ended his life, the maestro scribbled a few notes on a piece of paper. One reads, "My friend, Giulietta, companion of my life."

Selected Bibliography

Lizzie and Jane: Rossetti's Beatrices
Doughty, Oswald. *A Victorian Romantic*. London:
Muller, 1949.
Francillon, R. E. *Mid-Victorian Memories*. London,
New York, Toronto: Hodder and Stoughton,
[1914].

George Sand: Balzac's inspiration
de Balzac, Honoré. *La Muse du département*.
Paris: Gallimard, 2007.

Jeanne Duval: Baudelaire's nonchalant muse
de Banville, Théodore. *Mes souvenirs*. Charleston:
Nabu Press, 2010.
Guyaux, André. *Baudelaire, un demi-siècle
de lecture des Fleurs du mal. 1855–1905*. Paris:
PU Paris-Sorbonne, 2007.
Richon, Emmanuel. *Jeanne Duval et Charles
Baudelaire, Belle d'abandon*. Paris: L'Harmattan,
1999.

Virginia de Castiglione: Her own muse
Apraxine, Pierre, and Xavier Demange. *La Divine
Comtesse: Photographs of the Countess de
Castiglione*. New Haven: Yale University Press,
2000.
Decaux, Alain. *La Castiglione*. Paris: Perrin, 1965.
Hermange, Emmanuel, Pierre Apraxine, and
Xavier Demange, eds. *La Comtesse de
Castiglione par elle-même*. Exh. cat. Paris:
Réunion des Musées Nationaux, 1999.
Maurois, André, and Marianne Nahon, with
an introduction by Marta Weiss. *La Comtesse
de Castiglione, La Vierge au miroir*. Paris:
La Différence, 2009.

**Apollinaria Suslova: Dostoyevsky's
nihilist muse**
Dostoyevsky, Fyodor. *The Gambler*. New York:
Dover, 2006.

**Élisabeth Greffulhe: Proust's model for
*In Search of Lost Time***
Proust, Marcel. *Correspondance générale
de Marcel Proust*, vol. I. "Lettres à Robert
De Montesquiou 1893–1921," eds. Robert Proust
and Paul Brach. Paris: Plon, 1930.
———. *À la recherche du temps perdu*. Paris:
Gallimard, 1999.
———. *In Search of Lost Time*. Trans. C. K. Scott
Moncrieff and Richard Howard. New York:
The Modern Library, 2003.

Marie de Régnier: Pierre Louÿs's bride *manqué*
Fleury, Robert. *Marie de Régnier*. Paris: Tallandier,
2008.

La Goulue: Lautrec's cancan muse
Guilbert, Yvette. *La Chanson de ma vie*.
Paris: Grasset, 1927.
Mac Orlan, Pierre. *Masques sur mesure*.
Paris: Gallimard, 1965.
Perruchot, Henri. *La Vie de Toulouse-Lautrec*.
Paris: Hachette, 1958.
Souvais, Michel. *Moi, La Goulue de Toulouse-
Lautrec : Les Mémoires de mon aïeule*.
Paris: Publibook, 2008.

Lou Andreas-Salomé: Rilke's soul mate
Astor, Dorian. *Lou Andreas-Salomé*. Paris:
Gallimard, 2008.
Livingston, Angela. *Lou Andreas-Salome:
Her Life and Work*. Kingston, RI: Moyer Bell,
1984.
Rilke, Rainer Maria, and Lou Andreas-Salome.
The Correspondence. Trans. Edward Snow. New
York: W. W. Norton & Co. 2006.

**Annie, Marie, Louise, Madeleine, Jacqueline:
Apollinaire's muses**
Apollinaire, Guillaume. *Poèmes à Lou*. Paris:
Gallimard, 1969.
———. *Selected Writings*. New York: New
Directions, 1983.
Bonnefoy, Claude. *Apollinaire*. Paris: Éditions
Universitaires, 1969.

Yvonne Printemps: Guitry's diamond
Dufresne, Claude. *Yvonne Printemps, le doux
parfum du péché*. Paris: Perrin, 1988.

Lili Brik: Mayakovsky's muse and mentor
Brik, Lili, with Carlo Benedetti. *Avec Maïakovski,
par Lili Brik*. Paris: Sorbier, 1980.

Gala: The apple of Dalí's eye
Dalí, Salvador, and André Parinaud. *The
Unspeakable Confessions of Salvador Dalí*.
London: W. H. Allen, 1976.
Delassein, Sophie. *Gala pour Dalí*. Paris:
Jean-Claude Lattès, 2005.
Meyer-Stabley, Bertrand. *La Véritable Gala Dalí*.
Paris: Pygmalion, 2006.

Dora Maar: Picasso's captive queen
Dujovne Ortiz, Alicia. *Dora Maar, prisonnière
du regard*. Paris: Grasset, 2003.

Kiki: Queen of Montparnasse
Buisson, Sylvie, and Dominique Buisson. *Foujita*.
Paris: ACR, 2001.
Dutourd, Jean. *Le Figaro littéraire*. April, 7, 2005.
Mollgaard, Lou. *Kiki, reine de Montparnasse*.
Paris: Robert Laffont, 1988.
Montparnasse, Kiki de. *Souvenirs retrouvés*.
Paris: Corti, 2005.

**Marlene Dietrich: Josef von Sternberg's
alchemical muse**
Ciment, Michel. "Les rebelles de Hollywood"
in *Positif* (special issue), January 1991.
Dietrich, Marlene. *My Life*. London: Weidenfeld
& Nicolson, 1989.
Riva, Maria. *Marlene Dietrich*. New York: Knopf,
1995.
Sternberg, Josef von. *Souvenirs d'un montreur
d'ombres*. Paris: Robert Laffont, 1966.
———. *Fun in a Chinese Laundry*. London:
The Lively Arts, 1989.

Nancy Cunard: Aragon's temptress
Buot, François. *Nancy Cunard*. Pauvert: Paris,
2008.
Dreyfus, Simon, and Edmond Jouve. *Les Écrivains
de la négritude et de la créolité*. Paris: Sepeg
international, 1994.
Gordon, Lois. *Nancy Cunard: Heiress, Muse,
Political Idealist*. New York: Columbia University
Press, 2007.

Pivot, Bernard. "Nancy Cunard la scandaleuse."
Le Journal du Dimanche, October 14, 2008.

**Tina Modotti: The bittersweet muse
of Edward Weston**
Hooks, Margaret. *Tina Modotti, Photographer
and Revolutionary*. London: Rivers Oram Press,
1995.
Toffoletti, Riccardo. *Tina Modotti, une flamme
pour l'éternité*. Paris: En Vues, 1999.
Lowe, Sarah M. *Tina Modotti and Edward Weston,
The Mexico Years*. London / New York: Merrell,
2004.

Lee Miller: Man Ray's demon angel
Boutot, Anaïs. "Lee Miller, une battante sur
tous les fronts," *Transtlantica revue d'études
américaines* (www.transatlantica.revues.org/
pdf/4299).
Burke, Carolyn. *Lee Miller: A Life*. Chicago:
University of Chicago Press, 2007.
Penrose, Anthony. *The Lives of Lee Miller*.
London: Thames & Hudson, 1995.

Renée Perle: Lartigue's alter ego
d'Astier, Martine. *Jacques-Henri Lartigue*.
Paris: Gallimard, 2009.
Lartigue, Jacques-Henri. *L'Émerveillé, écrit
à mesure, 1923–1931*. Paris: Stock, 1981.

Dina Vierny: Maillol's archetypal beauty
Vierny, Dina. *Histoire de ma vie, racontée
à Alain Jaubert*. Paris: Gallimard, 2009.

Giulietta Masina: Fellini's childlike clown
Fellini par Fellini (in conversation with Giovanni
Grazzini). Paris: Flammarion, 2007.
Kezich, Tullio. *Federico Fellini: His Life and Work*.
London: I. B. Tauris & Co. Ltd., 2007.
Levergeois, Bertrand. *Fellini, la Dolce Vita
du Maestro*. Paris: Éditions de l'Arsenal, 1994.

Facing page:
During the late nineteenth century,
the French actress Mery Laurent was
the muse and lover of a great number
of writers, such as Théodore de Banville,
Sully Prudhomme, Leconte de Lisle,
François Coppée, and Mallarmé, as well
as the artist Manet, who painted many
portraits of her. Born Anne-Rose Louviot
in Nancy in 1849, she made an enduring
impression in *La Belle Hélène*, an opéra
bouffe by Jacques Offenbach, playing
the role of an almost naked Venus
emerging from a gilded shell. Émile Zola
recalls her erotic-cum-mythological
appearance in *Nana*. Photograph c. 1870.

Pages 234–35:
Renée in Paris, January 1931.
"Her lips coated with a new lipstick.
Cloud of perfume clutching at her hair.
Bracelets round her wrists." From
Jacques-Henri Lartigue's private journal.

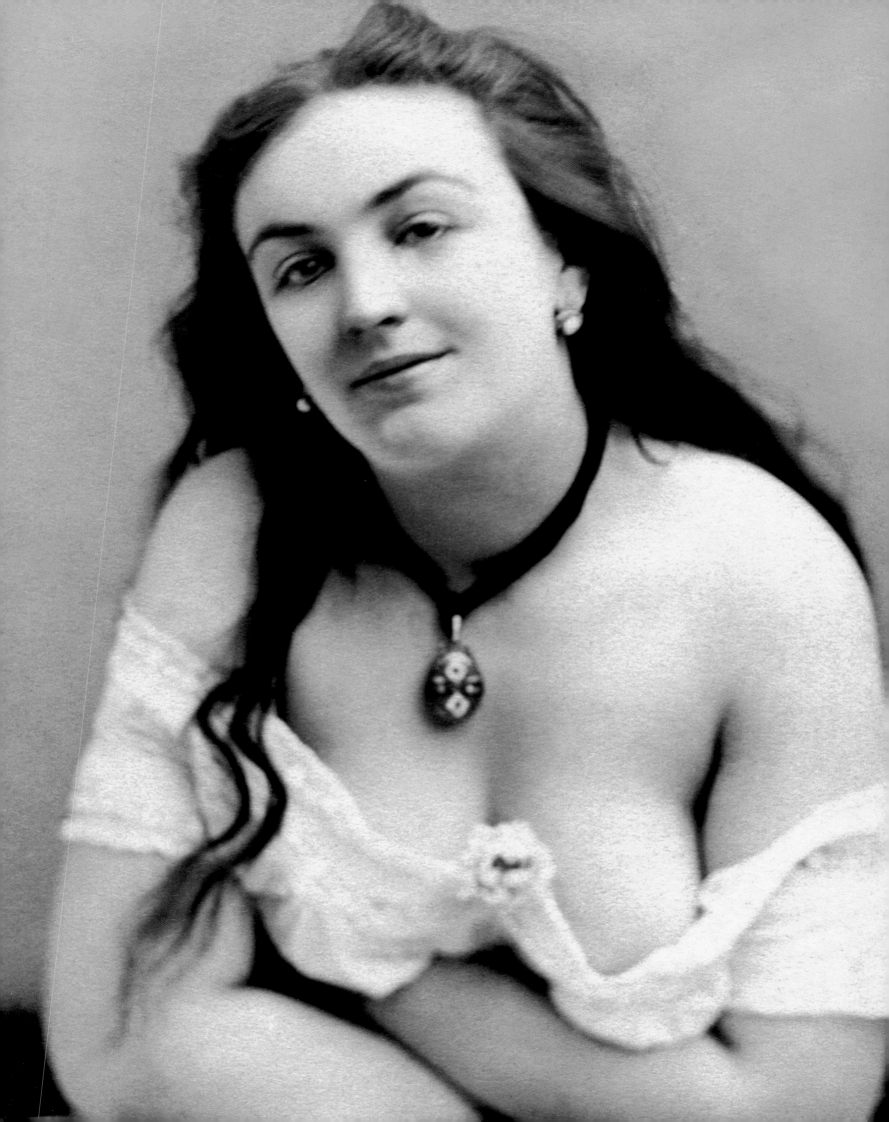

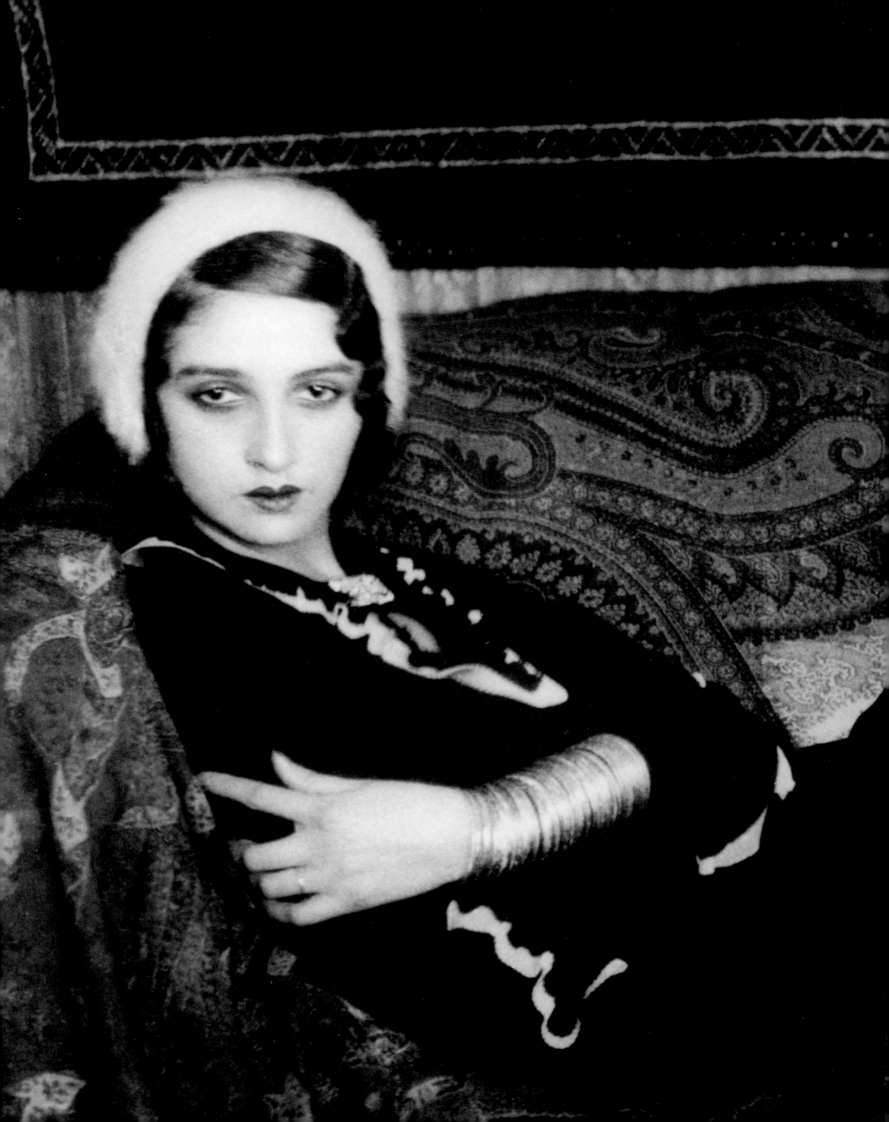

Photographic Credits